THE WORLD OF WILLIAM NOTMAN

The Nineteenth Century Through a Master Lens

ROGER HALL • GORDON DODDS • STANLEY TRIGGS

Foreword by Robert MacNeil

M&S

THE WORLD OF WILLIAM
NOTMAN

Canadian Cataloguing in Publication Data
Hall, Roger, 1945-
 The world of William Notman

Includes index.
ISBN 0-7710-3773-2

1. Notman, William, 1826-1891. 2. Photographers — Québec (Province) — Montréal — Biography. I. Dodds, Gordon. II. Triggs, Stanley. III. Title.

TR140.N6H3 1993 779'.092 C92-093320-3

Published simultaneously in the United States of America by
David R. Godine, Publisher, Inc.

THE WORLD OF WILLIAM NOTMAN has been set in a digitized version of Walbaum. Designed by the German typefounder Justus Erich Walbaum in the early nineteenth century, it shows the characteristics of the "modern" typefaces that originated with Bodoni and Baskerville and were sub-sequently introduced to France by Didot. Like its cousins, Walbaum is notable for its refined serifs, its upright stresses, and its classical contrasts between thicks and thins. With its slightly more open feeling and wider letters, Walbaum is more elegant than its peers, its contours softened by the sensitivity of the craftsman who cut it.
 The book has been printed by The Stinehour Press, Lunenburg, Vermont, on Mohawk Innovation, an entirely acid-free paper. Design: William Rueter.

McClelland & Stewart Inc.
The Canadian Publishers
481 University Avenue
Toronto, Ontario M5G 2E9

TITLE PAGE: *Mount Stephen and Mount Stephen House, Field, British Columbia, 1887. This Canadian Pacific Railway station, which contained a hotel and a dining room, was named after the president and main financier of the railway, George Stephen, later Lord Mount Stephen.*

Contents

FOREWORD BY Robert MacNeil vii

INTRODUCTION 1

CANADA

Montreal Roots 9
Trans-Canada 20
Branching Out 23

THE UNITED STATES OF AMERICA

The College Trade and the Centennial Exhibition 37
An American Branch Plant 48

Conclusion: The Notman Legacy 61

THE PLATES

ACKNOWLEDGEMENTS 228

PICTURE CREDITS 230

INDEX 231

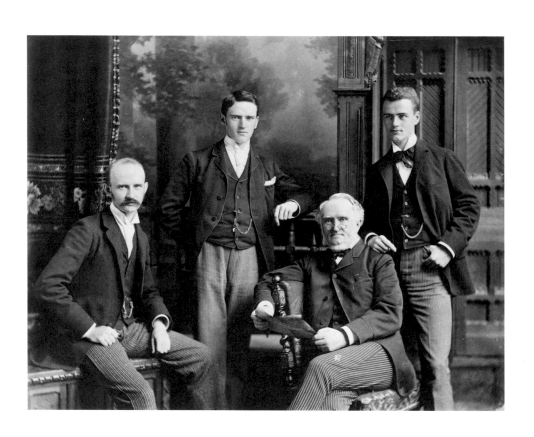

William Notman and his sons, 1890. Left to right: William McFarlane, George R.W., William, Charles Frederick.

Foreword

Robert MacNeil

MODERN HISTORY begins for me with the invention of photography. Psychologically, the arrival of the photograph marks off time since that point, say for convenience, 1850, from all human existence before. That is when the traces of our past take on an irrefutable and documentary validity, a different order of realism. A painting of a man being shot in a war may evoke pity or horror, but a photograph of a man being shot in battle causes a different thud to the heart, because this was an actual man losing his life in an actual place in an actual historical moment. The photograph becomes a piece of real time in a sense that no other art form quite matches.

So a man who slipped into history with cameras present has a reality for us, as Lincoln does, that another equally great man, like Jefferson, does not, because he lived a few decades too early. So do all the lesser lights of history and the ordinary people. A photograph of someone, no matter how great or humble, is a ticket of admission into the modern imagination.

Because they are on the margin of history – the first human images to emerge out of the mists of art into a reality we recognize – I am fascinated by nineteenth-century photographs, and in a small way collect them. So this book is a feast for me. I feel immense curiosity about all of these people snapped 130 years ago. I examine them minutely, sometimes with a magnifying glass, looking for the tiniest clues to what was going on in their hearts and their heads as they pose in their excessive, unpressed clothes, in their overstuffed interiors. I search their stiff figures and their posed, unsmiling faces, marvelling to myself: "You were actually alive in Montreal or Halifax or Boston in 1860. You could have known my great-grandparents."

The more we know about our families and our pasts, the more we know ourselves, and that is as true of the national consciousness as of the individual. The pity is that Canadians have been so slow in bringing such intimate and revealing historical materials to light. Our historical imagination was far too long distracted, bedazzled by other people's stories. But the historical gold rush is on now and *The World of William Notman* is an inspired bit of prospecting in the times when Canada was born.

Introduction

WILLIAM NOTMAN'S world was that of the Victorian nineteenth century – a period that has been labelled proud, confident, self-absorbed, and not a little arrogant. Notman was eleven years old when Victoria came to the British throne and, when he died in 1891, she had a full decade left in her reign. It was an era when it seemed, for Anglo-Saxons at any rate, that progress and improvement became a kind of birthright. For those with drive and ambition, the opportunities for worldly success proliferated.

Yet it is wrong – indeed it is hopelessly presumptuous – to define the Victorian age as all of a piece, as, somehow, a simpler or more comprehensible time than that in which we live. Moreover, William Notman did not live the most active years of his life at the supposed core of Victorian experience in Great Britain; rather, his mature life was spent in the Greater Britain that many hoped Canada would eventually become.

Although Canadian Victorian society mirrored many of the characteristics of the mother country, it was dissimilar in significant ways. There was much more of an openness, a practicality, and a regard for the pragmatic man of business in Canada than ever existed in the more rigidly stratified society of the United Kingdom. By examining William Notman's busy life we can better appreciate the nuances of the nineteenth-century transatlantic world. When his sizeable United States experience is mixed in, the portrait of the man and his age becomes even more absorbing.

It is safe to say, however, that the nineteenth century ushered in the real beginnings of the modern machine age. Before 1800, human and animal muscle provided the power that ran commerce and manufacturing; thereafter, machines gained wider and wider acceptance. One of those machines, we should not forget, was the camera – an invention that functioned to record, among other things, the extraordinary impact that other machines were having on human society. William Notman, for over half a century, stood behind or beside that camera, and chronicled the century's unfolding in one of its most boisterous theatres: North America.

The World of
William Notman

The impact of photography (first practically realized by the Frenchman Joseph Nicéphore Niepce in 1826) upon nineteenth-century culture and society is difficult to appreciate some hundred and more years onwards. Photographs, the most common icons of the age, represented more than a mere chronicling of events, more than the creation of "likenesses," more than a new and voguish aesthetic. Rather, they exhibited and conveyed to others a sense of the century's dramatic dynamism. Here, propped on the mantel, tacked to the wall, or held in the hand, was proof of the merit of the century's leading convictions: those confident and bourgeois notions of progress, advancement, and improvement. Photographs, for example, functioned as clear evidence of a sitter's advancing social status, or they were a sure and certain representation of visible progressive change in landscape or cityscape, or they made a clear and convincing technical record of man's conquest of and challenge to nature. And, not least, photographs, because of the technological innovations they themselves incorporated, became an outstanding symbol and substantial material evidence of the nature and value of progress.

More darkly, photographs unmistakably conveyed something of the period's immense contradictions. Subtly, and not so subtly, they showed both the Victorians' piety and their intolerance, their intellectual high-mindedness and their moral hypocrisy, their fascination with the secular religion of self-reliance and their defence of the snobbish privilege that so often resulted from its exercise.

To be a photographer in the nineteenth century was, in a way, to be midwife to our modernity. As well, photography linked the Victorians' love of the mysteries of art with their equal fascination with the promise of science. Through their skills, their mastery of and experimentation with technique, photographers mirrored and enlarged the world around them and, inevitably, at times distorted it. William Notman was a superior practitioner of both the art and the science of photography. He was also, unlike many other photographers, a consummate and imaginative businessman who turned his avocation as a photographer into a very lucrative vocation. However the nineteenth century is defined, Notman was very much a man of the period – and perhaps one of the better ways to understand that century is to examine more closely the careers of individuals like him.

Notman's photographs are widely considered to be synonymous with Canada, and particularly with Montreal. But Notman's scope was actually much larger, and it is the particular purpose of this book to display and explain that enlargement. Although some have been aware of the prodigious size of his American operations – that William Notman and his extended family operated a very large number of studios in the United States, and that the Notman name was a feature of the American photographic scene for almost sixty years – never until now have the details of these operations been researched. Many of these American portraits and scenes have never previously been

published, nor has so much Notman material from both countries
been collected in one volume.

William Notman's world was a wide one. It was his optimism, energies, ambitions, and abilities that assured him success, and it was his substantial Victorian family that helped him to sustain it. After his death, the structure he had built held for a while, but the dynamism inevitably failed as family members either lost interest, turned to other careers, or simply died. The core of William Notman's world was highly personal and individualistic. Fortunately for us, much of it remains in the prolific imagery he left behind. The characteristic stamp of his style and technique is eminently visible on images taken by him in the 1850s or by his studio nearly a century later.

William Notman was born in Paisley, Scotland, on the eighth of March, 1826, the eldest of a family of seven children. His grandfather had been a dairy farmer, catering to the profitable urban markets of Paisley and the city of Glasgow, a few miles to the east. His father, William senior, joined the swelling ranks of tradesmen and entrepreneurs eager to secure a slice of the wealth the industrial revolution was bringing to Scotland. Specifically, he designed and manufactured women's shawls, a fashionable accessory of the day. Available in plaids, stripes, and, of course, the distinctive Paisley prints, the shawls were of all sizes and fabrics and found a ready market amongst an expanding British middle class.

Like all fashion business, however, the shawl trade was cyclical, and in one of the periods of downturn, about 1840, William senior moved his young family to central Glasgow, where he broadened his interests to become a general cloth wholesaler. By this time, young William was fourteen, able to appreciate and take advantage of the thriving port, banking, commercial, and university city. For ten years the cloth business flourished well enough for the family to taste solid prosperity and boast fashionable addresses. Indeed, when the cholera epidemic of 1849-50 struck, they were able to buy a farm north of the River Clyde and commute to the city daily.

So young William had first-hand experience of both rural and urban living, and he knew something of hard times as well as good. He had a solid, classical education, with extensive training in drawing and painting, and he had toyed with the idea of becoming a professional artist. He was eventually persuaded by his more realistic father, however, to follow him into the family firm. It is not known exactly when Notman joined his father in the cloth business, but it is clear that before what proved to be the fateful year of 1856, he had travelled extensively for the company on the new railway system connecting the west of Scotland across the moors to the cotton mills of Lancashire, the English Midlands, the Cotswolds, and on to London. Perhaps it was on such a trip that the intelligent, spirited young Scot met Alice Woodwark, from a small village near Stroud in Gloucestershire. At

any rate he married her in 1853, and took her back to the Clyde.

We do know that the young man had another interest. He was a keen amateur photographer, and it is possible he had studied the new art with one of Glasgow's dozen practitioners. It is equally certain that, at this stage of his life, his photography represented no more than an engaging hobby. Thus far Notman's tale is archetypal rather than remarkable. William seemed fated to spend his life as a solid, anonymous Victorian burgher, growing plump and prosperous catering to the appetites of the Victorian marketplace. But it did not turn out that way. Within three years of his marriage, William Notman would be a bankrupt, the object of a financial scandal, and a resident of a rugged New World city an ocean away.

The manner of Notman's undoing was not untypical. Like any number of wholesale enterprises, the Notman business had a large and extended debt-load. Scotland had experienced something of a business downturn in the mid-1850s and a credit squeeze was felt by many firms, among them William Notman & Son. The firm's principal supplier of cloth, Marling, Strachan & Company, which was the Notmans' principal creditor as well, dramatically decided not to permit shipment of consignments other than those for which the Notmans had definite orders. Young William, to circumvent this problem, hit on the idea of ordering twice the volume of any customer's requirement and selling the unused surplus elsewhere through the Notman agency to pay off the debt. For a time, he carried this off successfully, but it was certainly reckless business behaviour. Eventually, troubled, he confessed the arrangement to the supplier, adding that he had only engaged in the fraud to gain monies to pay off the family debts to the firm in question, and offering his own household goods and whatever other assets he could muster to pay the money owed. The firm hesitated, but then decided to press charges, and William, evidently with the Notman family's full backing, decided to flee. Doubtless, had he remained the young man would have faced debtor's prison and severe penalties for fraud.

As it was, the family business, already in severe financial straits, was conclusively destroyed by the episode, the Notmans' reputation was ruined, their houses and personal property seized. The once-prosperous family faced ruin uneasily, with only a slim hope that far-away William might find a shred of opportunity in the New World. He would have to be quick about it.

North America was the traditional sanctuary of those escaping persecution of one sort or another in the Old World. William had fled Scotland south over the familiar rail lines and taken ship – not for the United States but for the Province of Canada, more precisely Canada East as it was then known, and its commercial capital, the hybrid, bicultural city of Montreal.

Why Canada? And why Montreal? The reasons are not precisely clear, but it is safe to say that, since 1854, Canada had been benefiting

mightily from a free trade agreement with the United States, and besides, it was easy to get to, and the passage was relatively cheap. As for Montreal, it was an odd place in the 1850s, and to the young exile it doubtless provided a heady combination of the exotic and the familiar. The population of about sixty thousand was one-third foreign-born. It was a city outwardly more English than French, although the growing industrial opportunities were attracting more French Canadians year after year. In Montreal, a Scot would find kith and maybe kin, and on its stone streets he would rub against the familiar architecture of his homeland. Yet everywhere he would hear the chopped cadences of Norman French and see the hooded and capped figures that signified the mysterious strength of the French Catholic churches that dotted the cityscape.

The colonial city had been profoundly shaken by Britain's scrapping of the Corn Laws and Navigation Acts a decade before. The disappearance of their protected markets in the Old Country saw many merchants teetering on the brink of commercial collapse, and some even clamouring, in 1849, for Canada's annexation by the United States. Nothing had come of that hysteria, nor, to the surprise of many, had financial collapse followed. Canadians found themselves, in fact, able to compete effectively for a share of the unprotected British market, and when new trade links were fashioned through reciprocity with the United States, the economy took off.

Politically and socially, the times were equally exciting. Canada was precariously bridging two worlds – stretched between old, safe colonial dependence and a newer national awakening whose sinews were felt through emergent self-government. It was a time of trial and error, of testing the new institutions of responsible government and getting rid of the old. Much of the commercial energy of the era was the result of the railway boom. Railways were thought to be the magic elixir of the nineteenth century, the sure source of prosperity for country and city alike.

For Montreal, in fact, the promise of the railway meant financial rescue. Its presence guaranteed that the city would retain its old importance as a transshipment and commercial centre. And it also meant jobs – not just secondary manufacturing, but heavy industry – and none was heavier than the railway industry itself. By 1853, the completion of the St. Lawrence and Atlantic, running from Montreal to Portland, Maine, gave the inland city access to a year-round ice-free port. The inconvenience of crossing the river to the terminus at Longueuil on the south shore remained, however. In the years that followed, lines were built running everywhere, and, in some cases, nowhere. But, importantly, the city was fully connected to the American rail web to the south and would soon be linked to the growing Ontario communities to the west.

The year of William Notman's arrival in the city, 1856, was a particularly propitious one. Perhaps William himself stood in the crowd

that cheered when a public ceremony in November of that year exuberantly celebrated the opening of the Grand Trunk Railway to Toronto. Banquets, speeches, torchlit processions, the roar of cannons, and fireworks all celebrated the event. It may have been circumstances such as these that suggested to William Notman the raw energy of the place and the scale of opportunity open to him. Probably as important, no one seemed interested in the details of his past.

Canada

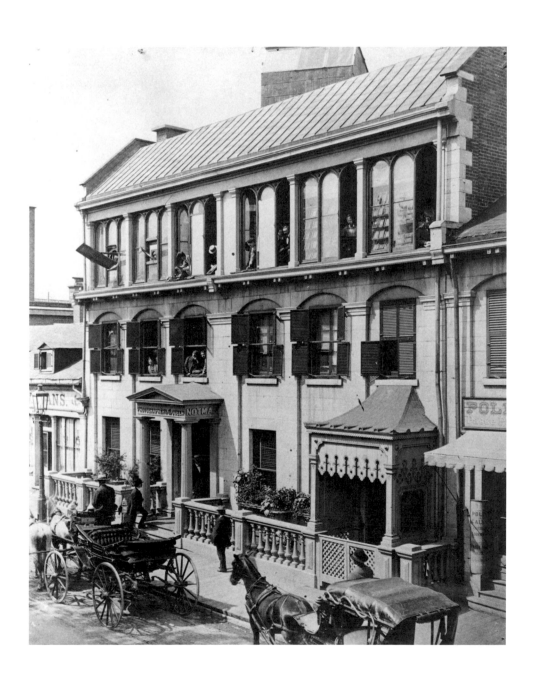

Montreal Roots

WHEN WILLIAM NOTMAN came to Canada in the summer of 1856, he had three considerable advantages: first, as a partner in his father's wholesale dry-goods firm in Glasgow he had a sound training in business; second, he had a compelling desire to succeed, fuelled no doubt in part by a wish to erase the stain of his family's business indiscretion; and, finally, he had an unripened talent: he was an excellent, although amateur, photographer. He soon put all three attributes to work in establishing himself in the rising city of Montreal.

Luck was with him from the beginning. He had no trouble getting basic employment – with Ogilvy & Lewis, wholesale dry-goods merchants. Although the dry-goods job was only of short duration, it proved to be one that brought him enough time to sort out his life and decide the direction for his future.

That future, he soon determined, lay with photography. As noted, Notman had always been interested in art and as a youth had trained in painting and drawing in Scotland. He had wanted to take up art as a livelihood, but his father soberly had advised him to enter the family business instead. An assessment of the relatively few photographers then practising in Montreal might well have convinced young William that there was a considerable opportunity for a man of his talents.

The young Scot certainly must have made a good impression on Messrs. Ogilvy & Lewis. After his short stay, he left the firm not only with their blessing but with a loan to help him establish himself in his new venture, and the promise of being able to return to his former position if things did not work out. And so, by the end of 1856, William Notman was able to open a small portrait studio at No. 11 Bleury Street, in a little red-brick house which was also to be a home for his small family. His wife and infant daughter, Fanny, had arrived in November, and shortly after moved into their modest new home. His parents and siblings were to follow in 1859.

Contemporary accounts suggest the immediate success of Notman's portrait business. Within a relatively short time, he had photographed many of the stalwarts that composed Montreal's elite. His work was

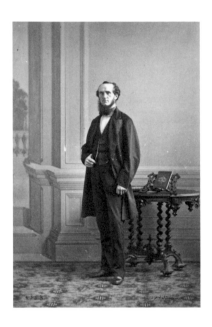

*William Notman, Montreal,
1862*

of a very fine quality, his posing of the subject skilful, his use of light subtle. Moreover, Notman's middle-class background, his education, and his acquaintance with the arts, all meant he was able to meet the upper classes of Montreal society on a common social and intellectual level. Besides, many were fellow Scots. On the other hand, his prices, although somewhat higher than average, were wisely kept in a range that permitted ordinary persons of modest means to sit before his camera as well.

From his earliest advertisement it is clear that William Notman offered a full line of photographic services. Ambrotypes, photographs on glass presented in a leather-covered or thermal plastic case, were extremely popular, as were tintypes, the equivalent on a sheet of metal. It is also possible that he made calotypes, photographs produced from paper negatives. Views and large portraits were made on wet-plate negatives, from which paper prints were produced.

At first he worked alone, except perhaps in the field, where he needed an assistant to help with the transport of the heavy and cumbersome equipment. He may even have had someone to assist in the darkroom. From one of Mrs. Notman's letters home to her family, we know that she acted as receptionist when William was absent on outdoor assignments. Since the studio was in an annex behind the house, and clients actually had to come through the house to reach it, this was easy enough for her to do without causing serious disruption to her family and domestic duties.

Before long, however, the work-load made it necessary for William to take on more than casual staff. William Raphael, a young artist from Germany, was frequently hired on commission to colour portraits, a task Notman had formerly performed himself. This service was to become very popular among Notman's wealthier clients. For a substantial sum they could have their portraits enlarged, coloured in watercolour or oil, and mounted in an ornate gold frame.

Soon, Notman's studio became something of an exhibition hall – and not merely for photographs. If photography danced along a tenuous demarcation line between art and science, it is safe to say that both artists and scientists were attracted to its potential. Notman's Montreal establishment became a mecca for Montreal artists, and photographic displays were frequently mixed with exhibitions of paintings, drawings, and sculptures. Science interested Notman too, although his enthusiasm was largely for how new developments could influence studio technique. Notman was one of the first to use magnesium flares for studio lighting tasks; and as early as 1860 he made a series of interval photographs of a solar eclipse.

In a way, though, neither art nor science, but rather engineering, secured his future. The coming of the railway transformed North American cities; similarly it would change dramatically the life and prospects of William Notman. In 1858 the Grand Trunk Railway commissioned Notman to photograph the much-celebrated Victoria Bridge, the long-awaited link between the north and south shores of the St. Lawrence River at Montreal. Apart from the magnificence of

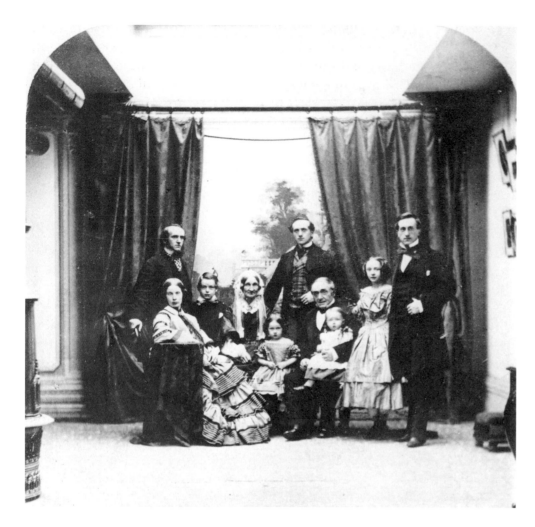

*Stereograph of William Notman and his family, 11 Bleury Street, Montreal,
1859. Left to right: William; his wife, Alice; his brother James; his mother, Janet;
his daughter Fanny; his brother Robert; his father, William senior; his son
William; his sister Maggie; and his brother John.*

the gigantic undertaking itself, this huge bridge meant an all-season
rail route, relying not on a south-shore terminus but rather stretch-
ing from the very heart of Montreal deep into New England, and par-
ticularly to the Atlantic seaports of Portland and Boston. The bridge
also meant a modern renewal of Montreal's gateway status to the rich
agricultural lands of Canada West and to the untapped promise of the
western prairies slumbering under the suzerainty of the powerful
Hudson's Bay Company. As it turned out, this commission would
prove pivotal in Notman's career.

Presumably he received a fee from the railway for documenting the
bridge's construction in all its phases. What was more valuable was
the staggering weight of the publicity falling on him because of the
intense international interest in a structure often called "the Eighth
Wonder of the World." Notman's stereograph cards (double-image
photographs which simulated 3-D when viewed through appropriate
apparatus) of the bridge construction and prints from the large ten-
by-twelve-inch glass negatives were collected avidly. When the bridge

was completed, James Hodges, the engineer in charge of construction, produced a lengthy report describing the progress of construction in complete detail. To illustrate the text, Hodges selected a number of vivid Notman photographs, produced as coloured lithographs, plus several Notman stereographs to be engraved in black and white. Along with the large-scale plans and drawings of the bridge, these were bound into a massive volume covered in red Morocco leather with decorative gold printing. It was dedicated to Albert Edward, the Prince of Wales (later Edward VII), who was to inaugurate the structure in August of 1860.

This would be the first official Royal Visit to Canada. The arrival of Queen Victoria's eldest son and the heir-presumptive to the throne of the British Empire was slated to be a gala event, and the Canadian metropolis was determined to spare no expense to show the nineteen-year-old Prince that he was welcome.

Edward's arrival in Montreal was planned for the afternoon of August 24, but owing to the wet and blustering weather, the steamer did not reach the harbour until the evening. Montrealers feared their greeting would slump like the soaked flags and bunting that hung limply in the city streets. It was agreed that the landing of the steamer at the wharf would be delayed until the next morning, which, by good luck, was one of brilliant sunshine and warmth.

The Prince came triumphantly ashore amidst the ringing of church bells and the crash of cannon from the old fort on St. Helen's Island. The proverbial whirl of social events followed: the Mayor, Charles Rodier, gave a proud, patriotic speech, first in French and then English; a great exhibition was staged to show off Canada's progress in the arts and sciences; and a grand ball was held in a specially constructed circular building (erected on Sherbrooke Street at a cost of twenty-five thousand dollars) with a court gallery running around its circumference for purposes of promenading. Into the space crowded four thousand revellers, and the enchanted (and enchanting) Prince was said to have danced until four in the morning.

As many as nine triumphal arches were also erected to repeat the welcome along city streets, and at each one, as the entourage stopped, local dignitaries gave speeches. Notman was on hand to photograph everything he could – but especially the glittering opening ceremonies of the Victoria Bridge.

In order that the young Prince have a lavish memento of the great event, William Notman had put together two large leather-bound, silk-lined portfolios of photographs placed in a silver-trimmed bird's-eye-maple box. The photographs included scenes taken during travels in both Canada East and Canada West, their villages, towns, and cities, Niagara Falls and other spectacular natural phenomena, plus, of course, many photographs of the Prince's visit. A large number of plates were of the construction of the Victoria Bridge. Owing to a delay caused by a misunderstood conversation between Notman and the Chief Commissioner of Public Works, John (later Sir John) Rose, the presentation was not made in Montreal, but eventually the Maple

Samuel Jarvis, Montreal,
1862

William Raphael, Montreal,
1861

Box, as it became known, and its contents were given to the Prince as a gift from the Canadian government. Evidently, when Queen Victoria and her science-minded husband Prince Albert saw it and its magnificent contents, they were much impressed. Interestingly, both the Queen and her Consort had shown a strong interest in the new art of photography: Roger Fenton, the Royal Photographer, had set up a darkroom in Windsor Castle for their (and his own) use, and they were both patrons of the London Photographic Society. It can therefore be assumed that when Her Majesty bestowed upon William Notman the title "Photographer to the Queen," the honour was based on the considered merit of his work, rather than because of the size and extravagance of the gift. Notman doubtless was delighted – and quick to take advantage of a Royal association and the increased social status it implied. A new portico was built at his studio bearing this title, and it soon became a popular place to have one's horse and conveyance preserved for posterity by Notman's camera.

From this point Notman's business expanded dramatically. He began to hire more photographers and assistants, as well as taking on extensive clerical and support staff. As early as 1860 he had established a formal "Art Department" to cope with the increasing demand for coloured portraits. John A. Fraser, a talented English-born portrait and landscape painter, was made head and soon attracted a coterie of equally capable artists: Henry Sandham, James Weston, and Edward Sharpe. Later, as they moved on, they were replaced by such men as Eugene L'Africain, G. Horne Russell, and the exceptionally skilled C. W. Dennis.

Staff records begin in 1863 and effectively chart the firm's rapid expansion. Notman, by that time, had thirty-five people on salary: photographers, artists, darkroom technicians, receptionists, printers, an accountant, clerks, and all the other staff necessary to run his business efficiently. By good fortune, Notman's "Wages Book" has survived from this period. Carefully maintained by the bookkeeper, Benjamin Franklin, who worked for the Notman organization for an astonishing fifty-three years, the book reveals a great deal about the firm.

From early on, Notman offered lessons in the technique and art of photography to interested amateurs. This was partially to ensure that people who bought cameras and supplies from him would derive sufficient pleasure from their new activity to continue coming back. But it also seems evident that William must have had a natural interest in teaching, in passing his knowledge on to others, since he frequently hired young apprentice photographers whom he instructed himself in every phase of the art, from the rudimentary coating of the glass to the finer points of composition and positioning of the subject. From the starting salaries of some of his studio photographers, it is clear that Notman hired both qualified practitioners and rank beginners.

Samuel Jarvis, for example, who came to Notman's in 1863, was a young photographer who started at a reasonably high salary (sixteen dollars per fortnight), indicating his proficiency with the camera. Jocia Bruce was a similarly gifted amateur. Others, including the

Jocia Bruce, Montreal, 1862

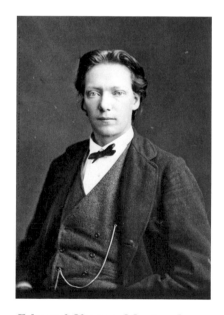

Edward Sharpe, Montreal, 1870

soon-to-be-celebrated William Topley, received pay that reflected their inexperience: Topley got six dollars per fortnight. In fact, by far the greater number of men who became Notman studio photographers joined the firm with no photographic background whatsoever. Doubtless Notman preferred this, for he could train them in his own way without having to break bad habits.

Later, when Notman established new studios in eastern Canada and

James Weston, Montreal, 1871

John Hammond, Montreal, 1871

William Fraser, Montreal, 1871

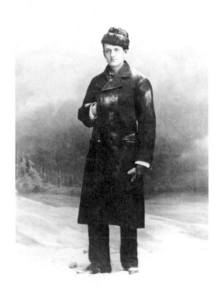

Eugene L'Africain, Montreal, 1879

eventually further afield in the United States, it was his policy almost always to choose as studio managers those whom he had trained himself. Prominent examples were his two brothers, John and James Notman, George Arless, Dennis Bourdon, Robert Summerhayes, William Webb, Aimé Jodoin, and the above-mentioned William Topley. In addition to managers and photographers, many of the support staff in newer studios had also served in the Montreal headquarters. This practice explains, in large measure, the consistency of the photographs produced by different branches, the characteristics and traits that became known as Notman "house style."

William Notman's compelling personal style, always evident throughout the firm's productions, remained the basis of the creative output of his staff long after they had left his direct tutelage. The aspect of Notman's vision that makes his work so distinctive is a strong tendency towards abstraction and simplicity of design. By choice of camera position, together with adjusting the play of light, he rendered his subjects, whether they were individuals, landscapes, or engineering structures, as monumental and heroic. His interest in extracting the essence of his subject through simplification did not preclude the inclusion of texture and detail so important to the "storytelling" or informational quality of his photographs.

Among the frequently displayed images were often the large composite photographs, which gained Notman international praise for their meticulous and innovative use of the paste-up technique. Some of the truly immense composites of snowshoe clubs contained over three hundred figures dressed in blanket coats and woollen toques, who seemingly graced the snow-covered slopes of Montreal's Mount Royal or other woodland settings. In reality, each person had been photographed individually in the warmth of Notman's studio. When prints were made from each negative, the figures were carefully cut out by members of the art department and pasted, one by one, on a large painted background.

The successful execution of this technique depended solely on the skilful blend of the talents of photographers and artists under William Notman's direction. Notman and his staff created many hundreds of composites, large and small. Subjects included various sports clubs, political groups, military organizations, family gatherings, and graduating students. The finished composites were copied in several different sizes, and, since each figure was an artful portrait, a sale to every person who appeared in the picture was likely. Some of the composites of public events, skating carnivals, and the snowshoe clubs, were popular items among the general buying public and tourists as well.

The Notman collection at Montreal's McCord Museum today contains some four hundred thousand images covering a period of almost eighty years of business in the city – from 1856 to 1935. It is one of the largest and most distinguished collections of photographs to be found anywhere, and the overwhelming mass of the material represents the

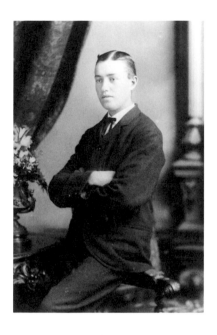

C. W. Dennis, Montreal, 1883

G. Horne Russell, Montreal, c. 1900

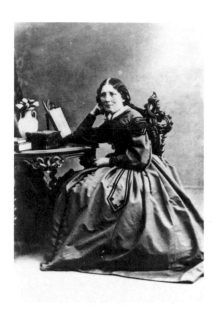

*Harriet Beecher Stowe,
Montreal, 1862. The American
author of* Uncle Tom's Cabin
lectured in Montreal.

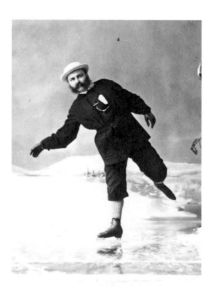

Mr. Lord, Montreal, 1867

busy output of the Montreal headquarters of the firm. Here, captured and chronicled by the efforts of a single firm, are the intimate details of a world now past, and not just an elite world populated by the rich and the famous, but one that includes street vendors, navvies, nurses, farmers, soldiers, lumberjacks, housewives, Indians, bakers, porters, storekeepers, and tradesmen. In addition, the Montreal collection contains a very large selection of photographs that Notman classed loosely as "views." Here is the pictorial record of the new world of North America finding its feet and flexing its muscles. Notman's "View Series" captures the full panorama of the frenzied occupation of half a continent in something less than half a century. Victorian and early-twentieth-century Canada is clearly portrayed: from cluttered street scenes to pastoral landscapes, from the Indian's lost life on the prairie to the urban and urbane elegance of Montreal's "Square Mile," from sweating stevedores on Atlantic wharves to robust railway surveyors planning the push of steel through British Columbia's "sea of mountains."

The mainstay of the Montreal business – and of the branches that would eventually follow – was, however, not views, but rather portraits. Until 1861 these were offered in the ambrotype and tintype processes. Larger portraits were made on wet-plate negatives, and, as mentioned, it is also believed that Notman may have used the calotype paper-negative process for this type of material.

Because the ambrotype and tintype processes did not involve making a negative, duplicates were difficult; indeed, if duplicates were desired, the customer had to bring the ambrotype back to the studio to be copied. Therefore, no records were required except bills and receipts, and none of these early accounts have survived.

In 1861 Notman introduced the carte-de-visite style of portrait. These were paper prints, made from a wet-plate negative, which could be mass-produced very cheaply. This feature alone allowed the new style to take over the portrait trade, virtually eliminating the older, cased photographs. It also meant a change in the clerical department, since, now that reorders could be made, a system had to be devised for storing, identifying, and retrieving any negative from the thousands that accumulated. In Notman's case he kept two sets of records for this purpose. The "Picture Books" were designed as a numerical file. Each photograph of carte-de-visite size had an extra print made, which was pasted into a large scrapbook with the number of the negative and name of the sitter written below. Photographs of large size were not pasted in but were allocated a space with identifying number, name, and size attached. The "Index Books" were kept to record alphabetically the names of the sitters as they came in to be photographed. The numbers of the related negatives were recorded alongside. Not only are the portraits recorded in the two sets of books, but all the views as well are written down in chronological order. It is a great stroke of fortune that all of the Index Books (42) and 95 per cent of the Picture Books (more than 200) have survived, as well as 200,000 glass negatives. Virtually any photograph taken by

Notman's Montreal studio can be dated and identified. The collection and its related documents form one of the most valuable references to nineteenth-century society in the world. The portrait files alone can be used extensively for the study of individual biographies, family genealogies, and style and fashion changes.

Significantly, the collection of photographs also tells much of the story of William Notman and his business. The first knowledge of his many branch studios was gleaned through reading the crests on the backs of his portrait cards. Analysis of the photos has revealed many of the techniques he developed. Counting the numbers of photographs made each year gives patterns of business growth and leads to the realization that he must have maintained a large staff. Notman's "Wages Book," in which he kept a careful record of the staff and their earnings, permits a greater understanding of the daily operations and allows an accurate count of the number of people on staff. The first entries in the Wages Book in 1863 recorded a staff of thirty-five. Over a decade, the number rose to fifty-five by 1874, which seems surprisingly large until one considers that at the time fourteen thousand photographs were being made each year. This figure also suggests a kind of intense mass-production effort, but Notman had an abundance of effective studio props and portable backgrounds which were changed for each sitter to ensure that the customer always took home a photograph with a fresh look.

Much of this sort of activity took place in an annex behind the premises, which he used for group photographs and ordinary portraits. He also had two more large "operating rooms" in his main building on Bleury Street: actually it was more like one huge room with a skylight at each end, making it very versatile. If a sitter could be more favourably portrayed, say with the light falling on a certain side of his or her face, the photographers set up at the end of the studio that would facilitate it. One of these "rooms" was usually set up as a winter scene, with large banks of snow, snow-laden trees, and a grey, lowering sky as a backdrop. The other might well be a beach or a forest dell, or perhaps a farmyard with a rustic fence. William Notman patented a method of creating a skating-rink in the studio. Realistic enough to fool the experts, it was merely a sheet of polished zinc with a bit of salt sprinkled around for a sparkling snowy effect. To simulate deep snow he often used sheep fleece. To create the effect of driving snow, he sprayed a cloud of Japan white in the air from a ladies' perfume atomizer and caught it on the glass negative as it fell. He could change the direction and force of the blizzard by changing the angle of the glass negative.

In 1866, one of these rooms was used by Notman to create a group of over forty photographs depicting hunting and trapping in Canada. The first part, "Cariboo Hunting," showed Colonel William Rhodes, his companion, and Indian guides in a wilderness setting, supposedly one hundred miles north of Quebec City. Rhodes was a remarkable person. Apart from being a noted sportsman, he was Canada's Minister of Agriculture and Colonization, a railway promoter, and a

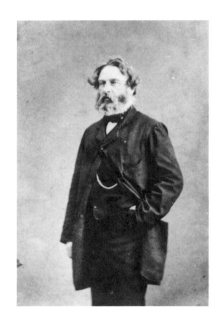

Henry W. Longfellow, Montreal, 1862. The well-known American poet visited Montreal in January of that year.

Mrs. Cowan's nurse, Montreal, 1871

The World of
William Notman

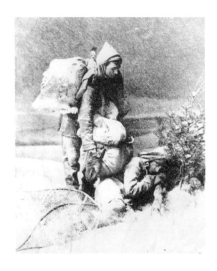

"Exhausted," one of the
photographs from the
"Cariboo Hunting" series,
1866

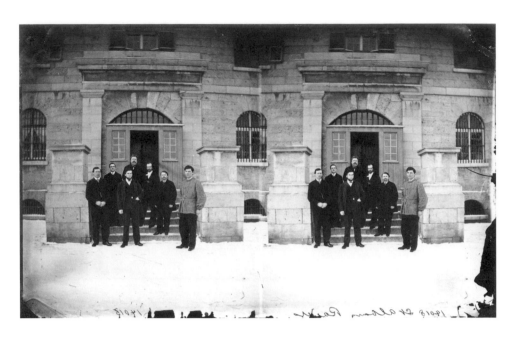

St. Albans Raiders in front of the City Gaol, Montreal, 1864. During the Civil War, a group of American Confederates, operating out of Montreal, robbed the banks in St. Albans, Vermont. The money was intended to support the Confederate cause. However, Canadian authorities captured the raiders, and they were jailed in Montreal.

dedicated experimental farmer. Although the scenes were created entirely in the studio, the effect in the photographs is one of authenticity. Rhodes and his guides have brought their own well-worn clothes, snowshoes, guns, and other equipment. Rusted steel traps and even a string of dried fish hang from the weather-worn tent. The later "Moose Hunting and Trapping Series" is similarly treated and has the same aura of reality.

These photographs may look somewhat stilted to the modern viewer, but when they first appeared in 1866 they caused a sensation, won top prizes in many international exhibitions, and were written about favourably in the leading photographic journals of the United States and Europe. *The Philadelphia Photographer* ran a number of lengthy articles on the series. One enthused: "Nature has been caught – not napping – but alive! Out of doors has been brought indoors with the elements, and photographed in a group, yea! in a number of groups, and in different positions." Referring to "Exhausted," the writer noted

… we find one poor fellow who, more eager than the rest had gone on before, and lying down is entirely "Exhausted." The snow is falling down in great heavy flakes, and he is almost covered with it when his companions overtake him. The storm and wind were too much for him, and there he lies, while his companion is trying to cheer and revive him. In this picture, the effect of the falling snow is very novel and complete. We can only *guess* how it is done (a Puritanic right), for it must not be forgotten that these pictures

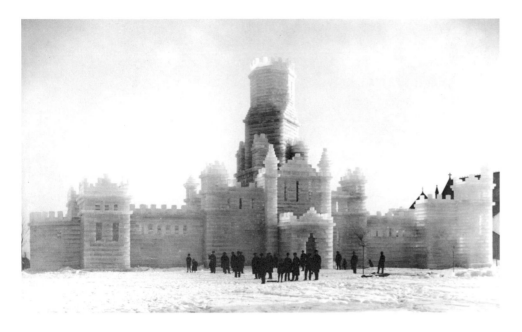

Ice Palace, Dominion Square, Montreal, 1884

Mrs. Walter Wilson, Montreal, 1866

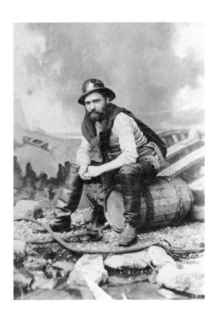

Captain Riley, Montreal, 1879. The subject sits in the studio on a real barrel in front of a portable background.

are all made indoors; but that the artist has given us a remarkable photograph of a snowstorm without snow, we cannot deny.

The article concludes, regarding the photographs: "Patience, artistic taste, knowledge of nature, and above all, study and *brains*, were required to make them, besides nice manipulation. Every photographer should deny himself, and buy a series of them for study. They will give him something to think about and aspire to."

About 1865, to make room for the many activities associated with the growing business, Notman enlarged the two grey-stone houses he had moved into five years earlier by adding a full third storey to them both. This addition was used mainly to provide more space for the processing, finishing, and packaging of the photographs. The printing, using sunlight, was done in the south-facing windows of the third floor. At this time Notman also installed a much bigger solar enlarger, an instrument that utilized a mirror to reflect sunlight through its lens. By this means very large blow-ups could be made, as long as the weather cooperated.

Most impressive was Notman's reception room, which measured thirty-five by seventy feet. This large space contained the reception counter, plus a number of comfortable chairs and settees for the waiting customers. There were also elaborate displays – of cabinet cards and stereographs, and of equipment, such as viewers, graphoscopes, and picture frames. The walls were decorated with large framed photographs, both portraits and views, as well as with paintings. Notman, as we have noted, frequently held exhibitions of paintings, watercolours, or sculptures, and his studio was a central fixture for those interested in the arts in Montreal.

Trans-Canada

ARLY IN HIS CAREER, William Notman began to document the cities and villages and the landscapes of Canada East and Canada West. Starting in his new home, he photographed the streets of Montreal and its important public buildings, took numerous bird's-eye views of the spreading urban growth, and of the workaday world of the railyards and the harbour and, of course, most especially that grand new structure, the Victoria Bridge. With his vigorous way of seeing things, he brought the city to life for citizens and for visitors alike, while leaving an invaluable chronicle of growth for future generations.

Shortly after the business's beginning – certainly by 1859 – he began to travel or to send staff photographers to more distant parts of British North America, often to areas whose geographical features had wide appeal. Niagara Falls and the swirling Niagara River, the Chaudière Falls at Ottawa, the Shawinigan Falls on the St. Maurice, and popular summer resorts like Murray Bay (La Malbaie) were all captured on glass plates. But as often as not he turned his camera on more prosaic subjects which, through his discerning but lively eye, were transformed into exciting images: the Grand Trunk Railway station at Rivière du Loup for instance, or the road leading to Fort Henry at Kingston, or a view of the Thames at London, Ontario. Each image showed evidence of his characteristic and remarkable ability, not only of mirroring the likeness of a subject but also of seizing the "essence" of a place, of capturing the intrinsic and unchanging aspects of his subjects. Thus it is that his pictures of any particular railway station capture the formal timetable-driven bustle of *all* railway stations, his photos of stationary cannon suggest the serenity that frequently surrounds destructive engines of war, and his downtown commercial shots portray the raw commercial bone and sinew that characterize striving young cities.

With the expansion of Canadian territory to include the prairies and the far West and the Maritimes, Notman and his photographers went even further afield. In the summer of 1869, 1870, and 1871, Notman or one of his staff was in Halifax making extensive coverage of the city and suburbs, with a side trip to Saint John, New Brunswick.

These stereographs and eight-by-ten-inch prints had extensive distribution, as they were displayed in all Notman's studios, as well as in book and stationery stores, in hotels, and in railway stations.

In 1871 Benjamin Baltzly, who had been with Notman for only a year, was sent in company with John Hammond to distant British Columbia. Notman had made an agreement with Alfred Selwyn, head of the Geological Survey of Canada, to dispatch a photographer and an assistant to accompany an expedition led by Selwyn to explore the North Thompson River. It was a three-way enterprise and included a team of surveyors working for the Canadian Pacific Railway. The railway crew was to assess the valley as a possible route for the much-touted all-Canadian transcontinental line. The government expedition was to explore the geological aspects of the district, and Baltzly's task was to record these momentous efforts. Selwyn was eager to create a photographic record of his findings, and Notman was interested in obtaining views of this exotic frontier to sell to his customers.

Notman paid the wages for his two men and supplied the photographic equipment, the Geological Survey Department provided the food, and the railway provided the transport. Baltzly did an admirable job of fulfilling his twofold task. He returned to Montreal with a set of thirty-six eight-by-tens and eighty-nine stereographic views, a stunning, and accurate, recording of the land and its immense challenges told in compelling imagery.

As the Canadian Pacific buckled more and more of the country together, finally linking Canadian territory from "sea unto sea," William Notman increased the number of these photographic expeditions. His eldest son, William McFarlane Notman, who had been with the firm since he was sixteen, was sent West in 1884. This was to be the first of eight remarkable western trips that the younger Notman was to make, all in connection with the continent-spanning Canadian Pacific Railway.

The scheme had been hammered out with the railway's chief, William Van Horne. The Notman firm was to record the triumph of the line, fast nearing completion. The deal included free transportation for Notman's photographer and assistant in exchange for a set of photographs. Notman, of course, would keep the negatives and the copyright. Van Horne asked for specific subjects to be recorded, such as the shops and yards at Winnipeg, a standard prairie station, and swiftly growing prairie towns, and he was especially keen to obtain views of the Rocky Mountains. Van Horne was a good businessman, and was acutely aware of the power of the photograph to inform and persuade. To attract settlers and tourists alike to the West was his admitted goal, and photography soon became a major element of the CPR's drive to increase rail traffic.

All the western trips William McFarlane Notman made were in connection with the CPR, and were always under the same arrangement of free passage in exchange for services. On two of the journeys, in

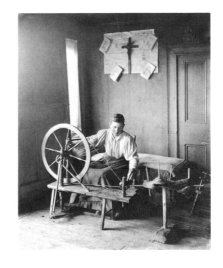

Spinning, Cap à l'Aigle, Quebec, 1899

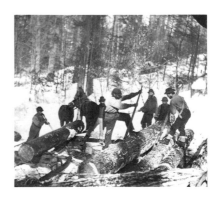

Loading logs on sleigh, upper Ottawa River, 1871

1887 and 1889, Notman and his assistant were grandly provided with a private car, complete with bedroom, parlour, galley, and darkroom. The pictures produced, incidentally, were popularly priced, selling for a dollar and a half apiece. Examples of the latest photos were displayed conspicuously in various public places throughout the country, in hotels and on the trains. They were frequently commented on in newspapers and generated good financial returns. Subsequent trips to the West were made by William McFarlane Notman in 1897, 1901, 1902, 1904, and 1909: proof of the high regard Van Horne and his successors had for the work of the Notman firm. As an additional result, Canadians had an enlarged sense of their own vast country and were given a palpable interest in what they were and could become. Through viewing these photographs, those who would never travel could still take pride in and share something of the enthusiasm that accompanied the fine art of nation-building.

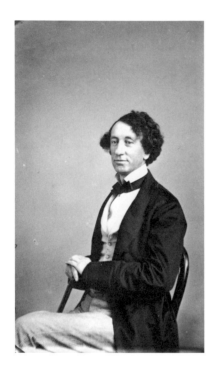

John A. Macdonald, Montreal, 1863

Branching Out

WHAT CAUSED William Notman to expand his business horizons beyond Montreal and establish branches of his firm in other Canadian cities? The answer is not entirely clear, but it should be remembered that Notman, because of his British business apprenticeship, was no stranger to travel and well understood the need for seeking and securing new opportunities in fresh markets. Neither would the simple advantages of economies of scale be unknown to him. Moreover, in the background were two significant political events that may well have provided motivation: first was the successful establishment, in 1867, of Canadian political independence from Britain with the confederation of the three British North American colonies of Nova Scotia, New Brunswick, and the old Province of Canada, an event promising growth through a wider national market, stronger credit opportunities, and a resurgence of immigration. Second, and no less significant, was the burly prosperity promised by the newly recast northern United States, rich and powerful in the wake of the Civil War, and poised to take advantage of the abundant opportunities of industrialization, a huge market-place, and the exploitation of the country west of the Mississippi. All this growth assured, both north and south of the border, the continued emergence of confident, powerful, prosperous, and aspiring middle and upper-middle classes – groups, one might think, more than casually interested in reflecting through photography their new-found identity.

The first branch studio William Notman established was in the fast-growing city of Ottawa in 1868. Formerly called Bytown after the British lieutenant-colonel who had built the Rideau Canal, which connected it to Lake Ontario, Ottawa, in a very short time, had come a great distance from the brawling northern timber town that Queen Victoria had chosen in 1857 as the compromise capital for the Canadas. Now the brawling was mostly verbal, and confined to the ornate chambers of the ruggedly picturesque new Parliament Buildings, whose lofty bulk dominated the city's skyline. In style as well as name, Ottawa had become a viceregal seat, and it had a grow-

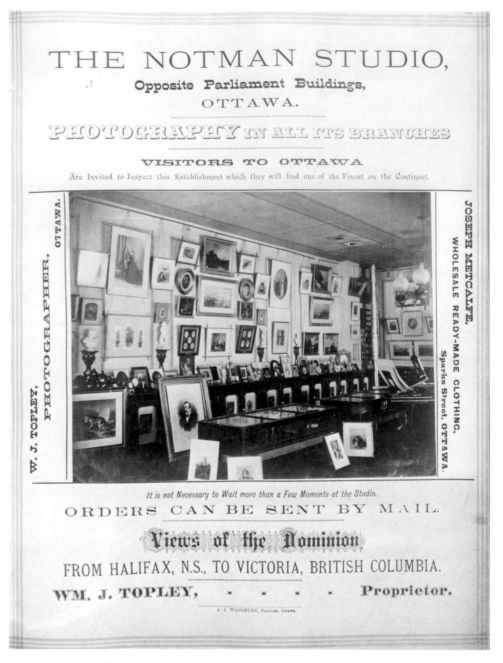

*Interior of the Notman Studio, Ottawa, c. 1875. This full-page advertisement
is from the Ottawa City Directory.*

ing retinue of distinguished, educated, well-born, and otherwise wor-
thy citizens to prove it. This was all profitable grist for Notman's mill.
Already, in Montreal, he had taken the likenesses of a number of
Members of Parliament: Sir John A. Macdonald, the Prime Minister,
had posed before Notman's lens, as had George-Étienne Cartier,
Macdonald's chief lieutenant and the Minister of Militia, Charles
Tupper, MP from Cumberland and himself a future prime minister,
Grit leader and Toronto *Globe* Editor George Brown, and many

others. The pomp, splendour, and airs of a national capital that could only grow and prosper would well serve Notman's enterprise. His instincts proved correct; Ottawa's population grew readily, and trade did follow the flag. The Governor General's suite was no less substantial than the Civil Service, the Church establishment, railway and transportation companies, the denizens of mercantile commerce, the old timber barons, and, of course, the politicos, those elected and those who hung on and around. If the place was, as Governor General Lord Dufferin found it in 1872, "very desolate, consisting of a jumble of brand new houses and shops, built or building, and a wilderness of wooden sheds," the townsfolk were attractive: "dignified, ...and polite, very gay and ready to be amused, simple in their ways of life and quite free from vulgarity or swagger." And they all came to Notman's studio. High officials, cabinet ministers, heads of state, Governors General – the cream of the social establishment and the mercantile and commercial classes – plus those ordinary, "attractive" townsfolk, paraded to the door of Notman's new studio at No. 60 Wellington Street, conveniently located across the street from the Houses of Parliament.

William Topley, aged twenty-one, was the branch manager. As we have noted, he had started in Montreal as an apprentice earning six dollars a fortnight only a few years before, in 1864, but both his talents as a photographer and his business skill had obviously impressed Notman. But William Notman kept a tight rein. As would become his custom in all branch studios, he made sure that the variety of styles and prices of Topley's branch met the standards set in Montreal. Life-sized photographs on canvas and coloured in oil, portraits on paper and tinted in watercolour or sketched with charcoal and pastel, miniature and locket-size prints, plus a complete line of frames and the popular new cabinet-size photographs (four and a quarter by five and a half inches) were all available at the Ottawa address. But, besides the portraits, Topley and his small staff kept busy taking eight-by-ten views and stereographs of the Parliament Buildings, of churches, streets, and monuments, and especially of the river and nearby waterfalls, plus commercial and recreational activities along the Rideau Canal. Ottawa was more than the "Westminster in the Wilderness" scorned by many: it had real commercial credibility, since it could still make a claim for being the timber capital as well as the national capital. Known (not always affectionately) as "lumber city," it harboured many sawmills around the Chaudière and the Rideau falls. Much of Topley's view production centred around this extensive lumber and timber trade: the booms, the massive saws and worksheds, the storage piles, and eventually the railyards that all served the industry. Many visitors proved eager to buy these views or others showing the great diversity of culture and landscape in the newly formed

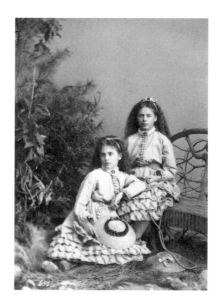

Misses Amy and Laura Ashurth, Ottawa, c. 1870

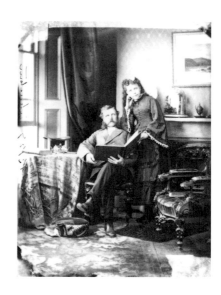

Mr. and Miss Johnston, Ottawa, October 1872

The World of
William Notman

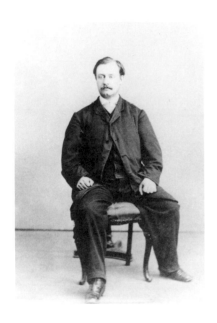

*John A. Fraser, Montreal,
1866*

Dominion. Notman kept the Ottawa showroom well supplied with views from his Montreal stock files. Taken by either himself or his staff, the photographs portrayed Canada from Halifax in the Maritimes to Victoria in the soon-to-be established province of British Columbia. Canadians visiting their wilderness capital received a strong sense of a national image from Notman long before any official government agency took a promotional hand in forging – at least in a visual sense – a national identity and national pride.

In 1872, however, William Notman sold the business in Ottawa to his manager. William Topley continued under the Notman name until 1875, when he moved to a new location and began using his own name. Just why this sale took place is not known. It *is* difficult to understand, especially since William Notman had established three other studios in three other cities by this time and all were doing well – and continued to be profitable for many years to come (as, evidently, did the Topley operation).

One of these new studios had been set up in Toronto later in the same year as the Ottawa venture – 1868 – in partnership with John A. Fraser, the head of Notman's Montreal Art Department. Fraser was the manager as well as the chief artist in this studio, located on fashionable King Street. He, too, carried on the business with the same philosophy as the home studio in Montreal, catering to a broad spectrum of society but offering high-priced extra services for those who desired and could afford them.

Like Ottawa, Toronto was a capital – albeit a provincial one – and the city was puffed up with all the self-importance that commonly attached itself to British provincial centres. King Street was the perfect situation for Notman's studio, the social and commercial thoroughfare of the city, and within a few years of Notman's setting up shop, "doing King" – the fashionable afternoon parade of Toronto's social elite – made it the place to see and be seen.

Moreover, Toronto, at the time of Notman's arrival, was itself beginning to feel a new corporate and political strength. The city, a British bulwark in an American midwest setting, was casting a commercial net north and west, one that would assure it pride of place as a trade centre. Especially through its rail links, it served as a terminus for Ontario's mineral-rich north and as an essential transshipment point for the English and later European export opportunities of the Canadian prairies. Once again William Notman was tuned to the times and put his finger on a sound investment.

In the move to Toronto, John Fraser was accompanied by Jocia Bruce, who, under William Notman's nurturing in Montreal, had developed his technical and aesthetic skills to the point where he was chosen as "Chief Operator" (head photographer) of the new studio. He stayed with Notman until 1875, when he opened his own studio, also on King Street.

Following William Notman's lead, Fraser continued the policy of

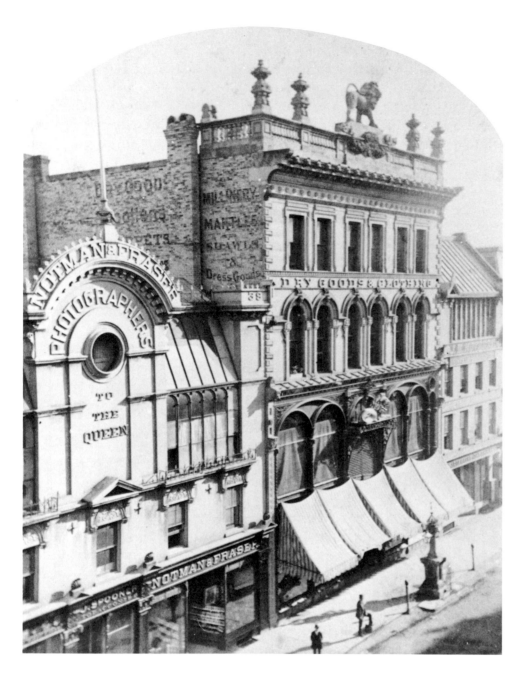

Stereograph view of 39 /43 King Street East, Toronto, 1879–80

making the studio a meeting-place not just for photographers but for artists of all kinds, and he also continued the practice of having exhibitions of paintings in the studio. A particularly significant event occurred in 1872, when, at a meeting in his home, Fraser and a group of fellow artists formed the Ontario Society of Artists. The society's first exhibition opened on April 14, 1873, not surprisingly at Notman & Fraser's grand new studio at 39 King Street East, just a few paces along from the first one.

Although John Fraser's career as a painter took a back seat to his photography, he never lost his desire to be recognized as a landscape artist. Eventually, in 1883, he left Toronto for Boston and made a

Back of a carte de visite, 1870

successful living there, gaining a considerable reputation as an illustrator as well as a landscape painter. However, he didn't leave Canada for good; he brought his family back many times to summer on the islands in Toronto Bay and made a very successful painting trip to the western mountains in 1886 with the Canadian Pacific Railway.

Before his move to Boston, Fraser seems to have bought William Notman's share of Notman & Fraser, reorganizing it under the name of Fraser & Sons, to be operated by his two eldest boys, Augustine and John Arthur, Jr. The company didn't last long, being bought out in early 1886 by Millman & Co., itself a short-lived venture. The following year, in the autumn of 1887, it was sold again, this time to Herbert E. Simpson. Significantly, in all cases advertisements claimed "Notman & Fraser negatives retained."

In 1869, when William Notman opened studio number four in Halifax, there were two means of travel to the Maritime cities from Montreal – by steamer down the St. Lawrence and along the long coastlines of New Brunswick and Nova Scotia, or by rail to Portland, Maine, followed by a shorter boat trip north. This lack of easy access to one of Canada's most important (and ice-free) seaports was recognized by politicians, businessmen, and the general population, for the idea of a rail link between central Canada and the Maritimes had been discussed for decades. At last, in 1869, serious construction had begun. Anticipation of an iron road might have been the deciding factor in Notman's easterly expansion of his growing chain of studios.

Halifax, for more than a century, had been the strategic naval base safeguarding remaining British interests in North America. It was also at this time a major seaport, which, locals argued, could only increase in importance as a winter port once the linking railway was completed. But Halifax appeared more prosperous than it really was. It had shared in the bounty of Union needs in the American Civil War but basked more in the promises of Confederation than it would in the realities. The population was about half opposed to union with Canada anyway, and, moreover, the old basis of the local economy – wind, wood, and sail – was passing. Still, there were grand opportunities: Halifax was and would be a capital, it would remain an important imperial base, would continue as the regional business centre, and just might, through the railway, become something of a manufacturing centre with the new country to the west as a vast potential market. However, when the promised Intercolonial Railway was finally finished in 1876, it seemed to be a one-way route: pumping the manufactured products of central Canada into the Maritimes and taking very little in return.

When William Notman had opened his studios in Ottawa and Toronto he had been moving into familiar ground. He had photographed in both cities and surrounding districts, and he had friends and clients in both as well. He also knew something of their respective economies and market potential. He therefore had set up the two

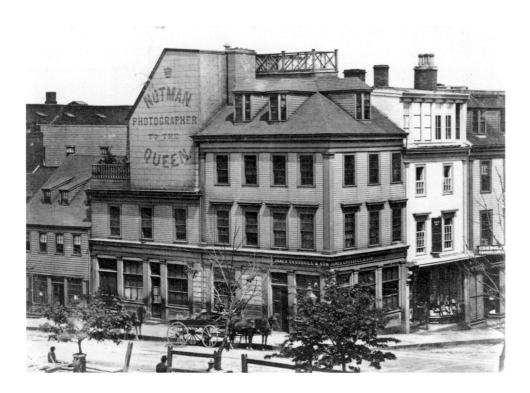

The Notman Studio, 39 George Street, at the corner of Barrington, Halifax, Nova Scotia, 1890

studios with little preliminary investigation. Halifax was a different story: Notman had no first-hand experience of the city, and he had never taken pictures there. Consequently, before he actually opened a studio, he held a series of exhibitions, with A. B. Almour from his Montreal studio as agent. The *Halifax Evening Express* reported that Almour arrived in the city on December 11, 1868. Later that month the same newspaper described the exhibition which had been set up in the Halifax Hotel: "M. Almour the agent of M. Notman has an exhibition at the Halifax Hotel, a beautiful selection of photos, both plain & coloured and a variety of handsome albums, suitable for holiday gifts at the present season of the year. The public are invited to call & inspect them." The exhibition ran until February; later there were smaller displays in the prominent Granville Street shop window of Buckley's bookstore.

The positive reception of these exhibits by those who attended and the favourable reportage in other city newspapers were convincing enough for Notman. Some time before June of 1869 the new studio was opened at 39 George Street. Almour remained on hand as manager, and had with him William Webb, one of the photographers from the Montreal studio. Almour left Notman in 1870, but he stayed on in the city in an attempt to run a similar business on his own. Perhaps because he was neither a photographer himself, nor, it seems, a painter, Almour's business evidently faltered. After 1876 it is no longer listed in the Halifax directories.

William Webb, on the other hand, continued with Notman for many

*Oliver Massey Hill, manager
of the studio in Halifax, Nova
Scotia, c. 1890*

years. With Almour's departure, Webb became manager as well as the chief photographer, and continued in this capacity until 1876, when he returned to Montreal. He worked in the Montreal studio until October 1879, after which date his name is no longer listed in Notman's Montreal records. He may have gone directly back to Halifax: we know from the city directory that he was working in the studio there at the time of William Notman's death in 1891.

To replace Webb as manager-photographer, in 1876, Notman wisely chose a talented and stable young Englishman. Oliver Massey Hill had been engaged by Notman first as a clerk, but was gradually trained as a photographer. He would be with the firm for twenty-three years and, after William Notman's death, would buy the Halifax location from the heirs and operate it until his own death in 1923.

Just as the two new studios in Ottawa and Toronto were modelled after the parent studio in Montreal, so the enterprise in Halifax followed the same pattern. Reasonably priced portraits to attract a large trade were supplemented by high-priced specialty features directed towards the wealthier clientele.

Painted photographs proved as popular in Halifax as they had in the other cities. In the first few years at least, the colouring jobs were sent back to the Montreal studio to be executed by one of Notman's proven artists. This was also true for the large composite photographs that always had wide popular appeal. A good example is "The Investiture of the Marquis of Lorne" of 1879. The photograph shows a group of over three hundred people attending the swearing-in of the new Governor General of Canada. Each person who appears in the photograph was photographed separately in the Halifax studio, and when prints were made they were sent to Montreal, where the staff of the Art Department cut them out and pasted them onto a painted background. After judicious retouching to conceal the handiwork, and often with a bit of colouring or highlighting added, the work was signed by the head of Notman's Art Department. In the case of "The Investiture" it was Henry Sandham who added his name. A later composite of a Halifax subject, "Red Cap Snowshoe Club," done in the mid-1880s, was signed by Eugene L'Africain.

Also just as in the other studios, the selection of stock photographs in Halifax was bolstered by the addition of photographs taken by members of the Montreal studio. Views of Niagara Falls, the Parliament Buildings in Ottawa, and the Thompson River Valley in British Columbia, and standard scenes of Halifax itself, were reported to be doing a brisk trade.

Very few of the glass negatives from the Halifax studio survive. Those that do date from the mid-1870s to about 1910, and, discounting a number of civilian portraits and city views, they run heavily to naval subjects: dockyards, ships and ships' crews, portraits of officers and men. This, in part, may be a reflection of the clientele whom the studio served, but it is more surely an indication of the

arbitrary nature of fate. Glass negatives are extremely fragile, but only a small part of the loss of the collection can be accounted for by accidental breakage. More devastating by far has been the eagerness with which many photographers sold their negatives for scrap, and to alleviate the problem of storage. It was common for entire collections of negatives to be bought up, for the emulsion to be scraped off for its silver, and for the glass to be sold for use in greenhouses.

Fire, the constant enemy of the nineteenth-century city, was another threat to survival. In June of 1877, for instance, a conflagration swept through the largely wooden buildings of Saint John, New Brunswick, burning most of the city to the ground. One of the many structures destroyed was the Notman photographic studio on Prince William Street. This disaster doubtless explains why there are no negatives from that era of the Saint John studio, but, curiously, neither are there any surviving from 1877 to 1890, when the business there finally closed. And there are very few prints extant – at least in public collections – from either period.

After getting the Halifax studio off to a successful start, Notman had soon turned his attention to Saint John, which seemed a likely site. It was a bustling port city of fifty thousand people and, if not the legislative capital of the province of New Brunswick, was certainly its social, intellectual, and economic metropolis, and it had, at first glance at any rate, the kind of upscale clientele that Notman favoured: prosperous merchants, well-to-do professionals, established civic officials.

To test the market, Notman performed the same experiments he had undertaken in establishing the Halifax studio. In April 1870 his agent, A. B. Almour, arrived in Saint John to set up a display of photographs for viewing and sale in the store of C. E. Potter, framer and gilder. Presumably reaction from the public was encouraging, for that summer, in the July 19 issue of the *Daily Telegraph*, Notman advertised that

Mr. Webb from Notman's Establishment, Montreal now engaged in taking Views of St. John, has affected an arrangement for taking a few PORTRAITS, plain or coloured, as may be required. LIKENESSES of any kind reproduced in any size, Miniature or Life.
RESIDENCES, GROUPS etc., also photographed.
As the present arrangements are only temporary, and Mr. Webbs stay will be very short only, it is requested that applications for sittings be made as early as possible. Messages, giving name and address, left at Messrs. McMillans, Prince William Street, will receive immediate attention. Further particulars can be had at the same place.

The Saint John studio opened in March 1872 under the management of William's youngest brother, James. Although the business at first bore James's name, all other indications point to joint ownership –

Back of a carte de visite, 1880

that is, a partnership between the two brothers. An advertisement appeared in the *St. John Daily News* on March 12 announcing that "Notman's Photographic Establishment," located on Prince William Street, was now open, and that "Special attention" would be "given to Enlarged Portraiture of every description." Elsewhere in the same paper, under the heading of "Local Matters," it was duly noted that "Messrs Notman & Co are now open in the finely arranged rooms in McCulloch's building. This firm requires no recommendations, their fame being world wide and their works which have been among us should be sufficient guarantee of their ability to make a 'counterfeit presentment in the best style.'"

James Notman had started working for his brother William in the Montreal studio at age seventeen, and drew apprentice wages. By the end of 1871 his salary had increased to the unusually high point of one hundred and sixteen dollars a month, a telling indication of William's view of James's worth to the firm. William was right. James Notman was a superb photographer.

Although there are few extant photographs from the Saint John operation, there are at least enough to show that photographs were produced with the same high regard for quality of technique and artistry expected from one of William Notman's protégés. Despite the entire studio being burned after only five years, the business was strong enough to recover. On the other hand, prospects in the devastated city could scarcely be considered cheering. Not only was 40 per cent of the place in ruins, but the calamity occurred at a time when a general depression had shrunk shipping and the lumber trade, which was itself undergoing vast technological changes that made the workers uneasy. Saint John had been bypassed for Halifax by the Intercolonial Railway as well — and the decision of local entrepreneurs to build the city into a powerful manufacturing centre for the new country were plagued by the outflanking financial strength, capacity, and location of central Canada.

Only two months before the 1877 fire, William and James had formalized a contract permitting either party to buy the other out after a period of seven years, provided that each agreed, and by 1884 William had bought his brother's share. But in any case, in 1878, when the studio had been re-established, brother James moved to Boston, where he was to become a major figure in the local photographic community. John Hammond, who years before had accompanied Benjamin Baltzly on his pioneering western trip, was sent from Montreal to manage Saint John. He had worked as a painter in the Montreal headquarters, beginning in 1870, colouring the smaller-sized photographs in watercolour or oil. Hammond was to remain manager at Saint John until 1884. From then until its close about 1890 the studio was under the direction of Clarence T. Lugrin.

Notman's gamble in emigrating to Canada had proved successful. By the 1870s, he was an established and respected Montreal man-of-

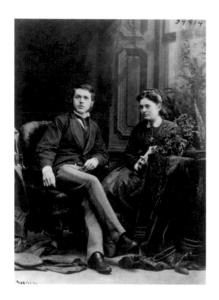

James Notman and wife, Montreal, 1869

affairs. His busy studios stretched across the eastern face of the young Dominion. He had triumphantly turned his picture-taking hobby into a profitable profession. Moreover, his fame as a photographic artist gave him immense personal satisfaction. That superior artistry had also gained him something of a reputation outside the country, principally in the United States. Increasingly, his energies and ambitions were turning to challenges and opportunities south of the border.

The United States of America

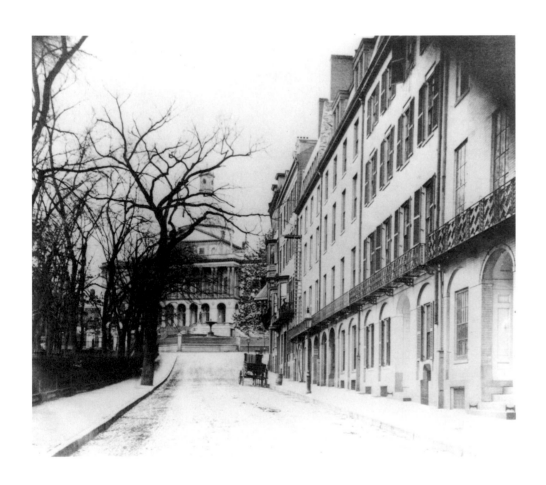

The College Trade
and the Centennial
Exhibition

THE U.S.-CANADA BORDER was not the sharp line of demar-
cation in the nineteenth century that it is today. Despite the
constant clamouring of champions of tariff regulation on
either side, the border remained relatively fluid, although rela-
tions between the two countries had been tense during the American
Civil War. Canada was considered by the Union to be something less
than neutral in the War between the States. The Canadian colonies
remained attached to Imperial Britain, which, if not openly recogniz-
ing the Confederacy as an independent country, certainly recognized
the South as a legitimate belligerent in the conflict. Friction was felt
over such matters as United States government demands for com-
pensation for shipping damages inflicted by a British-built Confed-
erate raider (the *Alabama* claims), the rights of Americans to pursue
deserters to Canada, and, of course, the well-known St. Albans Raid,
in which a Confederate raiding party was actually dispatched from
Canadian territory to raise money for the war by looting banks in the
town of St. Albans, Vermont.

As always, the animosity between the two countries was more
national posturing than personal prejudice. Many Canadians took
part in the Union's fight, others were openly sympathetic, especially
regarding the question of slavery, while still others saw little reason
for the war to do anything but increase their business in the United
States under the trading advantages conferred by the Reciprocity
Treaty of 1854. With the coming of peace in 1865, and Canadian
confederation two years later, settlement of the most outstanding issues
between Britain, her grown-up colony of Canada, and the swaggering
reunited States became a necessity. By 1871, with the negotiation of
the Treaty of Washington, a new era of harmony was declared.
Canada was a full beneficiary of this stability, and for the likes of
William Notman, whose New England operations were by then solidly
launched, the 1870s brought intriguing possibilities to the south.

Curiously, William Notman's operation in the United States is the
least-known aspect of his career. This is especially odd because, of

the twenty-six scattered photographic studios in which Notman or one of his enterprising relatives played a role, fully nineteen were located in the United States. Actually, William Notman's first direct association with the United States occurred during the Civil War. The link was Edward L. Wilson, arguably the most significant commentator on the American photographic scene from the end of the Civil War to the turn of the century.

Wilson was a man in some ways not unlike Notman himself: sprung from a sound middle-class upbringing, well educated (he eventually earned a Ph.D. from Washington and Jefferson University in Washington, Pennsylvania), with a strong background in practical business (nine years in wholesale hardware), a driving sense of personal and public morality, and an abiding interest in photography as a useful nexus of art, science, and, not least, commerce.

In 1864, Wilson founded *The Philadelphia Photographer*, a photographic monthly that was less than a trade magazine though more than a fan's notes. It was, in fact, an amazing record of photography's progress in North America and elsewhere, a personal chronicle that incorporated Wilson's wisdom and occasionally his wit in an eclectic mix of technical discussion, editorialization, advertising, and blatant photo-boosterism. It was also, significantly, a showcase for photographs. Wilson began noting William Notman's work in the December 1864 issue of his journal, even though he misspelled the Scot's name. Wilson described, in radiant terms, receiving an "elegant" packet of cartes-de-visite from "Mr. W. Nottman": "For a display of artistic taste and skill, and beautiful accessories, we never saw their superior or equal. They are to say the least superb, both in tone, finish, and execution; they are next to life itself."

A flattering correspondence grew up between the two men, mostly about technical matters. Some of it was reprinted in the journal, and soon Wilson began publishing "tipped-in" Notman views and portraits on a regular basis. It was plain that Wilson was an enthusiastic advocate for Notman, "to whose inventive genius," as he wrote in 1867, "there appears no end." Frequent exposure in the pages of *The Philadelphia Photographer* advertised William Notman's work among his fellow photographers, and it is thought that Notman's enthusiasm for the then-new cabinet-size four-by-five-inch print was influential in its North American popularization. The Notman Studio's innovative staged hunting scenes also received wide distribution through the journal in the late 1860s.

In the meantime, William Notman's younger brother John Sloan Notman set up his studio in Boston during the latter months of 1866. Evidently the business was established in partnership with his brother-in-law J. M. Gatehouse, a former florist, although the firm appears in advertisements as J. S. Notman & Co., and clearly William Notman was a silent partner. The company was located close to other photographic studios of the period in busy Tremont Street, not far from the

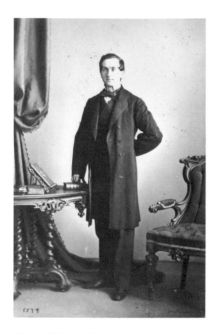

*John Sloan Notman,
Montreal, 1863*

business and political centre of New England (the State House was a few steps away).

Judging from contemporary accounts, J. S. Notman & Co. was immediately successful. The *Boston Transcript* called their cabinets "remarkable specimens of art – clear, soft and accurate, even to the minutest details … full of character," the *Boston Traveller* trumpeted that the photographs "are regarded as the most fasionable that have ever been introduced to the public," and the *Boston Courier* crowed at length:

Their superiority as Photographic artists is beyond question. They challenge comparison. The merit of their work leaves no doubt of their success here, which is already assured. Their establishment is already a fashionable resort, and their photographic specimens are of the highest excellence.

This was high praise indeed in a flourishing city that considered itself an artistic and intellectual centre and already boasted sixty-three resident photographers. It seems all the more unusual, then, that by 1868, after only two years in business, John S. Notman had packed up his cameras and equipment. Since the city directory of that year shows him at a new address on Winter Street and makes no mention of partner Gatehouse, one might consider either that there was a falling-out, or illness, or that John Notman did not have the means to carry on. Whatever the reason, he soon returned to Montreal and spent the rest of his career as an assistant, for reduced wages, in his brother William's studio. He died tragically in a collision between his carriage and a train in 1879. Boston photographic historians have been no less laudatory of his work than were contemporary journalists.

Boston would eventually be William Notman's most successful venue in the United States, but it was some time before the family threads were picked up there again. In the intervening years, William Notman engaged in a growing trade in United States colleges that he could conduct and control in forays, often along rapidly spreading railway lines, from his base in Montreal.

Photographing college classes was a long-established business in the United States. The first class photograph was made in 1840 by Samuel F. B. Morse, the celebrated inventor of the telegraph and an avid photographer. Employing a daguerreotype, he captured the 1810 Yale class at its thirtieth reunion. With the phenomenal growth of photography in the 1850s, a new specialist market arose. For a dozen years or so, the high concentration of universities and colleges in the Boston area made it the epicentre. The dominant local photographer at the time was Boston-based George K. Warren, who made rounds of the Ivy League schools.

William Notman began to tap this lucrative market in the late

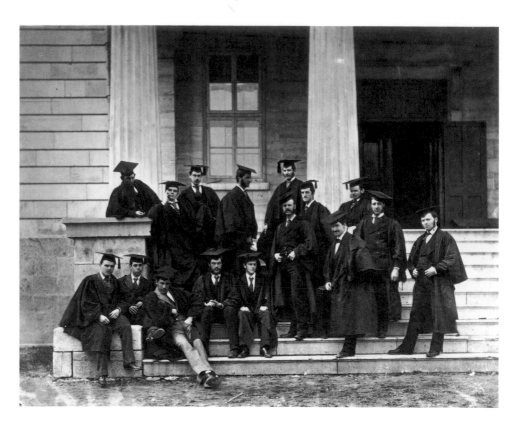

Graduating Class, Faculty of Arts, McGill College, Montreal, 1874

Miss Hannah Lyman, First Principal, Vassar College, Poughkeepsie, New York, 1869

1860s. In 1869, for example, he photographed the staff and students at the eight-year-old Vassar College in Poughkeepsie, New York. There may have been a Canadian link here, since Vassar's first principal, Hannah Lyman, previously had run a fashionable girls' school, Coté House, in Montreal. Whatever the connection, it marked the beginning of what would become a frenetic activity that annually saw Notman or his assistants riding the steel rails between college campuses throughout the northeastern United States. During much of the 1870s William Notman successfully competed with such well-known photographers as Napoleon Sarony, New York-based but French-Canadian-born, and New York's Pach Brothers. For a few years he absolutely dominated the college trade. *The Photographic Times* noted that, from 1872 to 1877, the Notman firm "probably manufactured more college photographs than all his rivals combined."

Nineteenth-century college albums were very different from university annuals today. They were enormous, handsomely bound, often gold-stamped and embossed photo-albums of twenty and more heavy leaves. The class photographer, who regularly tendered his services and was prey to the fickleness of the student groups who organized the event, arranged to take individual portraits of all students in a graduating class, plus their professors, plus interesting campus characters (like Harvard's "goodies," the women who changed the rooms), as well as group shots of fraternities and other clubs or athletic teams, and views of the campus buildings and the city. At least for the

portraiture, this was usually handled by establishing a local temporary studio and darkroom. The temporary quarters also served as a showroom where a student customer (frequently accompanied by parents) might come and, together with the photographer or his agent, choose from among the hundreds of available photographs an appropriate and unique record of his or her university experience. Of the hundreds of these albums that still exist in Ivy League archives, it is entirely possible that no two are exactly alike.

William Notman had been photographing the professorial and student body of McGill College in Montreal as early as 1860. So, when he began a similar activity in the United States, he was no newcomer to the trade. His first *known* school photographs from the United States were those taken at Vassar in 1869, and by 1872 he was photographing students and professors of both Harvard and Yale. It seems clear that college photography was considered a very important part of his business not only because of the considerable sums charged for the albums but also because of the social contacts made with what was seen as a new generation of wealthy, influential graduates. It is worth noting that 1869 saw Charles W. Eliot inaugurated as President of Harvard. Eliot became one of the most significant influences on American higher education. At Harvard, he soon overhauled the entrance requirements, upgraded academic standards, and introduced an elective system. The college curriculum was extended to offer business and professional subjects alongside the more traditional liberal arts studies. This model was widely imitated throughout the United States and Canada, and the period saw a great growth in university enrollment and an enhancement of education's role for those in the business community. The implications for William Notman's business were readily apparent.

All Notman's college work from 1869 through the early 1870s was undertaken, it seems, from the Montreal studio. The photographs were taken at the various colleges, then the glass negatives were sent to Montreal for printing, mounting, and assembly in albums. Travel, despite the ubiquitous railroad, was still arduous, drawn-out, and encumbered with the heavy equipment characteristic of wet-plate photography, which entailed carrying not only the heavy glass plates but the bottled chemicals needed to process the negatives on site.

William Notman made a fair number of these excursions himself. The first Vassar views of the college buildings, grounds, staff, and students seem quite clearly his work. Later, it is known that much of the student portraiture and standard views of buildings on campus were taken by assistants, particularly Benjamin Baltzly, though the Notman "house" style is plainly visible. As the United States studios developed (for example at Boston), the work was undertaken through the nearest studio, even when college campuses were closer to Montreal. Dartmouth College in Hanover, New Hampshire, for instance, was served by both Montreal and Boston studios.

The cost of albums is difficult to assess from remaining evidence.

UNITED STATES: College Trade and Centennial Exhibition

Miss A. Woods, student, Vassar College, Poughkeepsie, New York, 1870

Francis James Child, Harvard College, Cambridge, Massachusetts, 1876. Professor of English at Harvard, Child is remembered for his writings on the English poets Chaucer and Spenser and for his five-volume collection of English and Scottish popular ballads.

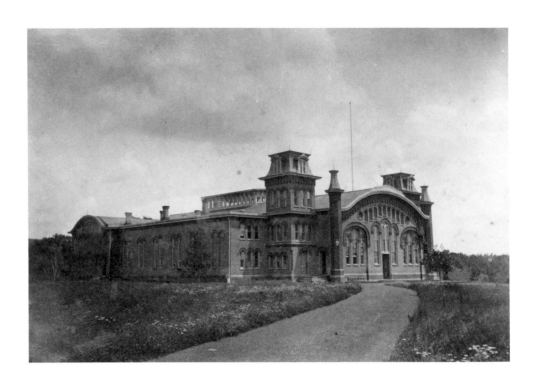

Gymnasium, Vassar College, Poughkeepsie, New York, 1869

The only substantive record is to be found in an 1879 issue of the *Yale News*. It advertised the price of albums alone at twenty dollars for twenty leaves, with extra leaves costing seventy-five cents each. They were not cheap: a photographer in Notman's Montreal studio in 1879 might make sixty dollars a month. Camera time was additional, and since there might be as many as forty cabinets, plus a dozen or more larger views, the album was, for its time, a very expensive investment. William Notman's studios definitely undertook this kind of work at Vassar, Yale, Harvard, Princeton, Dartmouth, Amherst, Smith, Trinity, and Mount Holyoke. Very likely he was at Lafayette in Easton, Pennsylvania, and as far afield as the new University of Michigan at Ann Arbor. At campuses like Harvard and Yale, the trade was lively enough for him to establish temporary seasonal studios.

William Notman became a familiar figure on the American photographic scene. He became even more so, again through photographic entrepreneur Edward Wilson, as a result of his involvement in a pivotal commercial and cultural event of 1876: the Philadelphia Centennial Exhibition. This great international celebration, held between May and October 1876 to commemorate the one-hundredth anniversary of American independence, was centred in the semi-official birthplace of U.S. liberty. It was, without question, the most important exposition ever held in the United States to that time, and was intended to be a monument to America's past, a showcase of its present, and a base upon which future success could be built.

Yet the timing could not have been much worse. Since 1873, the United States, and indeed much of the industrialized world, had suc-

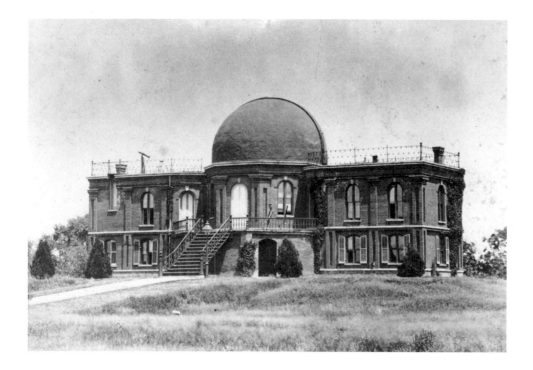

Observatory, Vassar College, Poughkeepsie, New York, 1869

Francis Parkman, Harvard College, Cambridge, Massachusetts, 1876. A graduate of Harvard Law School, he was beloved as an historian and considered the leading authority on the settlement of North America.

cumbed to an economic depression that would continue, in fits and starts, for two decades. Moreover, the United States government had scarcely been enthusiastic about the fair. Only at the last minute did it throw monetary weight behind the project. Financial support came largely from contributions from state and local officials and the adroit management of a joint-stock Centennial Corporation fortified by a particularly talented Centennial Board of Finance.

But the fair turned out to be a real triumph. Philadelphia's Fairmount Park proved to be a spectacular setting, more than forty countries sponsored exhibits, organization was exceptionally smooth, and visitors came from all over the world. America was perceived as both a serious rival to Europe in manufacturing and individual innovation – Bell's telephone was exhibited for the first time – and also, although by most contemporary standards the artistic achievements were formal and derivative, aesthetically more than a raw frontier. Moreover, photography had an immense role to play – not just in terms of the exhibits, but, as it evolved, in the conduct and day-to-day operations of the giant exposition.

William Notman's association with the fair was through an organization titled the Centennial Photographic Company. This business, another joint-stock operation, was chartered by the state of Pennsylvania and showed William Notman as President. Other officers were W. Irving Adams as Vice-President, William Notman's Toronto business partner John A. Fraser (of Notman & Fraser) as Art Superintendent, and, not surprisingly, Notman's now old friend and confidant Edward Wilson as Superintendent and Treasurer. The

Centennial Photographic Company held the "exclusive concession" to take photographs at the world fair. What this meant for William Notman and the other shareholders was the right to advertise and sell the company catalogue of views of the exposition, together with exclusive rights to all photographic work done at the Fairmont Park site. In short, if photographs were to be taken at any point in the grounds, in one way or another it was necessary to deal with the services of the Centennial Photographic Company.

William Notman's direct involvement in this venture is not extensively documented. It seems that Wilson, the man on the spot, may have intended to pursue it alone with Irving Adams, but when finances became challenging, the wealthier Notman interest was brought in, along with the artistic flair of John Fraser, almost certainly a Notman precondition. It is entirely unlikely, given William Notman's character, that his role was merely titular. As with so much of his work in Montreal, it is not always easy to attribute specific individual photographs to William Notman. In any case, all photographic prints are stamped Centennial Photographic Company. On the other hand, the company's work was of a very high order – and doubtless the meticulous Notman thoroughly inspected any product to which his name and money were attached. Eventually the company amassed a catalogue offering some two thousand eight hundred and twenty scenes and exhibit views from the exposition. The list ran to forty-eight pages of small print, with photographs available in various formats: stereo, cabinet, carte-de-visite, eight-by-ten and larger specialty orders, and even lantern slides touted for educational application.

The cost of this remarkable monopoly was reasonable – three thousand dollars payable to the Centennial Board of Finance. The popcorn concession was, by comparison, a touch or two higher at five thousand dollars. The company did have to finance construction of a building, maintain a large staff (it grew during the summer of 1876 to one hundred persons) and darkroom equipment, and, at the fair's end, provide a further royalty on product sales to the Centennial's financial authorities. It is not clear what monies were expended, although it is known that there was some early scepticism over the chances of the firm's success. William Notman, John Fraser, and Irving Adams held the most shares – 25 each out of 100 – with Edward Wilson holding another 20. Two minority stockholders, M. L. Brennan of Philadelphia and Robert J. Christy also of that city, took 3 and 2 shares respectively.

The total capitalization was ten thousand dollars, which seems a reasonable amount for the task at hand. Contemporary financial observers noted that while William Notman was "very well to do," expenses were "large" and photography by mid-May 1876 was "slow-selling." Success seemed "doubtfull." Earlier, without disclosing exact figures, Wilson had complained to the Chairman of the Committee on

Grounds that the company's building (designed by the exposition's eminent chief architect, H. J. Schwarzman) "had been erected at twice the cost we agreed on in order to honor the situation." The building, practically arranged around a large centrally lit court for exhibitions, with three substantial rooms adjacent for studio, developing, and administration, was in fact most advantageously situated. The chosen spot was right on Belmont Avenue, one of the main routes of the fairground, next to the Jurors' pavilion, opposite the ornamental lake. It was the nearest commercial building to the main entrance.

There is sound reason to believe that the company was a substantial commercial success. When the fair ended, the firm (according to the exhibition's records) turned over the prescribed 5 per cent royalty on sales – a sum amounting to $13,219.48. That would make the gross sales almost $90,000. Even when costs to the original shareholders are calculated and added to the price of the building, the wages of employees, production costs, and the original concession fee of $3,000, there still must have been a sizeable profit. Moreover, interest in the exhibition did not die with its closing. Edward Wilson, on his own initiative, continued to advertise the company catalogue of available photographs for a good number of years afterwards. Furthermore, the Philadelphia extravaganza was a stunning advertisement for the Centennial Photographic Company, whose name appeared on every photographic reproduction. Letterhead and broadsides, bills and receipts listed also in prominent fashion the officers of the company. Once more the Notman name was put before an admiring American public.

Three particular aspects of William Notman's association with the Centennial are worth further consideration. First, the event showed that John Fraser, representing the Toronto partnership, was financially capable of involving himself in a substantial enterprise, suggesting that the Toronto branch was indeed flourishing under his management. Second, William Notman himself, as photographer, exhibited extensively at the exhibition and walked off with high praise and a gold medal for his work, particularly of "life and hunting groups." *The Philadelphia Photographer* was customarily lavish in praise, calling the Montrealer's work "magnificent" and "splendid." The writer, presumably Edward Wilson himself, described the Notman exhibit as

... at once attractive and full of artistic merit in every department of photography. It is the splendid exhibit of Mr. Wm. Notman, Montreal. This is the largest contributed by any one house, and in elegance of work, richness of mounting, framing, etc., fully sustains the high reputation Mr. Notman has long enjoyed, not only in Canada, but throughout the United States. Here are plain photographic portraits in card, cabinet and 8 x 10 sizes, larger portraits in India-ink and water colors, and life sizes in crayon and oil. Mr. Notman

UNITED STATES: College Trade and Centennial Exhibition

Centennial Photographic Company price list, 1876

not only produces the most faithful and artistic portraits but also illustrates some of the sports and customs of his people.... No one can leave a careful inspection of this exhibit without gaining some new thoughts, or being impressed with the high character and capabilities of photographic art.

More objective, since they were not from the pen of his business partner, although appearing in the latter's journal, were the views of the German academic and photographer (and, incidentally, teacher of Alfred Stieglitz amongst others) Hermann Vogel. One of the official judges, Vogel attempted to assess in what directions the photograph was moving – especially in America – and came up with an interesting observation:

Canada, in all its exhibits, is leaning more to America than to England. The similarity in all its proportions can be noticed very easily. Here and there are prevailing life-size pictures, which have received more or less changes by retouch; and we also notice here the same highly cultivated photographic routine. Ahead of all stands Notman. I am not satisfied with the painting in several pictures executed in oil. The groups in the skating rinks show skill, but what most attracted me was the smaller pictures, especially the handsome groups of hunters and skaters. In these Notman shows the man of inventive genius and taste.

The final Notman link with the exhibition is the use, almost certainly for the first time, of the modern photo-identity card. Large expositions in London, Paris, and elsewhere had all experienced problems with properly identifying employees, exhibitors, press, and officials who made recurrent trips to the exhibition site. A signed card or pass was unsatisfactory, as it could be handed on and used by other persons. The solution at Philadelphia was what was called "the photographic ticket." Here is the rather magisterial description in the Centennial's official report:

The photographic ticket ... in the form of a book-cover and engraved by a bank-note company.... On the front the number of the ticket, the name of the holder, and his or her relation to the Exhibition fully set forth. On the border of the inside a space was set apart for each day that the Exhibition was open, and its date engraved thereon. Detailed instructions as to how to use it were engraved upon the left-hand side, and on the right-hand side was set apart a space, of well-defined size, to be occupied by a photograph of the holder, which was encircled by the seal of this Department. Upon presentation at one of the class of gates reserved for photograph tickets, the photograph was compared with the holder, and if satisfactory to the gate-keeper, the space upon which the date of the day of representation was engraved was cut out by a self-registering punch.... The stamping of the photograph at the office, and the refusal to permit the tickets to be used on which the

photographs were not stamped, prevented the use of this class of tickets by any other than those to whom they were issued.

A less formal reckoning of this innovation was given in a contemporary account by J. S. Ingham in *The Centennial Exposition, Described and Illustrated*:

In the earlier weeks of the Exhibition the reception room and studio [of the Centennial Photographic Company] building presented a most unique and interesting sight. It was required by all who held free passes, whether exhibitors or others, to have their photographs taken and pasted on their passes, and these photographs were taken by this company. Here a motley crowd used to be assembled. There were Tunisians, Algerians, Turks, Chinamen, Japanese, Africans, Germans, Austrians, Italians, Frenchmen, Spaniards and Arabs, all jabbering in their turns in their national way, showing their international measure of push and enterprise in getting ahead, giving evidence of their several dispositions as circumstances required. A true Babel, indeed, and a most picturesque sight. Day by day, nearly seven hundred heads were taken off for the purpose named.

By the end of 1876, William Notman's reputation in the United States was on firm ground. He was fully recognized, even celebrated, by his peers, had obviously enjoyed some financial success, and had gained the public interest as well. The time was ripe for the ever-canny Montreal entrepreneur to further exploit the growing American opportunities.

UNITED STATES: College Trade and Centennial Exhibition

Centennial ticket with photograph, 1876

His success at the Philadelphia Exhibition and in New England college yearbooks clearly confirmed the value of setting up a formal business base in the United States. Wisely, Notman chose Boston, then as now the urban focal point of a vast complex of colleges and universities. His brother James moved south from the studio at Saint John, New Brunswick, in 1877, to become a partner in the new venture, as did Thomas Campbell from the Montreal operation. William – thought to be worth about seventy-five thousand dollars at the time – was to be Senior Partner. For capital, he transferred all his assets and goodwill already established in the United States to the new company. Or, as the "Articles of Co-Partnership" put it:

... The Iron Studio at New Haven Conn. also the 2 wooden studios at Cambridge Mass & Hanover Also the lease of the Studio at Easton (Penn) Also all the studio furniture and fittings, cameras, lenses for Portraits, groups & views at present belonging to said Wm Notman in the States aforesaid & in use for College business & of his private business at New Haven & Easton aforesaid also all the view negatives ... taken of the various colleges ... in fact everything concerning college business except the Photographs & albums for past years & for such contracts as end June next. ...

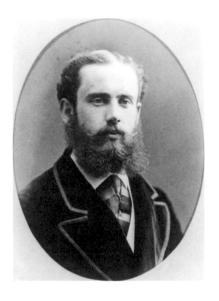

*Thomas Campbell, Montreal,
1873*

*Mrs. Cornwallis West, Boston,
1877–80*

The value of William's contribution was put at $8,500. James contributed $4,250 in cash (although it is probable that William also paid the larger part of this amount) and Thomas Campbell paid in $3,000. William agreed to supply any other capital required, and brother James and Thomas Campbell were to run the operation with William providing long-distance advice.

The firm was to be called Notman & Campbell and it took up generous rooms in a fashionable address at 4 Park Street, where the public gardens lay across the street, the State House surmounted the rise to the right of the front door, and the Boston Athenaeum was just around the corner.

Within a year, James was bought out of the partnership by brother William, who became the majority shareholder (two thirds to Campbell's one). The reasons are not clear. James, perhaps used to being his own boss in the Maritimes, may have found the partnership too confining. Yet advertising on a cabinet card suggests William Notman may have also been James's partner in a new studio and residence at 99 Boylston Street in a newly fashionable upper-middle-class district, not far from the earlier location on Park Street. He was the first photographer to start up on what became a popular strip for high-toned studios. He quickly set about cultivating the social register and was enormously successful, carving out a reputation as both a fine photographer and a sound businessman. Boston blue-bloods, and their intensive social and philanthropic activities, provided James Notman's living. His photographs possess an originality and reveal a vitality that richly deserve the status and praise accorded him by contemporaries. Within a very few years he had moved his residence

elsewhere and eventually located the studio in larger, more lavish quarters further along Boylston Street. In the mid-1880s he was joined in Boston by his nephew, George Sloan Notman, who took a share of the growing work-load, and interestingly was followed by other Notman family members, a number of whom joined Notman's Park Street studio in Boston. Clear evidence of their success can be seen in the speed with which the mortgage at 99 Boylston (for the then considerable principal of twenty-one thousand dollars) was discharged, and by the fact that James Notman also located himself at 7 Brattle Street and at 400 Harvard Street, across the river in Cambridge, to take advantage of the university trade.

James Notman remained active in the Boston area until 1895, when he closed his studio and took an early retirement (he was only forty-six), moving with his wife to Pictou, Nova Scotia. There, for nearly forty years, he pursued a lifelong hobby of salmon-fishing until his death in 1932. His nephew, George Sloan Notman, left the James Notman studios in 1889 to become a Boston portrait-painter. By 1892, at the age of twenty-eight, he had dropped the Notman name officially and remained until his death in 1942 as George Sloane, having added an "e" to Sloan to distinguish himself from another Boston artist, John Sloan.

William Notman, in the meantime, was engineering new moves. Notman & Campbell, operating out of Park Street, was doing a very considerable business in a very short time – not unlike Notman's sudden success twenty years before in Montreal. He not only reigned supreme over the college trade but also launched additional, often massive, photographic undertakings, such as the individual portraiture of the entire judiciary of the state of Massachusetts or the collected schoolmasters of Boston and so on. As with the college trade, items would frequently be arranged in large albums and sold to members of various professions. There was much group photography of professional associations and standard portraiture, not only of worthies and dignitaries but also of the city-wide public.

Yet, although the Boston business was doing well, William Notman's new American *headquarters* was not to be located there but rather in Albany, New York. There seemed to be good reasons for choosing this site. First, Albany provided ready access to Montreal by rail; second, it was near the geographic centre of projected Notman interests in the United States; third, the laws of New York appear to have been more liberally inclined to business operation than those of Massachusetts; and finally, Albany itself was seen at the time as the hub of a fast-growing state, the centre of government, and the natural focus of an influential portion of the state's society.

Albany was established and growing, had a commercial and industrial base as well as a bureaucratic and administrative function, and with a population of ninety thousand could be expected to enjoy reasonable future growth. The city of New York was not considered. In any event, New York was already swarming with photographers, not a

UNITED STATES: An American Branch Plant

George Sloan Notman, Montreal, 1882

Annie Notman, Montreal, 1882

Back of cabinet card

few of them already energetic rivals to William Notman in the lucrative college trade.

The first foray into the Albany market was made in early September 1877. At this stage, the office appears simply to have been called the Notman Studio or the Notman Photography Studio. It was entirely owned by William Notman and was managed by Edgar McMullen, an established Albany photographer.

Formal articles of incorporation under New York State law came two years later. The proposed new firm was no minor operation. Capitalized at one hundred thousand dollars, it took the corporate name "The Notman Photographic Company Limited." The stock books were opened at the company's offices, 55 North Pearl Street, along the main commercial artery of Albany, on September 19, 1879. Not surprisingly, the chief investor in the company was William Notman of Montreal. In fact, of the 570 shares taken up (at one hundred dollars a share) by the time the papers were filed in March of 1880, William owned 221 shares and his son, William McFarlane Notman, had 200 shares. Thomas Campbell, the old Boston partner in the Park Street studio, owned 69 shares, and an old friend and neighbour, Alexander Ramsay of Montreal, held 50 shares. The American shareholders, Andrew Jones, James Walker, James Duncan, Albert Stevens, and Edgar McMullen, all had 5 shares, except for Duncan, who had 10. The Notman & Campbell partnership of Boston was formally dissolved at this time, but the studio at No. 4 Park Street continued under the new name.

There is no doubt that the new Notman Photographic Company was a classic branch-plant enterprise, Canadian-owned and -directed with a few "token" Americans attached. These "tokens" were well-known local photographers and businessmen in the Albany region. They were included to inspire confidence, and did so. State law required half the subscription to be paid up before a company could start operations. The firm therefore began with operating capital in the vicinity of fifty-seven thousand dollars. William Notman was, of course, President, but day-to-day activities were to be handled by the Secretary and Treasurer, Albert Stevens of Albany, with Thomas Campbell and Edgar McMullen acting as a board of trustees.

The firm's business plans were ambitious. Branches already existed in Boston, Hanover, Cambridge, New Haven, and Easton, Pennsylvania. They would soon, it was announced, open in New York City and at Ann Arbor, Michigan. Not only were the American offices to be photographic studios but they were also to act as suppliers of photographic goods and equipment.

Despite all of these fond hopes and careful plans, the Albany operation would not prove entirely successful. Perhaps the timing was wrong – America and the rest of the western world, as noted, faced an ongoing series of recessions and depressions for more than two decades following the notorious commercial panic of 1873, or perhaps, and more likely, conservative Albany, small-minded capital

Fresco in the New State Capitol, Albany, New York, c. 1879

Stereograph of the Assembly Chamber in the New State Capital, Albany, New York, c. 1880

of a huge, progressive state, was simply not the right place to base the headquarters. Regular financial reports on business credit-worthiness suggest that there was doubt that the Albany firm was doing much more than minimal business for most of the early 1880s. Further evidence is seen in the nature of local market adver-tising: specials, price reductions, and cut-rate offers were all tried to attract public attention. Though the firm's corporate seal was intend-ed to last twenty-five years, enthusiasm was waning by the time of William's death in 1891. The Albany branch-plant scheme was not so much a failure; rather, it had not been an unqualified success.

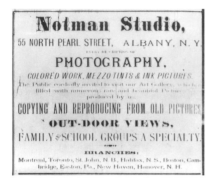

*Studio advertisement, Albany
City Directory, 1878*

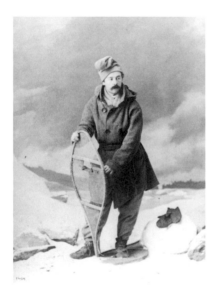

*George Arless, Montreal,
1866–67. Arless was the
manager of the Notman
studio in Newport, Rhode
Island.*

Regular dividends of 10 per cent were taken, however, and the new firm did flex its corporate muscles with its divergence into a new and potentially significant market.

The late nineteenth century saw the broad discovery of American pleasure travel. Formerly the exclusive reserve of the rich, "tourism" had been restricted to those travelling to Europe for the edifying grand tour or to those journeying to fashionable watering-holes like Newport, Rhode Island, for the season. "The Spa" with its connotations of health and wealth had long been a feature of American as well as European social life, but only for the monied few. After the Civil War, there was a growth in opportunities for pleasure and relaxation amongst the middle classes as well. Such enthusiasms were propelled by the ready availability of rail and steamship. The active pursuit of leisure became within reach, literally and figuratively, of the many rather than the few, and, as a result, older spas and resorts were expanded with new hotels and conveniences, and new ones were developed which offered a broader range of attractions. Photographers were eager to seize the opportunities implicit in these changes, and the newly minted Notman Photographic Company was also poised to compete.

Indeed, if the 1870s was the decade of college photography for William Notman, the decade of the eighties was that of resort photography, although he probably began casual resort work earlier. In these years, the Notman imprint was increasingly seen at new and fashionable locations in Saratoga, New York; Poland Springs, Maine; Magnolia, Massachussetts; and the parent of all grand American ocean resorts, Newport, Rhode Island.

The business at some resorts was not unlike college and university photography. Primarily, it was first a seasonal affair that could be conducted through temporary studios, with the processing handled in Albany or Boston. The notable exception to this was Newport, where a complete studio was maintained on "Millionaires Row," Bellevue Avenue opposite the Redwood Library. Individual portraiture and family groups were the backbone of the trade, as Victorian captains of industry and manufacturing eagerly sought to record their status at one site or another. Certain advertised specialties marked different places – especially, once again, in Newport, where the clientele was better-established (and better-heeled). Here the Notman studio offered "portraits in Oil, Water colors or India Ink, of all sizes from the small Locket miniatures to Life Size," and promised "satisfaction" for "landscape photography, Garden parties, Horseback and Carriage-Parties"; as well, the firm notably indicated that "copying old pictures" was "a specialty."

The Notman Photographic Company had other notable successes as well. Just as William Notman had invented a photographic "first" with the photo-identity card at the Philadelphia exposition ten years earlier, he reached yet another level of innovation in Hartford,

Engraving of the Poland Spring Studio, 1880s

Grocery store, Albany, c. 1880

Connecticut, in the mid-1880s with his work for the Travelers
Insurance Company, then, as now, among the largest American insur-
ance concerns. It was also, according to Travelers' own records, the
first commercial organization of its kind to use photography – Notman
photography – for advertising purposes.

WITH COMPLIMENTS OF THE TRAVELERS INSURANCE COMPANY.

Union Commanders, 1883. A composite photograph commissioned by the
Travelers Insurance Company, Hartford, Connecticut.

The photographs in question were composites (a well-recognized
Notman specialty by then for many years) prepared in the Montreal
studios. They were part of a promotional scheme conjured up by
Major Edward Preston, Travelers' first Superintendent of Agencies.
Working with Edgar McMullen, who by then had become Treasurer
of the Notman Photographic Company and had relocated to Boston
from Albany, Preston ordered two sets of composite photographs of

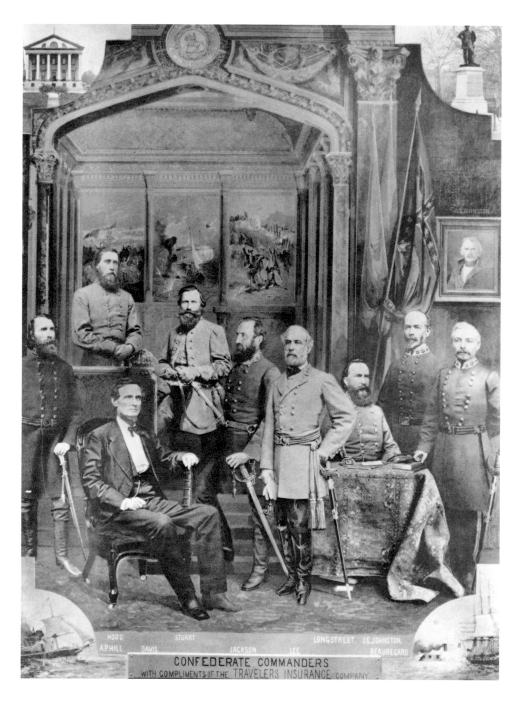

Confederate Commanders, 1883. A composite photograph commissioned by
the Travelers Insurance Company, Hartford, Connecticut.

the rival commanders of the Civil War – one Confederate, the other
Union. The artwork on this ambitious project was undertaken by
Eugene L'Africain, the chief artist at the time in the Montreal studio.
L'Africain had joined the Notman studio in 1878 and developed his
skills under the watchful eye of seasoned veterans such as Henry
Sandham and James Weston. He is remembered particularly for the
animated winter-sports composites realized in the late 1880s at

George R. W. Notman,
Montreal, 1888

Montreal. Some of the photographs of the rival commanders were secured by the Notman Photographic Company from other photographers. Others were taken directly by its studios.

The Travelers Insurance Company executives were delighted with the composites; large quantities were reproduced, and an extensive distribution was made to customers through its agency system. The first copy of the Confederate series was, for example, sent to Jefferson Davis in Montgomery, Alabama, through the local agency there. Further prints were sent to all living generals in the two pictures. Following upon this achievement, the Notman company prepared a substantial number of these composites for The Travelers to distribute – among them "Famous American Authors," "Eminent Women," and "Famous Editors."

The Notman company also had a hand in what has proven to be one of the most enduring forms of insurance advertising, not least at Travelers – the calendar. The hanging calendar, with visible dates, was something of a novelty when first introduced in the company's advertising in 1869; it was soon embellished with decorative engravings and, after a few years, with Notman photographic imagery, including the authors and generals series but also, for example in 1890, with political figures such as U.S. President Benjamin Harrison and his Cabinet.

Travelers engaged the Notman company on at least one other project. This was the 1885 production of a souvenir pocket album of *Views of Hartford*, "not intended," as a laudatory article declared in the *Hartford Daily Times* of October 17, 1885, "for sale or general distribution by the Company, but designed solely for gifts to its helpful friends." The small book was subtle boosterism of the solid insurance city and incorporated views of its bustling business district. Included too were portraits or views of the residences of such Hartford notables as Samuel Clemens, Charles Dudley Warner, Harriet Beecher Stowe, Samuel Colt, and of course James Batterson, who was president of the Travelers.

The understandable civic pride of the *Hartford Times* was swelled to bursting:

These views are not at all like ordinary photographs. They are dissimilar in beauty, location, and originality to any pictures that have yet been issued. In looking at them, any foreigner would be impressed by the fine appearance of our city. . . . Each autotype is a revelation of beauty. The lights, shadows and outlines of the buildings, the luxuriance of the foliage, the fine perspectives of the streets, the exquisite details of the views, and above all the *atmosphere* in these gems of photography, lift them into the realm of art. . . .

Notwithstanding the exuberance of civic promotion, the Notman magic was indeed evident. It is entirely probable that similar commissions were undertaken for other companies, or at least contemplated by William Notman in the light of such success. Certainly the extensive distribution of these items (a Travelers estimate runs to the

tens of thousands for some) advanced the firm's name, which was clearly engraved on every plate along with that of The Travelers.

At the time of William Notman's death in 1891, his bold American endeavours were at their zenith. The driving force and unquenchable enthusiasm that were an innate part of Notman's character diminished measurably when his son William McFarlane Notman took over the firm in Montreal. William McFarlane seems to have spent time in the Boston studios in the year following his father's death and may have decided to modify American operations. It may also have been William McFarlane who sent his younger brother, George R. W. Notman, from the Boston scene to New York City in 1893. George was well versed in Notman studio affairs, having accompanied his elder brother on the Western Canadian photographic commissions for the Canadian Pacific Railway in 1884 and 1887, and even having represented the Notman company in London at Queen Victoria's Golden Jubilee in 1887, when he was only eighteen years old. He had replaced his brother Charles Frederick at the Park Street studio in Boston when William died.

Perhaps it was considered that the New York initiative was useful for George R. W.'s career or that a niche could be made in that fiercely competitive metropolitan market as it had years earlier in Boston. Whatever the motive, a studio was opened on Madison Avenue in 1893 under George's guidance, but it moved to Fifth Avenue by 1895. By 1898, however, the New York operation closed, and George R. W. returned to one of the Boylston Street studios in Boston. Within two years he had moved to Montreal and, like his uncle James Notman, had given up photography altogether – in his case not to fish but to manage the Eclypse Acetylene Gas Company of Montreal.

The faltering of the Albany enterprise by the late 1880s had forced the Notman Photographic Company back onto its Boston base. The Albany studio did continue more modestly until 1898 (from 1892 under the management of Aimé Jodoin, who was sent down from the Montreal studio), at the North Pearl Street address of the Albany Art Union. But that year the premises were vacated and much of the stock (including a large quantity of mammoth negative plates) was taken over by a local photographer, Stephen Schreiver, who took pains to maintain the Notman name. It was from Boston that the company staff made seasonal college or resort forays in the 1890s, many conducted by one of William Notman's most skilled associates, Dennis (or Denys) Bourdon. He had been with the Notmans most of his life, beginning as an apprentice in Montreal in 1868, and advancing rapidly there until 1877, when he left Montreal to join the Notman & Campbell Studio in Boston. There he was the main photographer in 1880, and four years later became the principal mainstay of the Notman Photographic Company, as manager of the whole operation. It was under his supervision that the company expanded, moving from Park Street to its second Boston location at 280 Boylston Street.

Bourdon seems to have done much travelling, including a fair share of the college trade. *The Dartmouth*, the college newspaper in Hanover,

UNITED STATES: An American Branch Plant

Lady in a grainfield, 315 Madison Avenue, New York City, c. 1893

N.H., described his visit there in its October 17, 1879, issue:

Notman & Campbell's agent, Mr. Bourdon, has completed his work of taking pictures for the senior class, and gone to New Haven. They are all much pleased with the polite and accommodating manners of Mr. Bourdon, and his skill as an artist we do not question. Many hearts are broken on acount of the naturalness of their pictures; they have been promising them for three years to their lady friends, and they fear they will not meet their expectations. Nature is to blame, not Bourdon.

Aimé Jodoin, c. 1870. Jodoin was the manager of the Notman studio in Albany, New York.

Dennis Bourdon was also very well known, on behalf of the Notman Photographic Company, at Poland Springs House resort in the State of Maine. One of the Notman photographers from the Boston studios had begun seasonal work there as early as 1891, and Bourdon made annual visits to Poland Springs beginning in 1895. He was still working regularly more than a quarter of a century later. Poland Springs' *The Hill Top* magazine noted Dennis Bourdon's August arrival in 1927 and urged guests to hurry to the Notman Photo Company's studio at the end of the boardwalk, where they would have "an exceptional opportunity of having their photographs made by one of the finest artists in America." The same publication confirmed that William Notman's Cambridge studio on Massachusetts Avenue was still alive under Bourdon's management. But it was more than his management. In 1918, after fifty years of service, Bourdon had become President *and* proprietor of what remained of the Notman Photo Company in the United States.

There were any number of reasons for the Notman retreat from the American market. To begin with, the death of the founder deprived the operation of its driving force. William McFarlane Notman, despite his many obvious talents, simply did not have his father's ambition to maintain and manage a complex and far-flung business enterprise. Perhaps, in classic fashion, the firm could not expand successfully beyond the reach of personal family control.

But much can also be attributed to a pronounced shrinkage of the market. The college trade had changed by the late 1890s with the emergence of printed college annuals, interest in composites recording large groups had fallen with the introduction of faster emulsions, and cheap mechanical-reproduction techniques made single landscape or city views redundant.

Another blow – one felt by all commercial photographers – had come in 1888. It was in that year that George Eastman marketed his Kodak camera. By the 1890s the roll film, daylight-loading, and the handy Kodak were being enthusiastically embraced everywhere. This technological marvel did not mean the end of commercial photography, but it did shake up the profession. Eastman's slogan said it all: "You press the button and we do the rest." Success wasn't guaranteed to amateurs, but clearly the professional studio business would never again be quite the same.

Conclusion:
The Notman Legacy

HUNDREDS of thousands of images taken over many decades by literally dozens of photographers in at least twenty-six studios and innumerable locations is a formidable legacy of a single family photographic business. Of course, not all these images have survived. Many of the prints that surface from time to time, in archives, historical societies, libraries, and museums, and from private hands (often the descendants of Notman studio clients), are the natural product of a wide-ranging business and clientele. If the prints do not bear the characteristic studio imprint scratched in the emulsion or stamped as a logo on the reverse of the photographic mounts, they are normally identifiable by the distinctiveness of the Notman house style.

During the life of William Notman and his son William McFarlane Notman, the Notman business went through various partnerships to take advantage both of shifts in the trade and of turnover of personnel. In one or two cases, as perhaps with John Fraser and Henry Sandham, it was to avoid losing talented artists who had added materially to the firm's reputation. None of the partnerships was more important than the carefully forged arrangements between William and his brothers and sons. These arrangements satisfied commercial and legal niceties and certainly afforded a measure of assured employment and professional training. But more significantly they reflected William Notman's keen, pragmatic ambition of maintaining stability and continuity in a fiercely competitive trade. Doubtless, William Notman's own association with his father in the Glasgow cloth agency, and his patently close family ties, led him to organize his business along these tight family lines.

Fortunately, the early success of William's business enabled the family to be together. In the fall of 1859, William Notman, Sr., with his wife, two of their sons, and one daughter, arrived in Montreal for permanent settlement. Another son, Robert, had emigrated earlier, and two married daughters remained in Scotland.

Certainly Notman's career in the New World was a striking success.

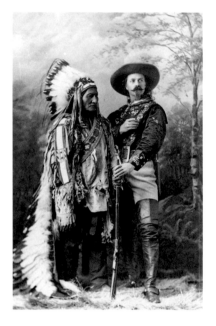

*Sitting Bull and Buffalo Bill,
Montreal, 1885*

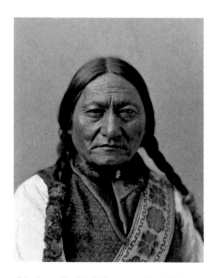

Sitting Bull, Montreal, 1885

The commercial indiscretion that had spurred his sudden move from Scotland to Montreal had long been forgotten, as parents, brothers, sister, and children alike had all joined in the burgeoning success of his North American enterprise. Moreover, he became a firm pillar of Montreal society, as much for his artistic interests and religious convictions as his material wealth. Throughout his career, Notman was community-minded. His early training in art and his continued interest in the field led to his becoming something of a patron. He encouraged the exhibition of paintings and other artworks in his own studio space from his earliest days. He also took an active role in the formation of the Art Association of Montreal, the founding meeting of which took place in his Bleury Street studio in January of 1860. Later he became chairman of the building committee for the Art Association's gallery, which opened in 1879 on Phillips Square, near Ste. Catherine Street. This was all good promotion of his own business, but for Notman, commercial and personal interests were happily intertwined.

Church work was important too. Notman had been brought up as a Presbyterian, and his wife was Church of England. For a number of years they attended Zion Congregational Church in Montreal, but in 1868 he shifted to his wife's Anglicanism. Notman subsequently served for many years on the finance committee of St. Martin's Anglican Church on Upper St. Urbain Street. Earlier, he had performed in a similar capacity at St. Mark's Anglican Church in Longueuil across the St. Lawrence River, where the Notmans had a summer home. Other philanthropic interests and responsibilities included a term as Governor of the Montreal General Hospital and as an executive member of the YMCA.

Longueuil was the focus of speculative real-estate ventures for Notman. Together with partners John Molson, F. W. Thomas, and Ovid Dufresne, the photographer appears to have benefited from land development in the 1870s. Later, he was part of a syndicate that built the Windsor Hotel, close by the Canadian Pacific Railway's Windsor Station, in central Montreal. Longueuil also permitted him to be the complete family man, a role he enjoyed immensely. There, in a large house that, with additions, could accommodate the entire Notman clan, he indulged his love of water sports, especially sailing and rowing on the St. Lawrence. For a time the family lived year-round at Longueuil, but eventually they moved back across the river to Montreal, where, in 1876, Notman bought an impressive stone mansion on Sherbrooke Street (still standing), next to his banker friend and associate John Molson.

Here, just a short stroll from his studio, he lived until his death, the result of a bout with pneumonia in 1891. Not surprisingly, he seems to have been active and enterprising right to the end of his life. If not all his ventures had proved entirely successful, they had at least been pursued with energy and vision.

The business went on. William McFarlane Notman, nurtured in the

firm from the earliest opportunity, had become a partner by 1882 and, as eldest son, was the logical inheritor of the company at his father's death. In 1884 at age fifteen, George, the middle son, had accompanied his brother William on his epic westward trip with the Canadian Pacific Railway, and he did so again in 1887. He worked in the Montreal studio until 1890, when he left for Park Street in Boston. In the same fashion, Charles, the youngest son, after completing high school in 1888, had been sent to the Park Street studio in Boston as an apprentice. He too accompanied his eldest brother, William McFarlane, on another CPR journey to Western Canada in 1889. He left the Boston studio to return to Montreal at his father's death in 1891. When, within three years of William's death, the studio moved from Bleury Street to a then-more-fashionable address in Phillips Square, Charles also was brought into the firm as a partner by his brother. If William McFarlane's particular ability was to create the serene landscapes and views of the Rockies, the Maritimes, and Newfoundland, Charles Frederick's talents were conspicuously evident in portraiture, the art that had rocketed his father to such sudden fame in the late 1850s and early 1860s.

When William McFarlane Notman finally fell victim to cancer in 1913 (the disease had been diagnosed in 1906 with a prediction of from three to seven years' survival), Charles assumed responsibility for operations – including moving to the new studio on Union Avenue in Montreal. At that period, Notman's was still considered to be Montreal's most prominent photographic studio. It was Charles who kept the studio running through the vicissitudes of the war years, during which William McFarlane Notman's two sons were killed, and it was he who sold the American operation to Dennis Bourdon in 1918. In the post-war period, Charles's lens focussed more and more on recording the Montreal elite. His father's interests in society and engineering, his landscapes and his street-scenes, were replaced by portraiture. Nevertheless, the size of the firm remained substantial: at the end of the war, he still had upwards of twenty-five employees, a constant figure since 1900. Charles opened new initiatives with some advertising photography and increased copy work, and undertook photo shoots for insurance firms.

On April 2, 1935, Charles sold the Notman family business in Montreal (by then the only "Notman" studio still operating) to Associated Screen News. He had turned sixty-five by then and decided to retire. He may have been influenced in his decision by the death of his veteran employee William Haggerty, who had started as an apprentice with William Notman at the age of fourteen. Haggerty had been the proprietor's right-hand man for at least two decades when he died in the autumn of 1934.

In the details of purchase it was agreed that Charles would remain as director and vice-president in charge of the Notman studio. As well, the studio negatives, prints, and record books remained in place.

Conclusion: The Notman Legacy

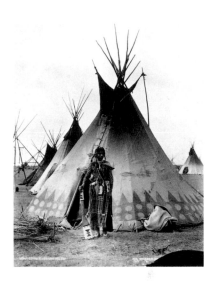

Blackfoot brave, near Calgary, Alberta, 1889

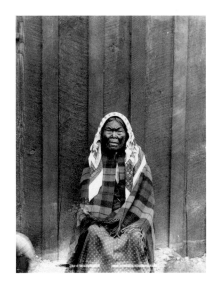

Indian woman, New Westminster, British Columbia, 1887

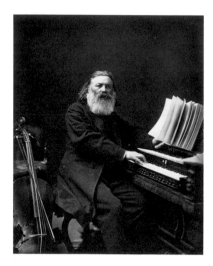

Mr. Vogt, Montreal, 1868

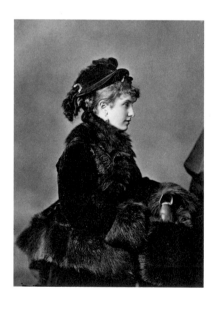

Miss Legge, Montreal, 1867

Charles, as it turned out, continued his association with the portrait studio for almost another twenty years until his death, at age eighty-five in 1955. Associated Screen News was reorganized that same year, but earlier had decided to sell both the studio and the historic photograph collection separately.

For the first time in its ninety-nine-year history, the Notman business was without Notmans, and its great store of plates and prints was in danger of being carelessly dispersed – even destroyed. There had been some attempts to find the massive collection a good home: contacts had been made with McGill University's Redpath Museum in Montreal and the Public Archives (now National Archives) of Canada in Ottawa. Beaumont Newhall, in a November 1955 contribution to *Image* (the journal of George Eastman House), credited William Notman with a rightful claim to highly innovative studio photography and dubbed him "Canada's first internationally known photographer." This claim was true, for Notman had exhibited widely throughout Europe and the eastern United States, and even in Australia, during his lifetime. Yet it is only fair to say that by 1955 the Notman name was little known beyond the city of Montreal. A consortium of three benefactors – the Maxwell Cummings Foundation, Paul Nathanson of Empire Universal Films, and *Maclean's* magazine – eventually bought the Notman collection. Their undertaking was to donate the entire Notman collection of negatives and prints to the custody of McGill University through its McCord Museum in 1956. Thus the Notman Photographic Archives was formed.

With this act, the world of William Notman, as captured and preserved so sharply and boldly through the lenses of his firm's cameras, was both safeguarded and revealed. *Maclean's* entered into an agreement with Montreal's McGill University to allow it first use of the photographs for the first three years. A series of heavily illustrated articles followed under the guidance of Pierre Berton and, slowly, Notman's fame again began to grow.

No real effort was then – or is now – necessary to appreciate the general quality of Notman photography. The cameras and talents of William Notman, his sons, brothers, nephews, and staff photographers, overcome the rigidities of the photographic technology of their day to reveal a remarkable humanity in their portraiture and create substance and presence in their views. The Notman world is not exiled in a quaint or nostalgic mist like many other nineteenth-century specimens. His photography is as fresh and engrossing as when it was taken because it so successfully conveys a sense of ongoing and visceral reality, a quality that is more easily recognized than described, but one that has the elusive quality of bridging past and present.

The Plates

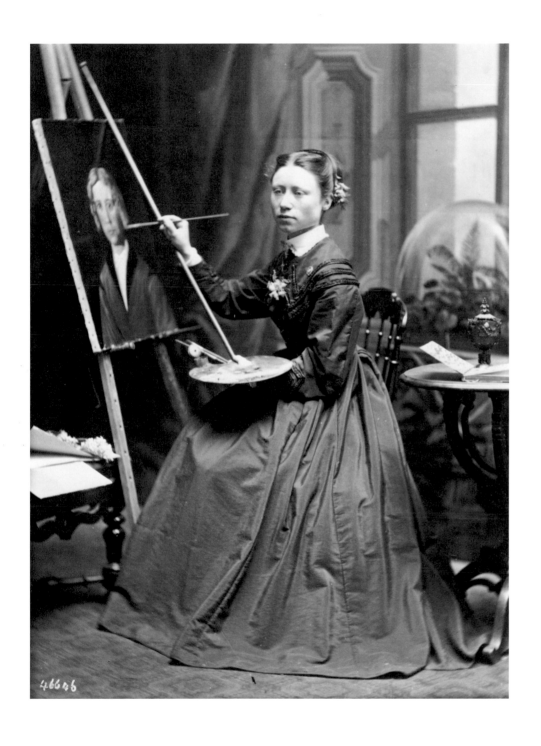

PREVIOUS PAGE: *Miss E. Coffin, Vassar College, Poughkeepsie, New York, 1870*

1 *Victoria Hockey Club, showing interior of Notman's large "operating room," sloping skylight, moveable backgrounds, and camera, 1888.*

67 ❦

Montreal Studio: Portraits

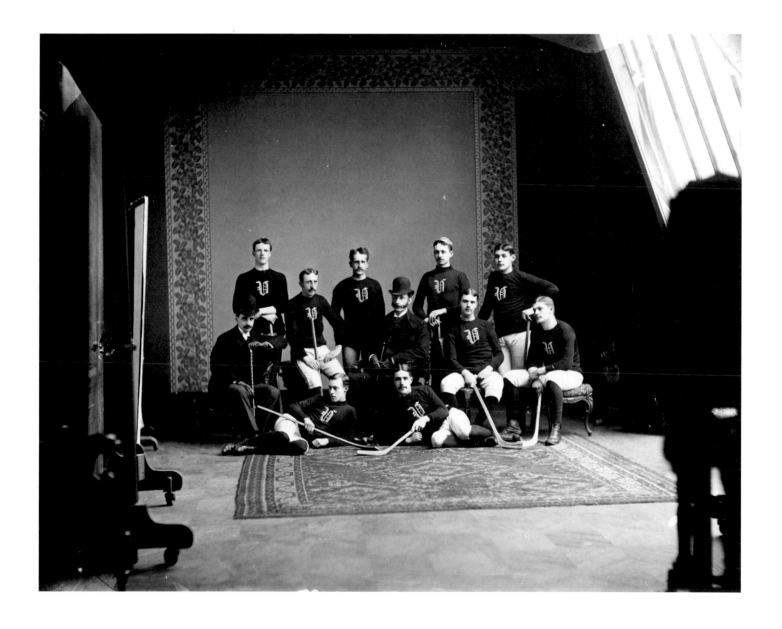

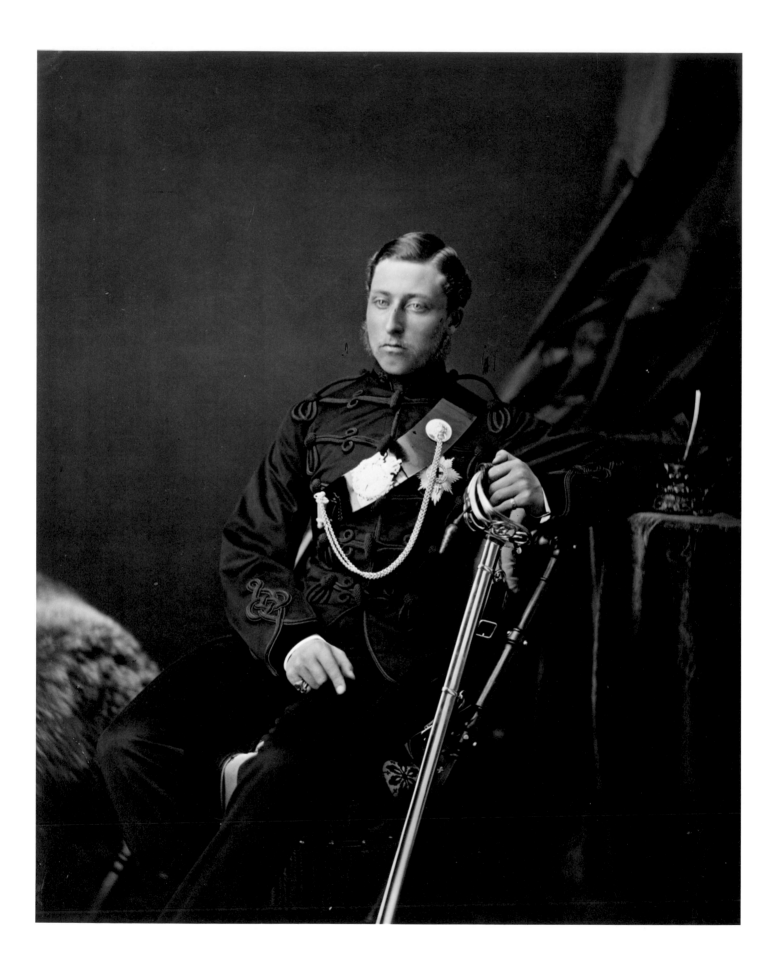

2 OPPOSITE: *Prince Arthur, Montreal, 1869. The prince was in Canada from 1869 to 1870 in officer training, first with the Royal Artillery, then with the Rifle Brigade. He was with the Rifle Brigade in 1870 when they repelled the Fenians in one of their raids south of Huntington, Quebec.*

3 BELOW: *Edith, Jessie, and Amy Brehan, Montreal, 1863*

4 BELOW: *Masters Notman and Chipman, Montreal, 1863. William Notman's eldest son, William McFarlane, is on the left.*

5 OPPOSITE: *Miss H. Frothingham and dog on the porch of the family home, Montreal, 1871. Her father, John Frothingham, was a prominent importer, manufacturer, and wholesale hardware merchant.*

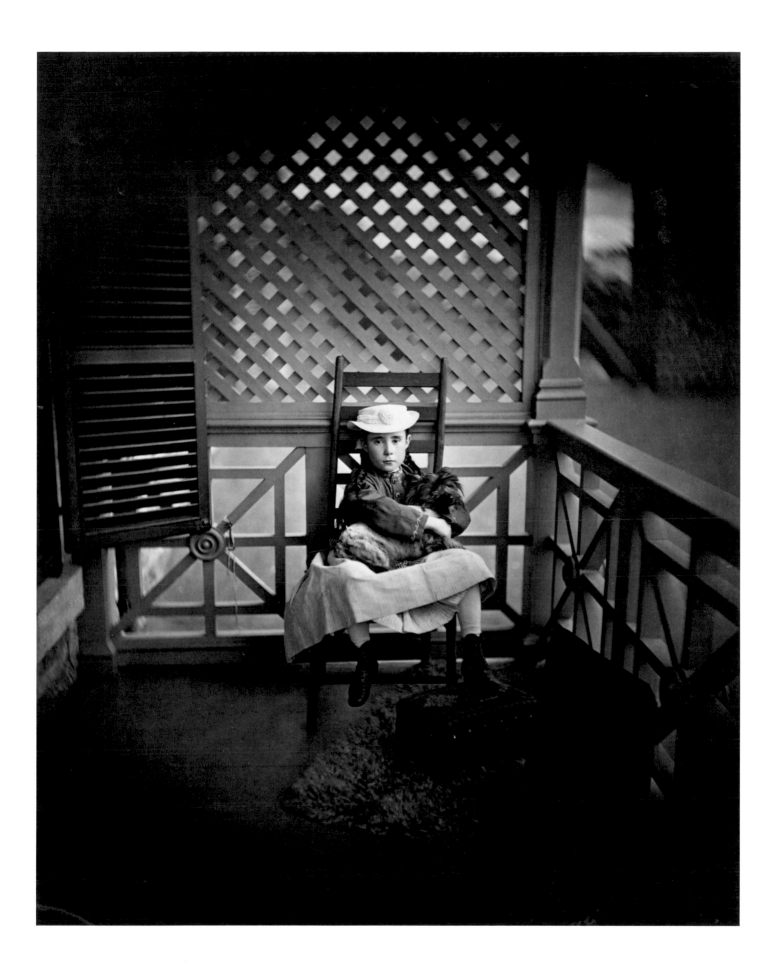

6 *Mayor Aldis Bernard (1810-1876), Montreal, 1873. A Montreal dental surgeon who trained in Philadelphia, he was active for over thirty years in Montreal municipal politics and was mayor from 1873 to 1875. He died in California the following year, but was buried in Montreal.*

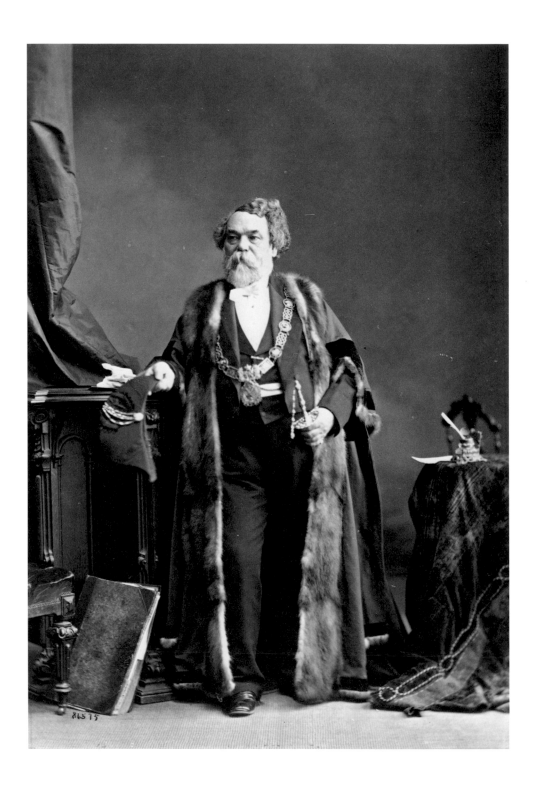

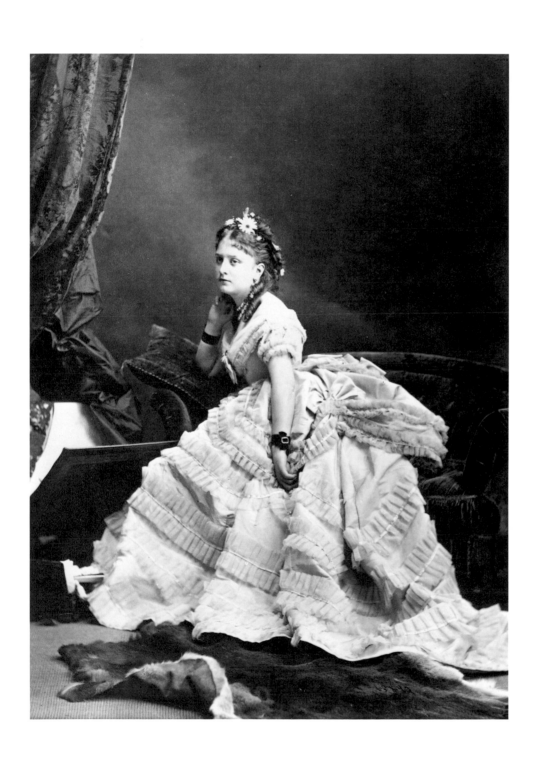

8 BELOW: *Mr. Remington and Mr. Ralph, Montreal, 1889. The American artist Frederick Remington (1861–1909), here on the right, famous for his paintings of the "Wild West," made annual trips to Canada to hunt, fish, camp, and paint. The picture was taken in Notman's studio.*

9 OPPOSITE: *Miss Grace Gillelan, Montreal, 1885. Daughter of William S. Gillelan, owner of the Banknote Company, she was photographed in the studio. The "snow" is salt.*

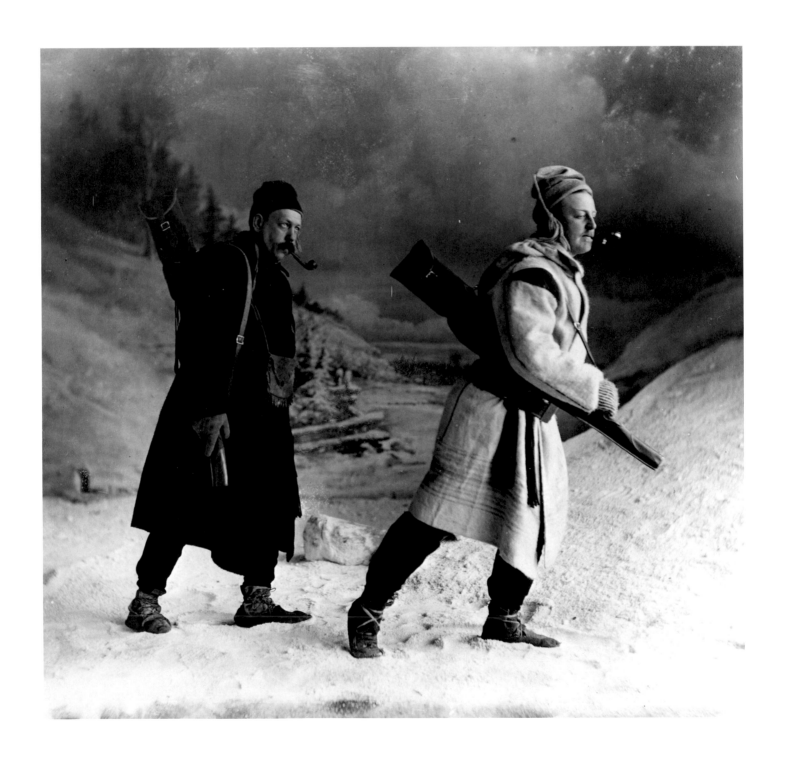

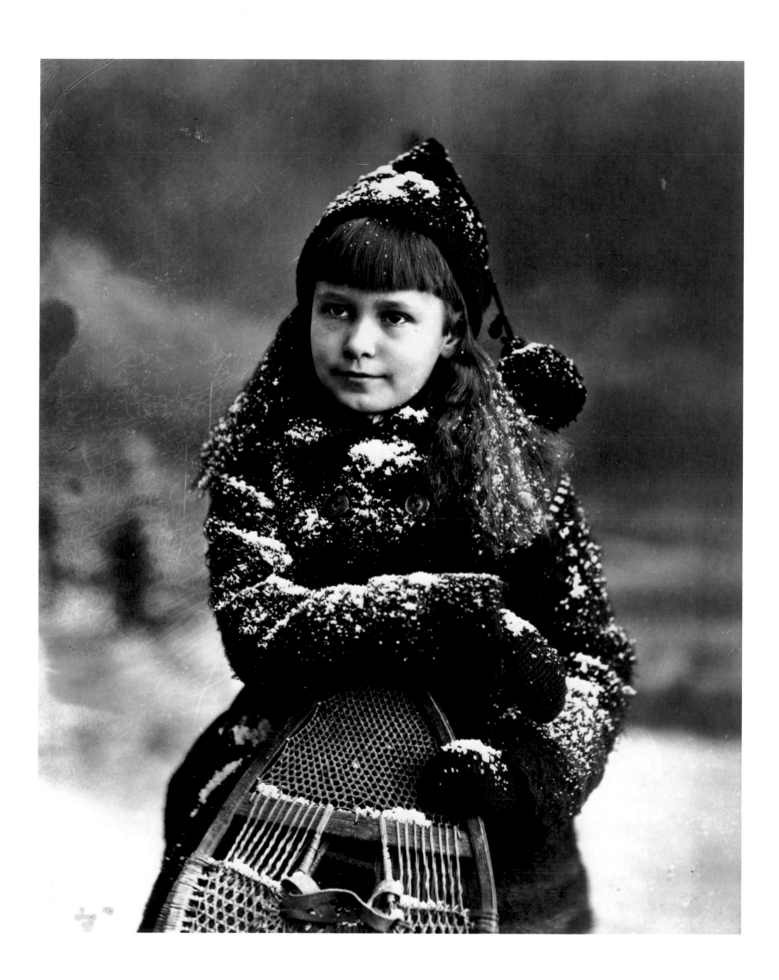

10 BELOW: *Jefferson Davis's children, Montreal, 1867*

Montreal Studio: Portraits

11 OPPOSITE: *Jefferson Davis and wife, Montreal, 1867. Davis was formerly the President of the Confederate States of America. During the American Civil War he sent his wife and children to Canada. When he was released from prison in 1867, he joined his family in Montreal, where they had been living for two years. They left Canada after a general amnesty was declared in 1868.*

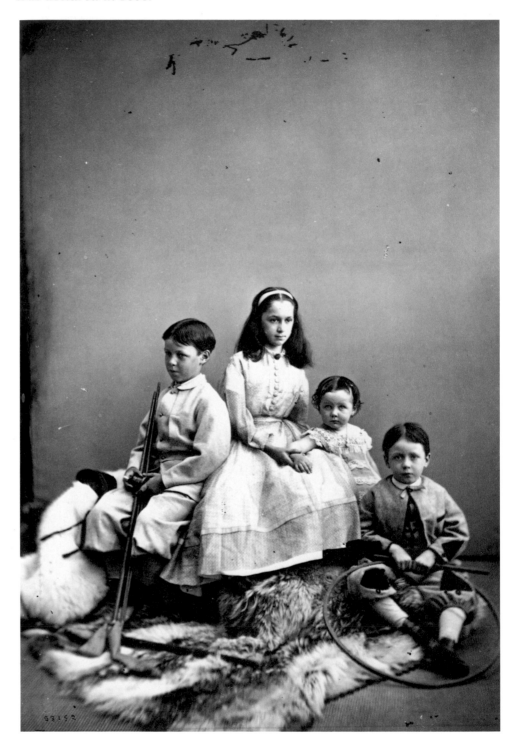

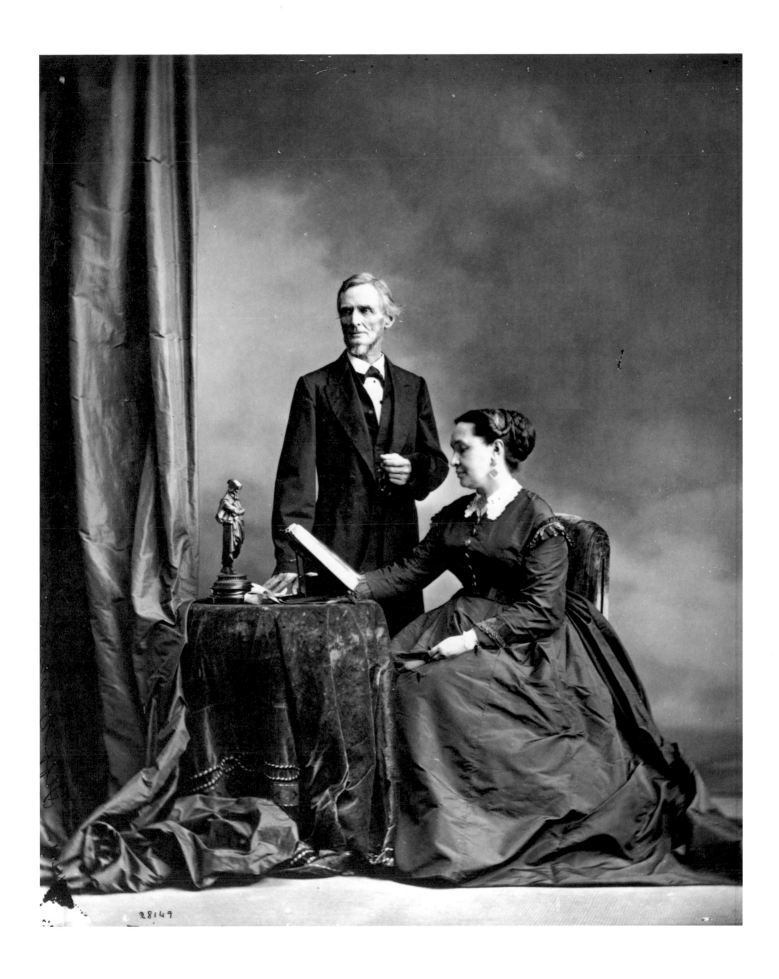

28149

12 BELOW: *Mr. Barnjum's Gymnastic Group, Montreal, 1870. The gymnasts are wearing red Garibaldi blouses, red stockings, and black velvet skirts. Frederick S. Barnjum was professor of physical education at McGill University for twenty-three years. He was one of the founders of the Gymnastic Club, which subsequently developed into the MAAA (Montreal Amateur Athletics Association). An officer of a volunteer militia, the Prince of Wales Rifles, he saw action in the Fenian raids and other border skirmishes. He rose to the rank of major.*

13 OPPOSITE: *Sergeants of the 78th Highlanders, Montreal, 1867. The 78th Regiment of Foot, 2nd Battalion, Seaforth Highlanders, was stationed in Montreal, 1863–69.*

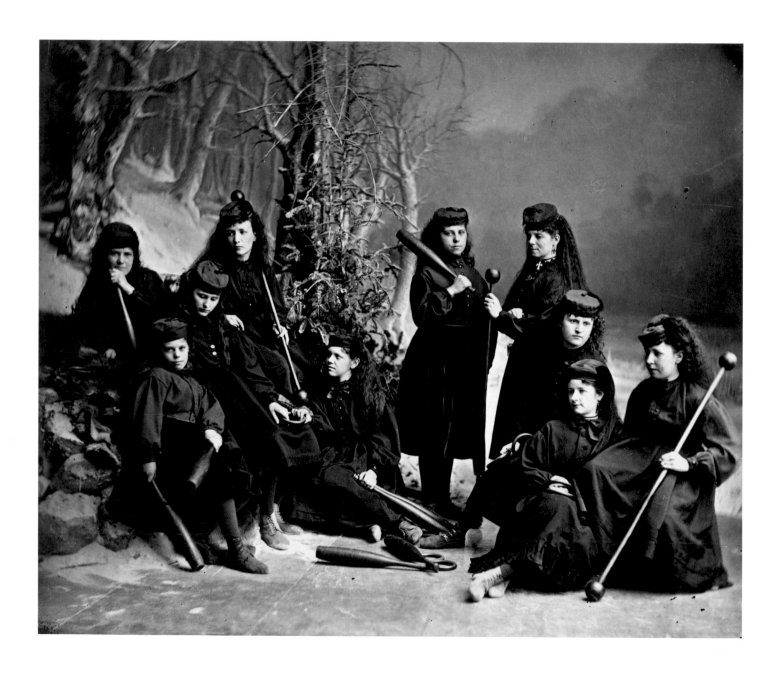

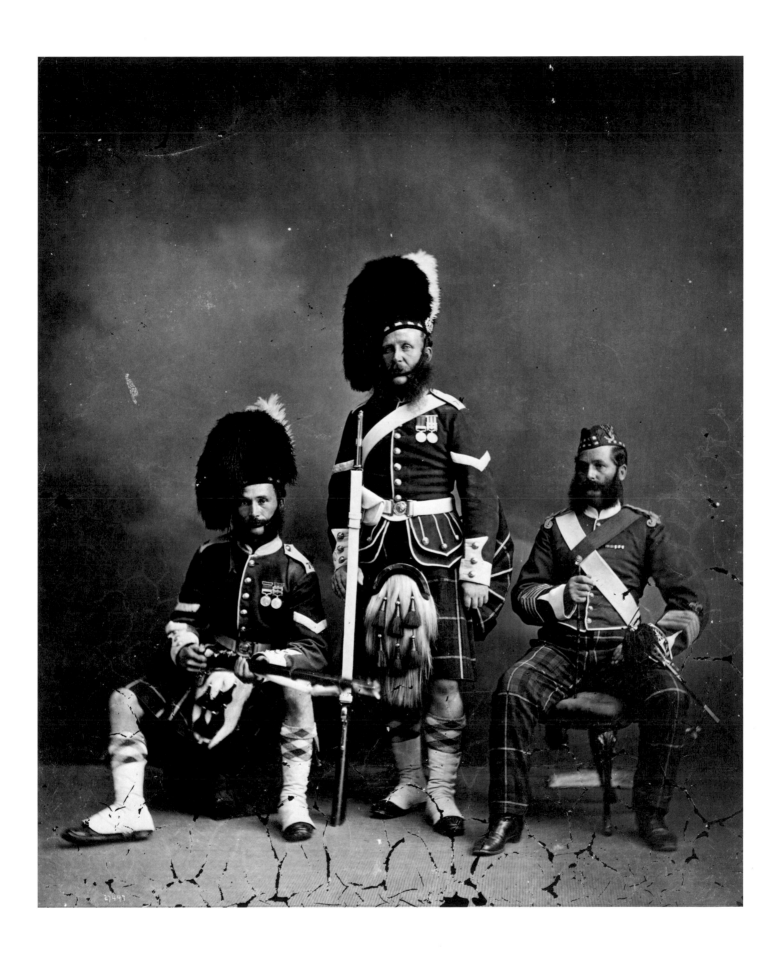

14 BELOW: *Members of Buffalo Bill's Wild West Show, Montreal, 1885.*
Left to right: an interpreter; Crow Eagle; Sitting Bull; Buffalo Bill; Johnny
Baker (billed as "The Cowboy Kid"), a sharpshooter; and the American
naturalist W. H. H. "Adirondack" Murray, who operated a restaurant in
Montreal at the time.

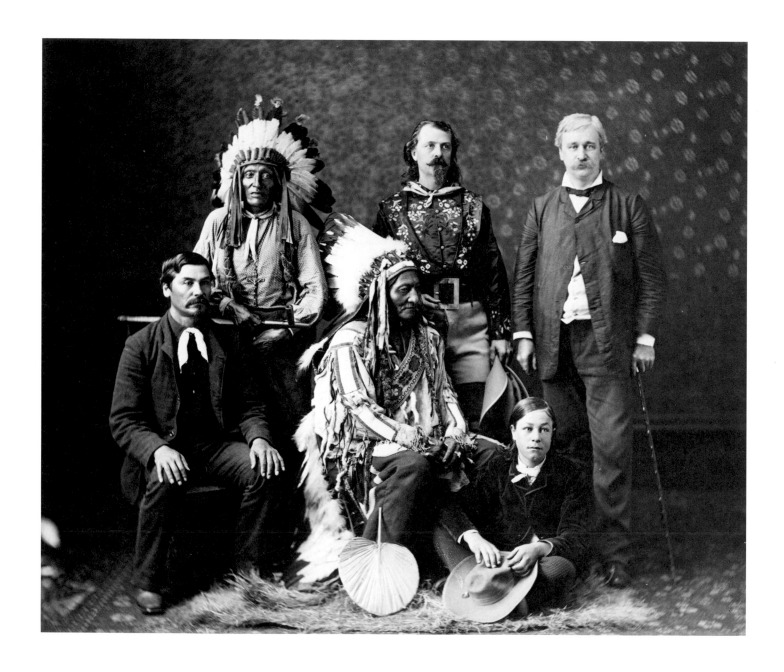

*15 The Stuart Family, Pullman's Island, New York, 1872. George
Mortimer Pullman (1831–1897), founder and president of the Pullman
Palace Car Company, owned an estate on one of the Thousand Islands in
the Upper St. Lawrence River, west of Alexandria Bay. William Notman
made a series of thirty photographs of the Pullman family and their friends,
as well as of the house and grounds. This is the only surviving photograph.*

taken in Notman's Bleury Street studio in preparation for this composite photograph.

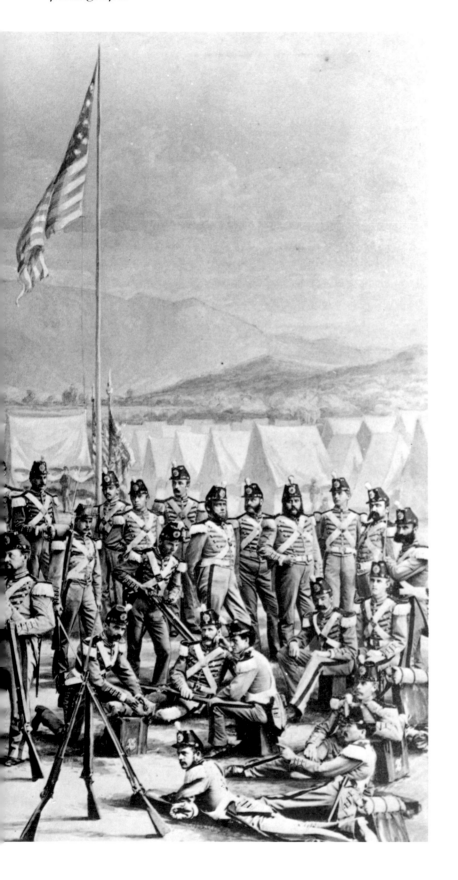

18 *Master Redpath, Montreal, 1880. The Redpath family were prominent Montreal sugar manufacturers and public benefactors, especially of McGill University.*

*19 View from Notre Dame Church, Montreal, 1863. Looking east
over the St. Lawrence River and St. Helen's Island.*

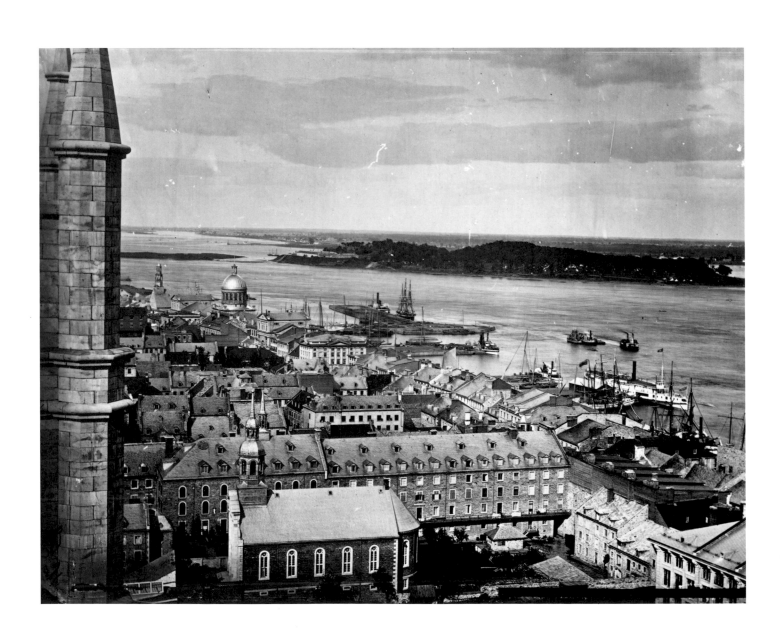

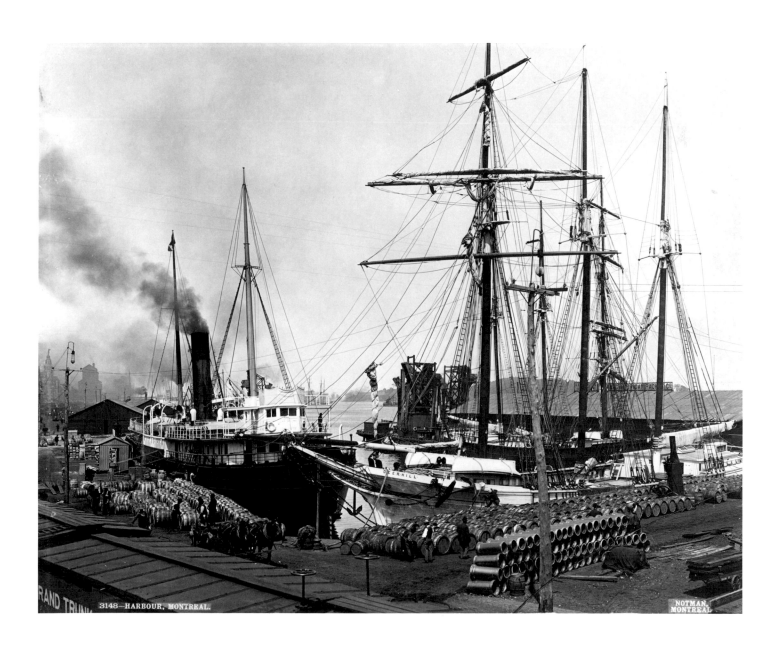

21 BELOW: *Place d'Armes, showing the New York Life Insurance
Building and Notre Dame Church, c. 1887*

22 OPPOSITE: *Main Hallway at Terrace Bank, residence of
John Redpath, Montreal, c. 1866. John Redpath founded the Redpath
Sugar Company in 1854 .*

Montreal Studio: Views
Across Canada

23 Royal Artillery at Hochelaga, near Montreal, 1870. The view shows the frozen St. Lawrence River and Saint Helen's Island in the background.

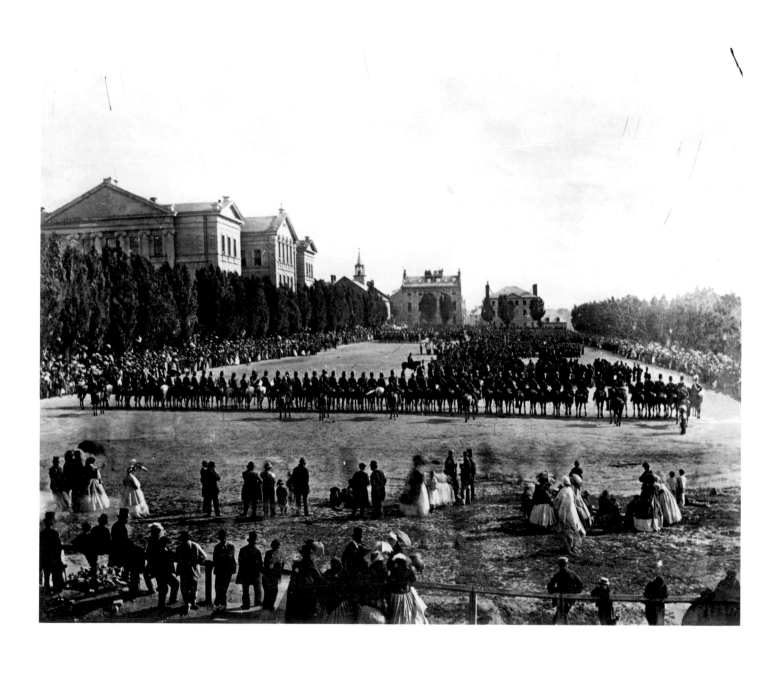

*25 Temporary fill and spur line to service the construction of
Victoria Bridge, Montreal, 1858-59*

27 *Street railway crossing under construction, corner of St. Catherine and St. Lawrence streets, Montreal, 1893*

29 BELOW: *Harbour and Lower Town, Quebec City, on the occasion
of the tercentenary of its founding, 1908*

30 OPPOSITE: *View of harbour and Château Frontenac, Quebec
City, c. 1895*

QUEBEC & LEVIS FERRY

SOUTH

2786. CHATEAU FRONTENAC QUEBEC.

NOTMAN,
MONTREAL

31 Old Indian Church, Tadoussac, c. 1895. The church was built in 1747.

32 Murray Village (La Malbaie), Lower St. Lawrence River, 1899. William McFarlane Notman's son Keith is in the cart.

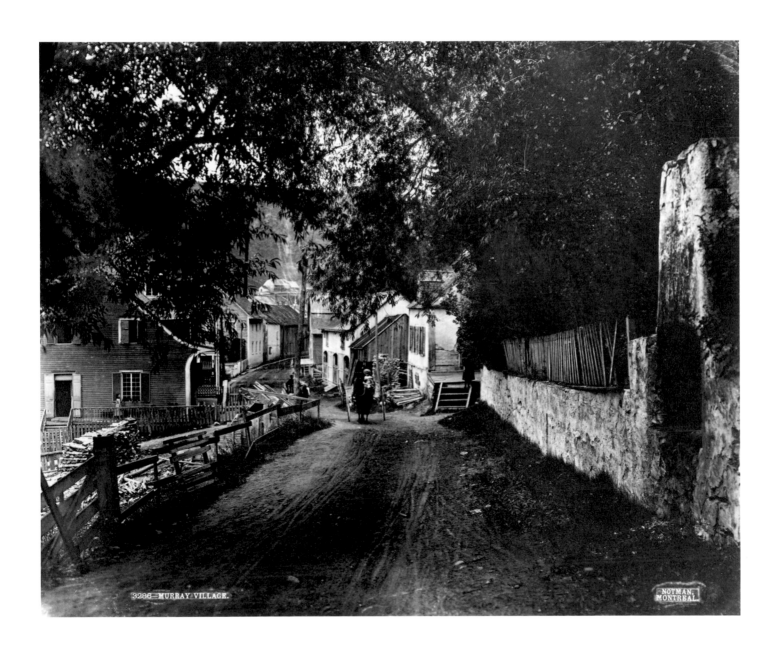

*33 Wilfred Rotte's farm, St. Jérôme, Lake St. John District,
Quebec, c. 1906*

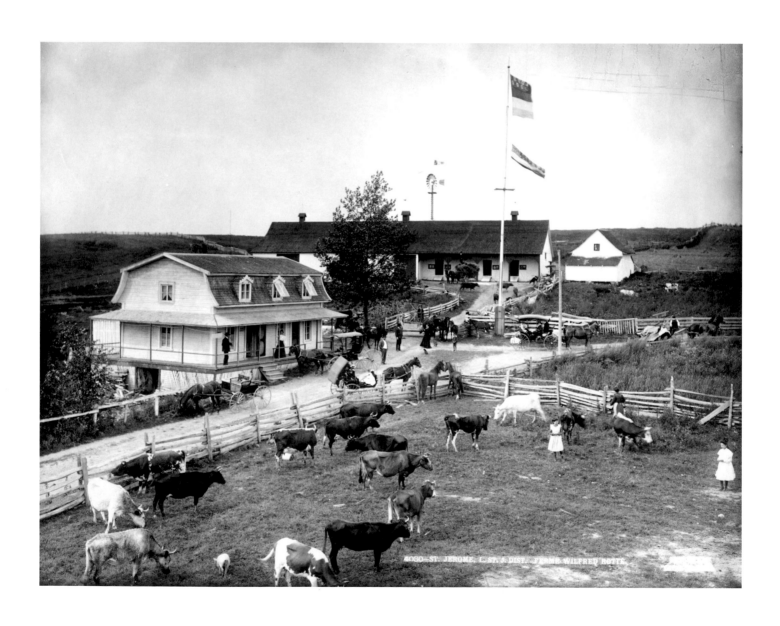

Montreal Studio: Views
Across Canada

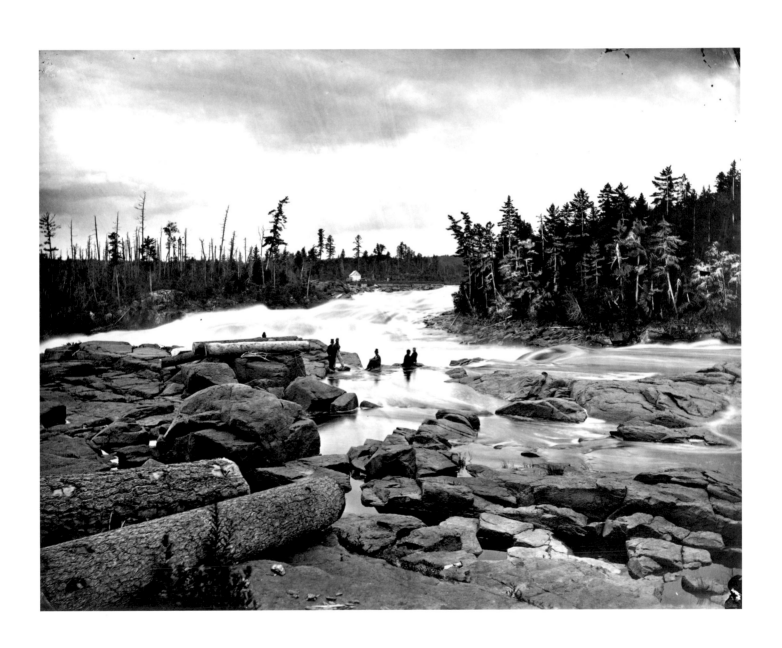

35 *View from Trinity Church, looking west, Saint John,
New Brunswick, 1870*

Montreal Studio: Views
Across Canada

ST. JOHN N.B FROM TRINITY CHURCH, LOOKI

Montreal Studio: Views
Across Canada

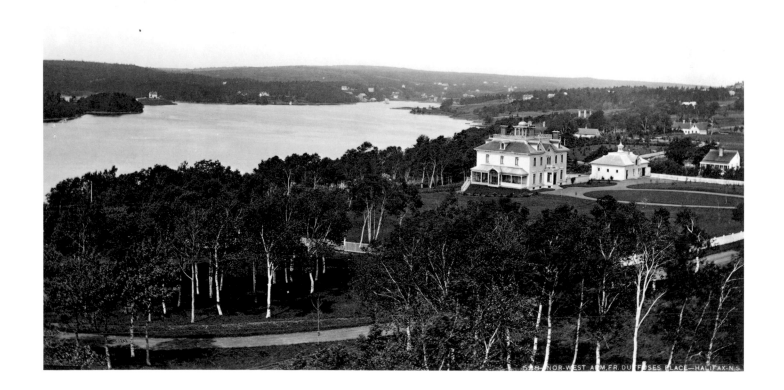

Montreal Studio: Views
Across Canada

37 BELOW: *Birchy Cove, Bay of Islands,*
Newfoundland, 1908

38 OPPOSITE: *Tilt Cove, Notre Dame Bay,*
Newfoundland, 1908

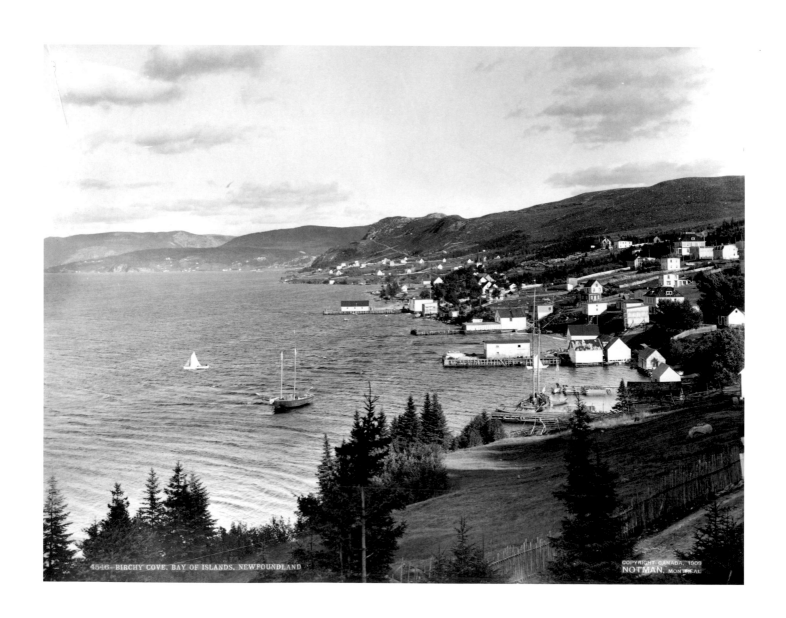

39 TOP: Mountain Maid *steamer, Capt. Fogg, on Lake Memphremagog,
Eastern Townships, Quebec, 1860*

40 BOTTOM: *From cupola of City Hall, with Fort Henry and harbour,
Kingston, Ontario, 1860*

Montreal Studio: Views
Across Canada

42 *Parliament buildings from Nepean Point, Ottawa,
Ontario, c. 1878*

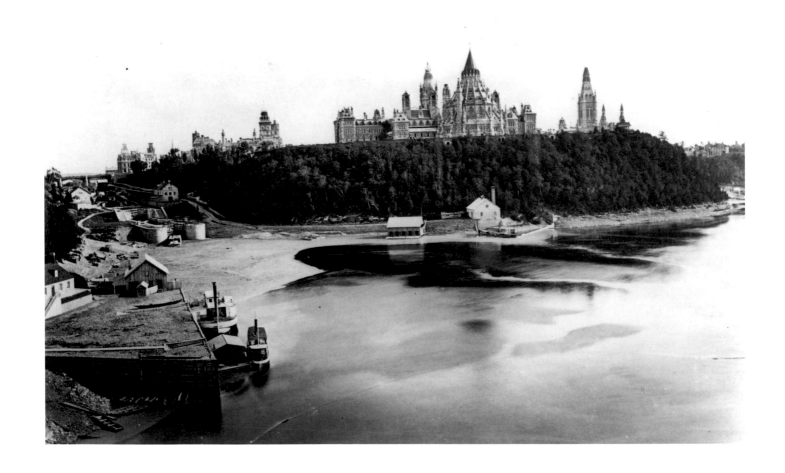

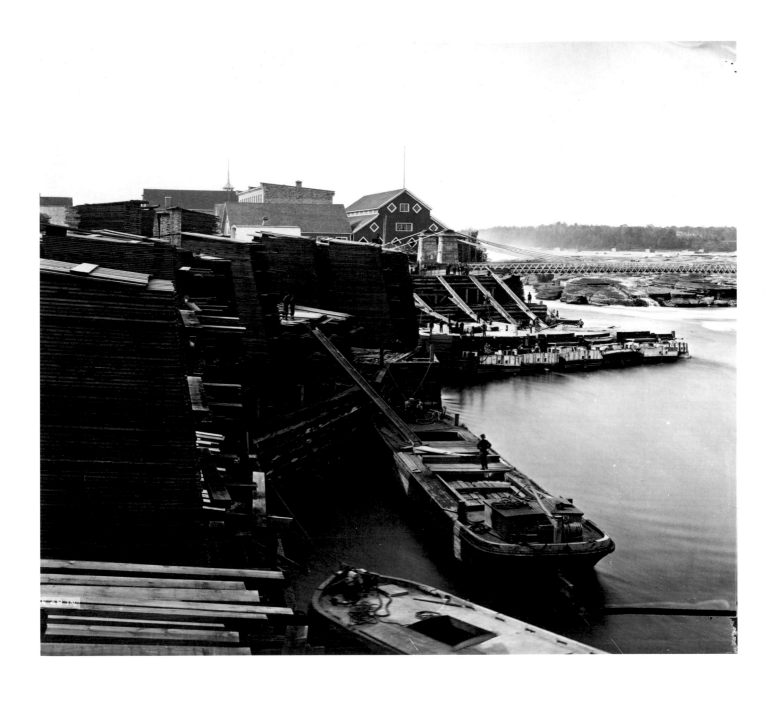

44 Post Office, Toronto Street, Toronto, 1868

45 Ontario Bank, Wellington Street, Toronto, 1868

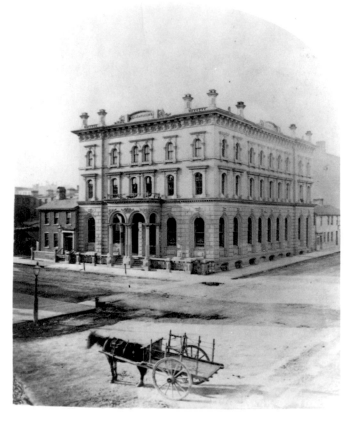

46 Bank of Toronto, Toronto, 1868

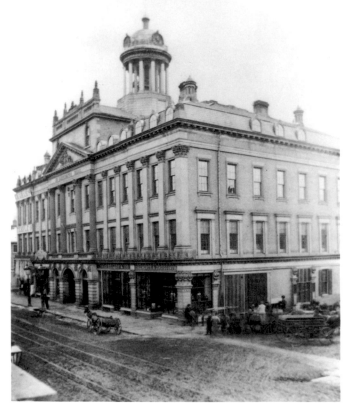

47 St. Lawrence Hall, King Street, Toronto, 1868

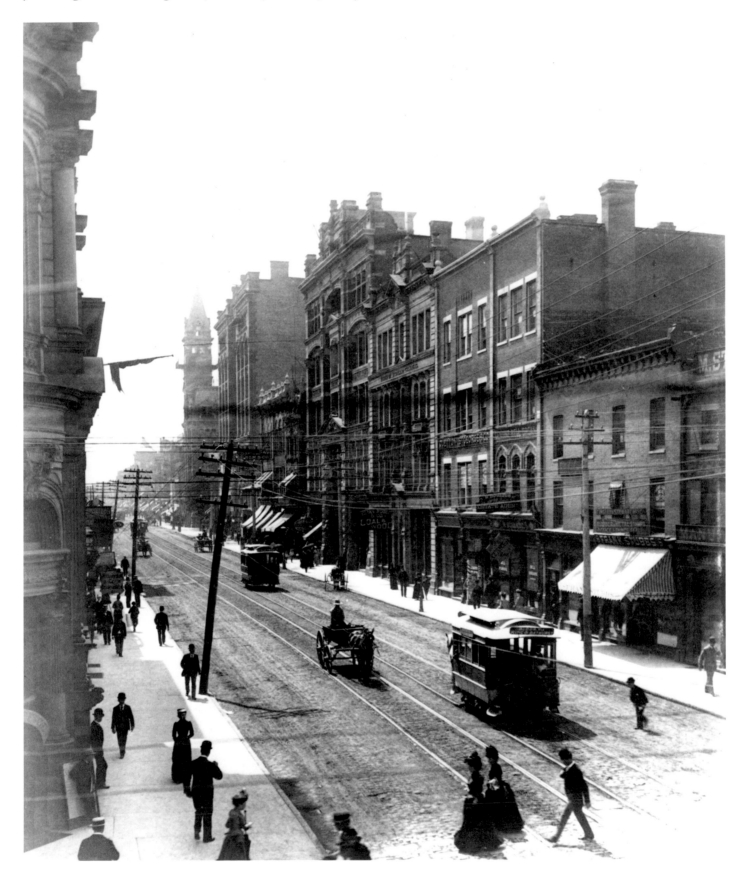

49 BELOW: *American falls taken from Niagara Falls, Ontario, 1869*

50 OPPOSITE: *Suspension bridge over Niagara River, Niagara Falls, Ontario, 1869*

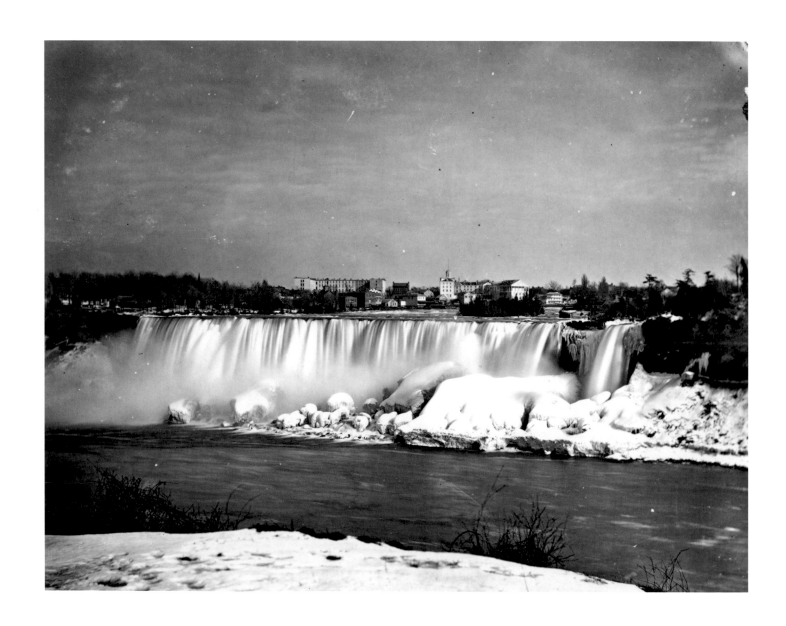

51 *Holy Trinity Church, St. Mary's Avenue, Winnipeg, Manitoba, 1884*

Montreal Studio: Views
Across Canada

52 Main Street, Winnipeg, Manitoba, 1884. With the arrival of the Canadian Pacific Railway, Winnipeg turned overnight into a major railway, industrial, and agricultural centre.

Montreal Studio: Views
Across Canada

53 OPPOSITE: *Kuskita au Musqua (Black Bear). Cree woman near Calgary, Alberta, 1887.*

54 BELOW: *Indian dance, Blackfoot reserve near Calgary, Alberta, 1889*

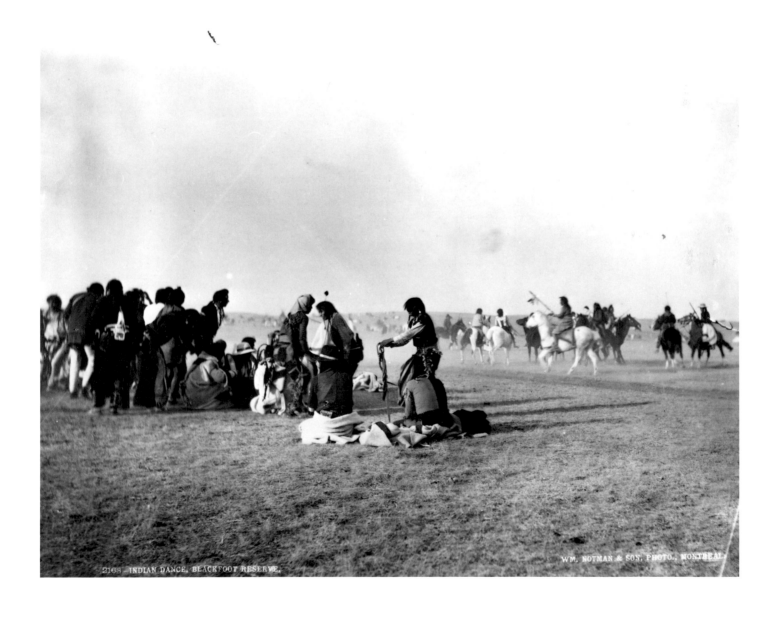

Montreal Studio: Views
Across Canada

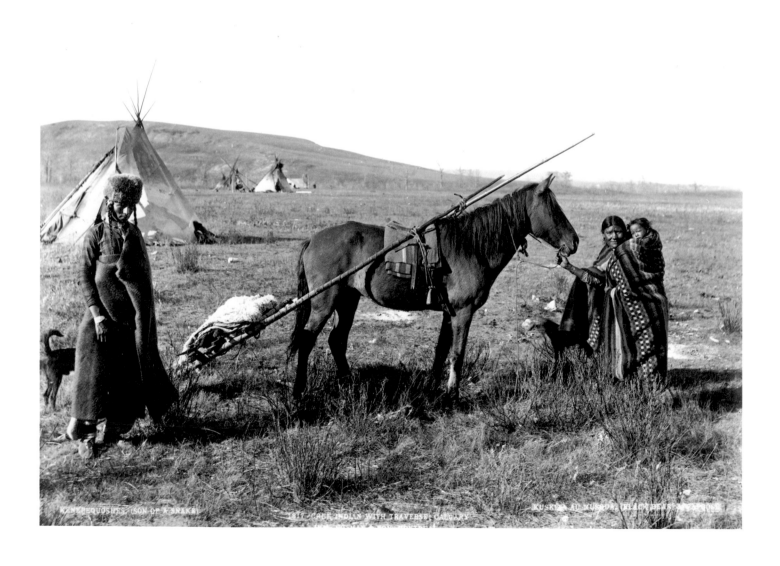

56 BELOW: *Branding calves, Bow River Horse Ranch, Cochrane, Alberta, 1904. Established in 1881 as the Cochrane Ranch by Senator M. H. Cochrane, by 1888 it was known as the Bow River Horse Ranch, and in 1894 it was bought by G. E. Goddard, the former manager.*

Montreal Studio: Views
Across Canada

57 *Canadian Pacific Railway bridge over South Saskatchewan River, Medicine Hat, Alberta, 1884. The steamers* Baroness *and* Minnow *are in the foreground. The* Baroness *was built by Alexander Galt to haul barges from his newly established coal mines near Lethbridge. In 1885 she carried troops to help quell the North-West Rebellion.*

1376—MEDICINE HAT BRIDGE SASKATCHEWAN RIVER

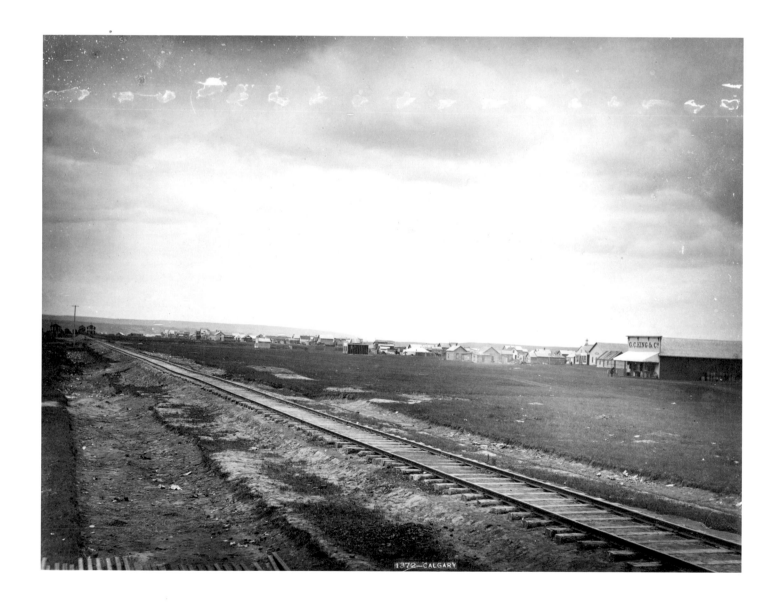

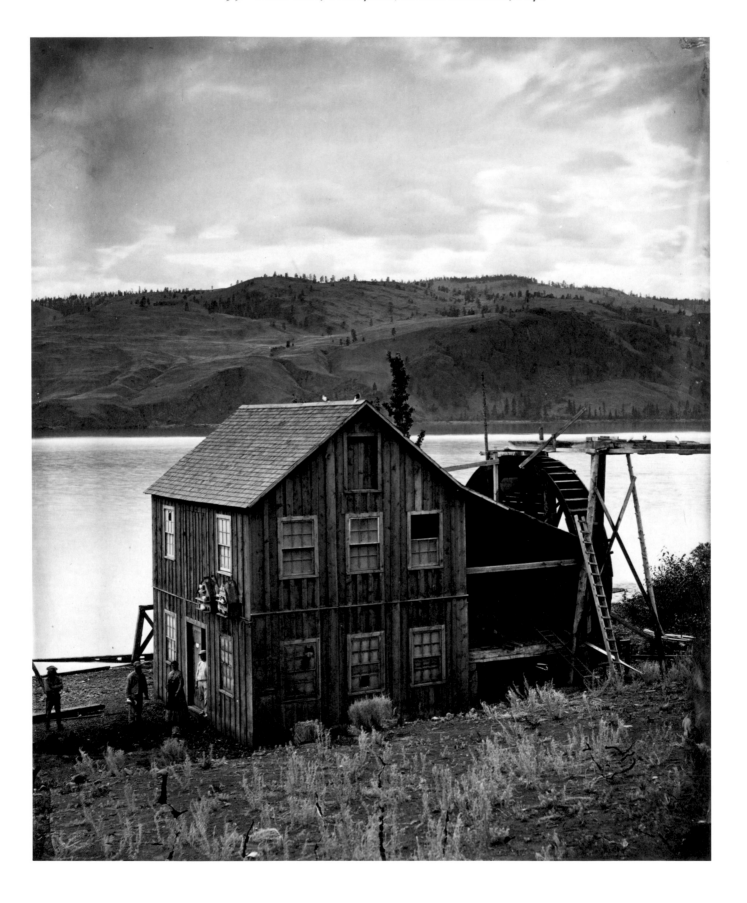

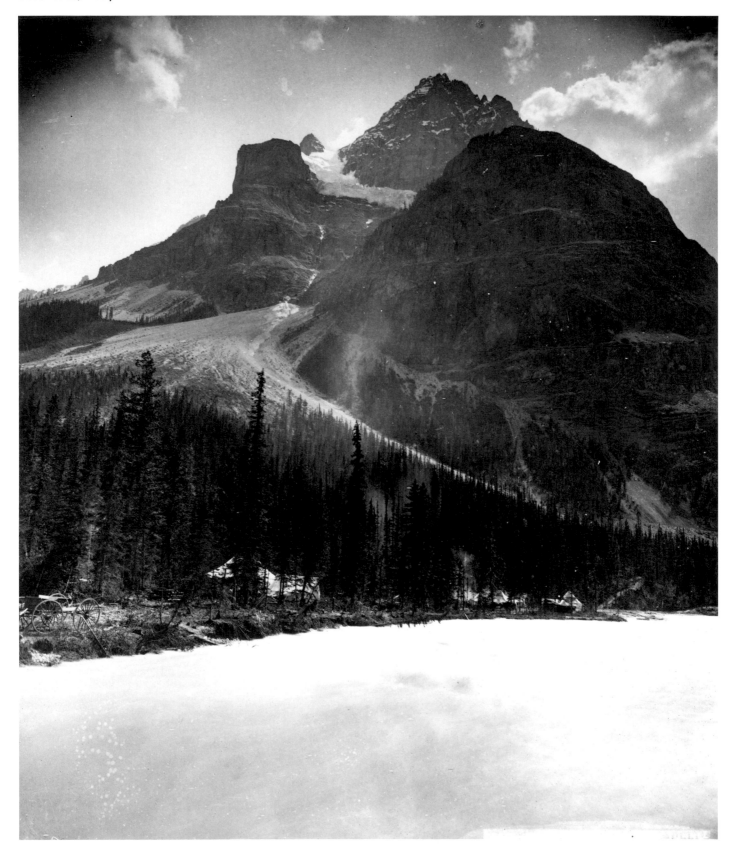

61 BELOW: *Mountain Creek Bridge, Glacier Park, British Columbia, 1897. Fed by a mountain stream, the hydraulic "monitor" is being used to transport gravel and earth to form an embankment under the end of the bridge.*

62 OPPOSITE: *Cariboo Road bridge above Spuzzum, British Columbia, 1887. The bridge to the Cariboo goldfields was built over the Fraser River by Joseph Trutch in 1864. The Canadian Pacific Railway line can be seen in the background.*

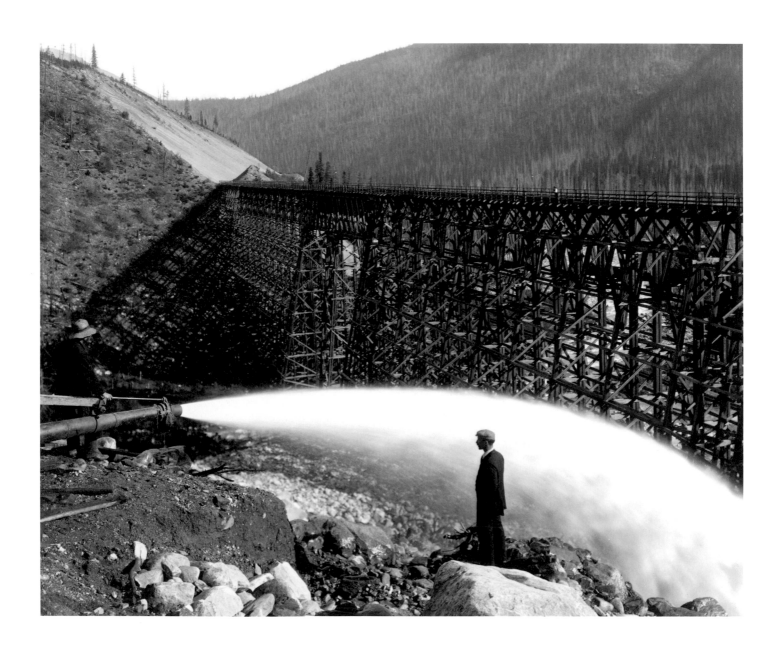

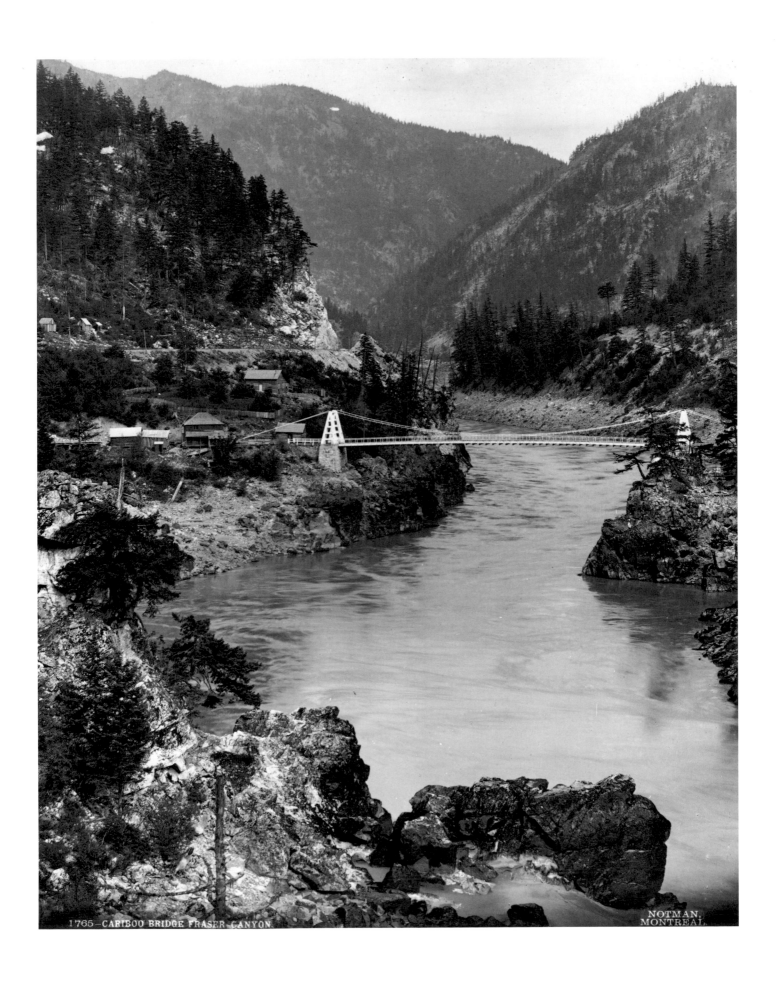

1765—CARIBOO BRIDGE FRASER CANYON.

NOTMAN,
MONTREAL.

63 Lytton, British Columbia, 1887. The settlement was at the fork of the Fraser and Thompson rivers.

Montreal Studio: Views
Across Canada

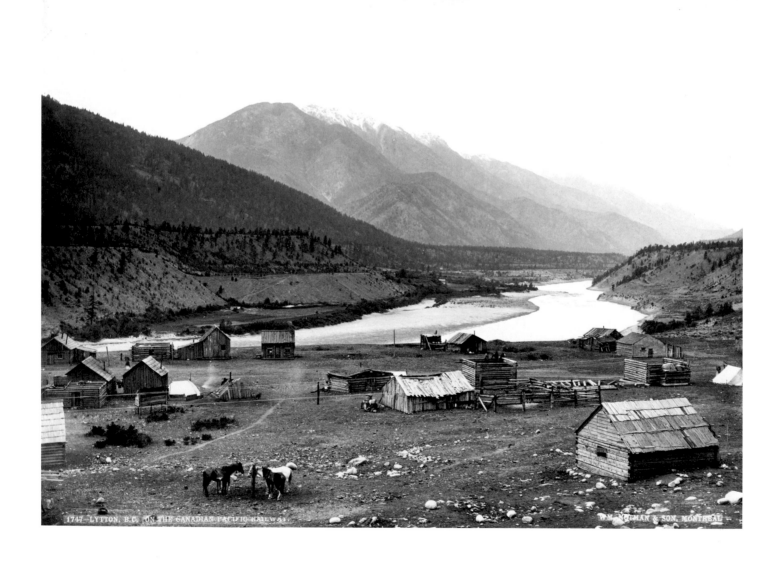

*64 Great cedar tree, Stanley Park, Vancouver, British Columbia, 1897.
Mrs. William McFarlane Notman is posing for the picture.*

Montreal Studio: Views
Across Canada

Montreal Studio: Views
Across Canada

2141—C. P. R. DOCKS, VANCOUVER, WM. NOTMAN & SON, PHOTO., MONTREAL.

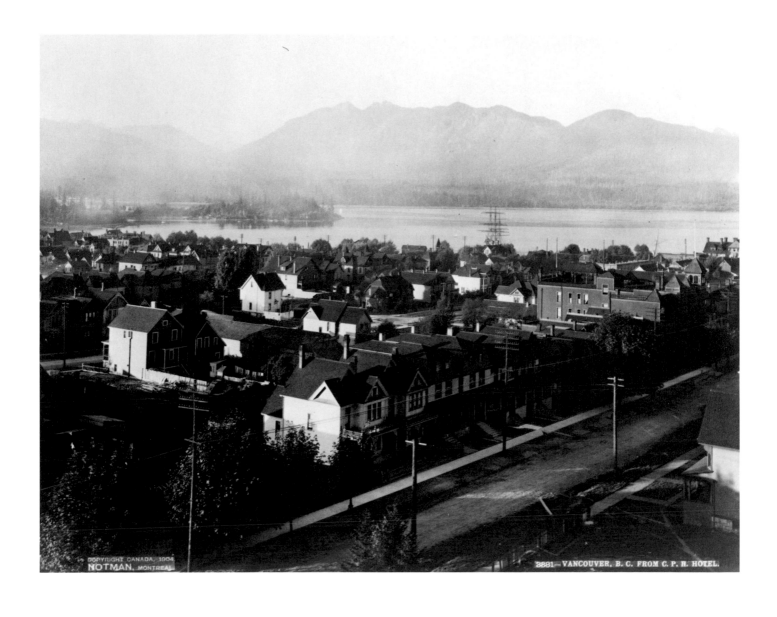

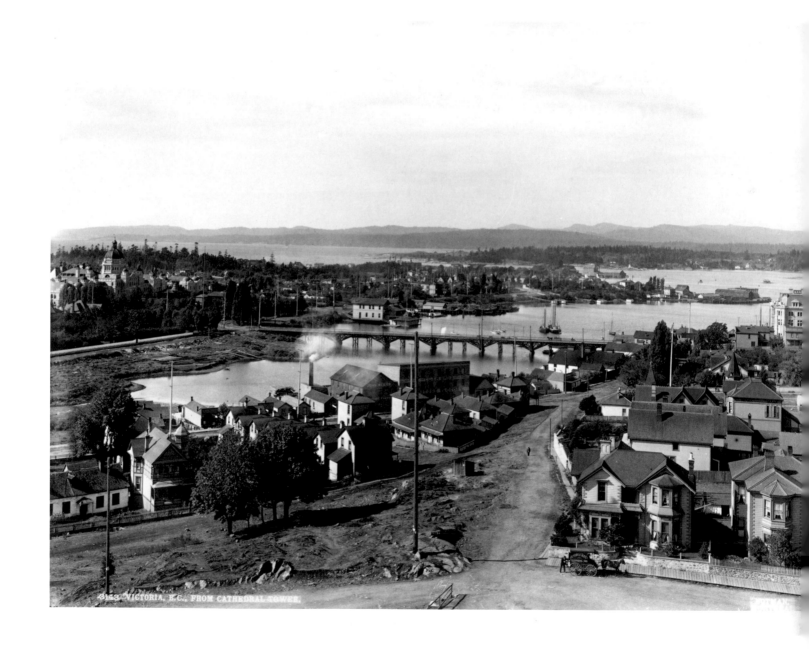

3143 VICTORIA, B.C., FROM CATHEDRAL TOWER.

67 *View from the Anglican cathedral tower, Victoria, British Columbia,*
1897. This panorama was made from two 8 x 10 negatives.

Montreal Studio: Views
Across Canada

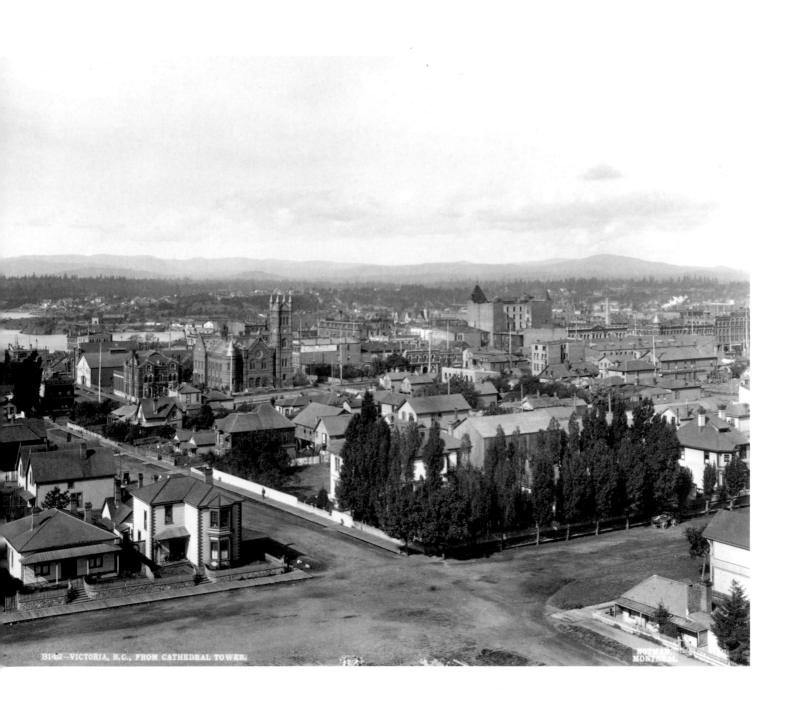

3142—VICTORIA, B.C., FROM CATHEDRAL TOWER.

68 *Lumber barges and steam tug* Aid, *Ottawa, Ontario, c. 1875*

Ottawa Studio

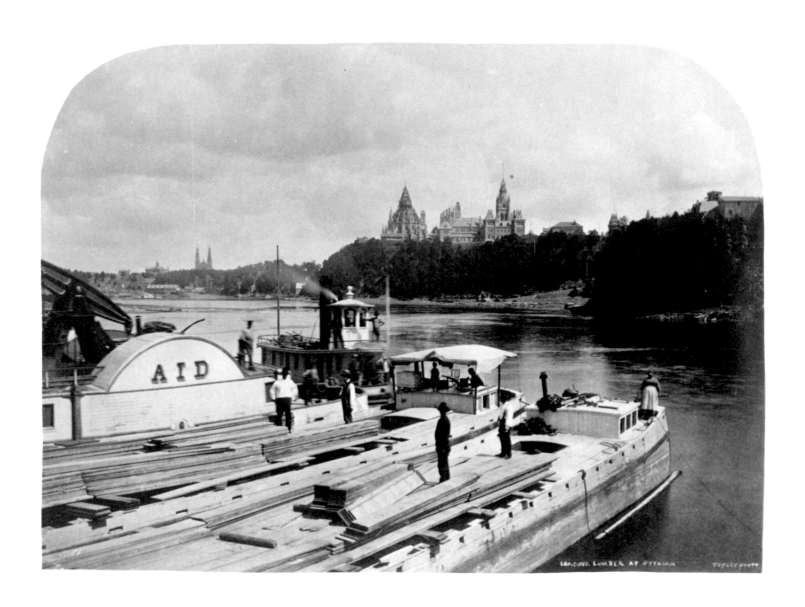

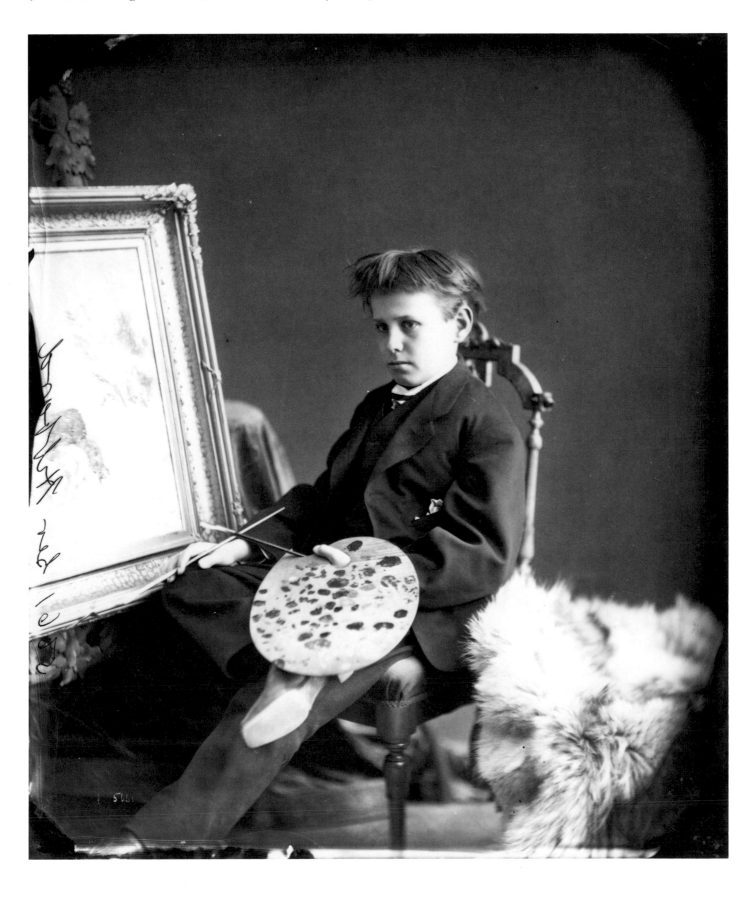

Ottawa Studio

70 *The Honourable Joseph Howe, c. 1873. Howe was born in 1804 in Halifax, and died there in 1873. Newspaperman, politician, and statesman, he became Premier of Nova Scotia in 1860, Secretary of State in Ottawa in 1869, and Lieutenant-Governor of Nova Scotia in 1873.*

Ottawa Studio

72 *Daniels' Hotel, corner of Queen and Metcalfe streets, Ottawa, Ontario,*
c. 1875. After enlarging and refurnishing the hotel, the proprietor,

Ottawa Studio

S. Daniels, renamed it Windsor House.

*73 Servants group, Belmere, Lake Memphremagog, Quebec, 1870. This
was taken during the visit of Prince Arthur to the estate of Hugh Allan, the
founder of Allan's Steamship Lines.*

Ottawa Studio

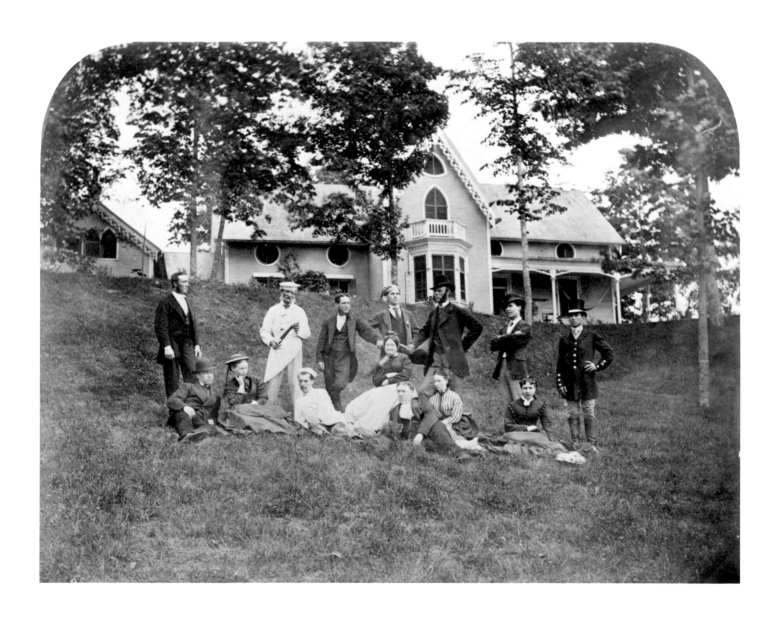

74 BELOW: *Chaudière Falls, Ottawa, Ontario, c. 1870*

Ottawa Studio

75 OPPOSITE: *Sandford Fleming, Ottawa, Ontario, c. 1870. Born in Scotland and educated there as a civil engineer, he made his career in Canada as a railway engineer and surveyor. In 1871 he was appointed engineer-in-chief for the Canadian Pacific Railway, superintending the explorations and surveys for the best route to the Pacific. He later invented the Standard Time system and pioneered its use. He received a knighthood in 1897.*

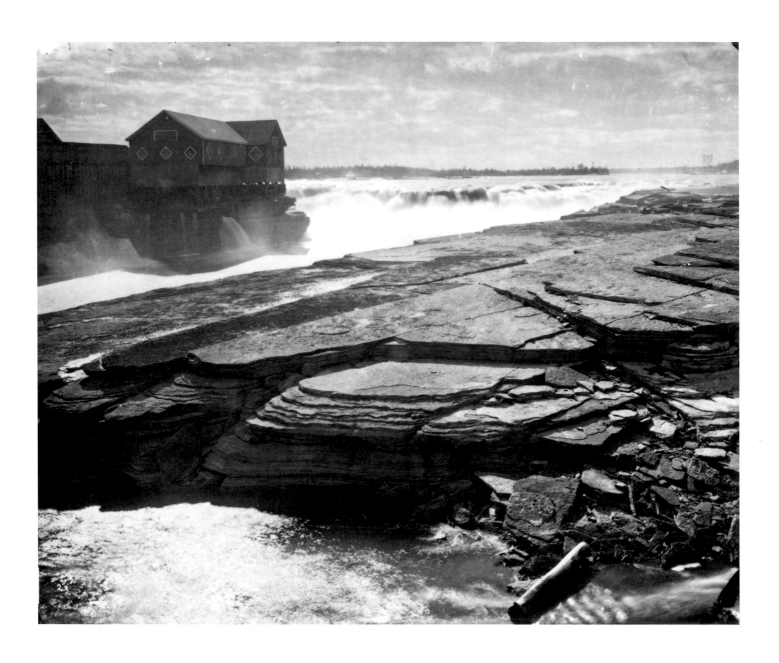

Toronto Studio

76 *Lord Dufferin, Toronto, 1872. Frederick Temple Blackwood, the 1st Marquis of Dufferin and Ava, was Governor General of Canada, 1872 to 1878.*

Published by special permission of His Excellency Earl Dufferin, Gov.-General.
Copyright secured and entered according to Act of Parliament—Canada 1872.

NOTMAN & FRASER TORONTO, ONT,
PHOTOGRAPHERS TO THE QUEEN.

COPYRIGHT

Published by special permission of His Excellency Earl Dufferin, Gov.-General.
Copyright secured and entered according to Act of Parliament—Canada 1872.

NOTMAN & FRASER TORONTO, ONT,
PHOTOGRAPHERS TO THE QUEEN.
COPYRIGHT·

Toronto Studio

78 BELOW: *The Denison family, on the steps of "Rusholme," Toronto, 1871. George Taylor Denison III (centre in profile), a native of Toronto, was an internationally known lawyer, magistrate, soldier, military historian, and author. He commanded his own cavalry troupe in the Fenian Raids and the North-West Rebellion.*

79 OPPOSITE: *Lieutenant-General Sir Charles Hastings Doyle, Toronto, 1873. Doyle was commander of the British troops in Nova Scotia during the U.S. Civil War, and subsequently became that province's Lieutenant-Governor from 1867 to 1873.*

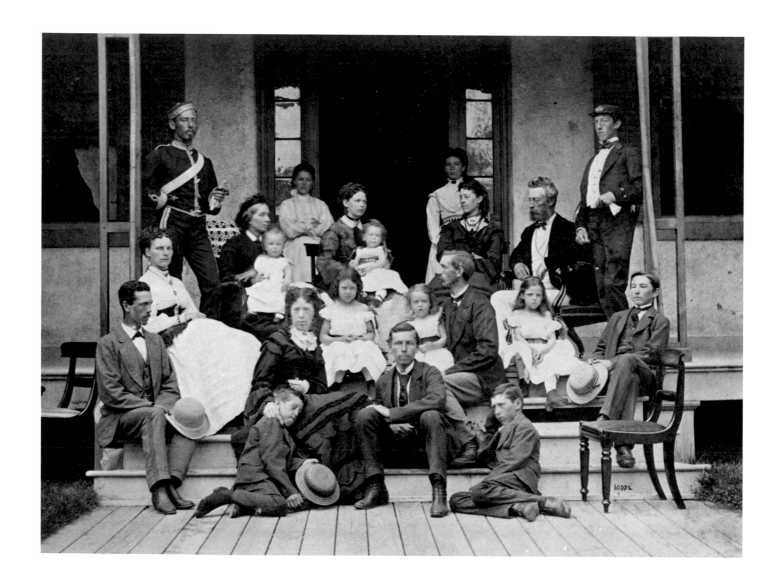

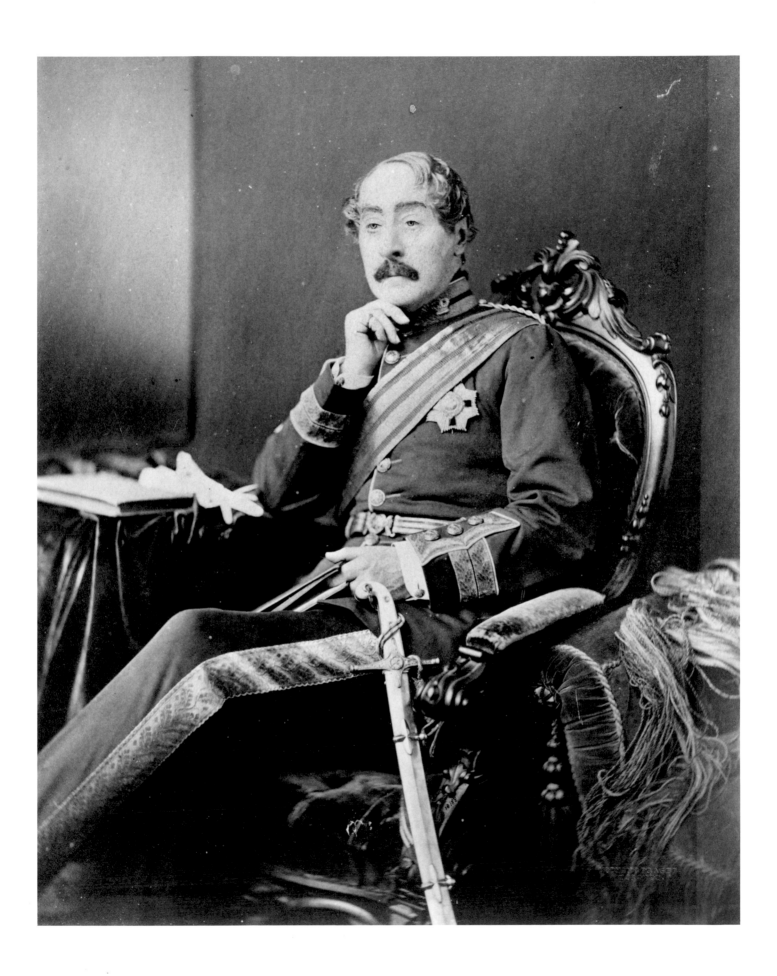

80 *The Toronto Safe Works, J. & J. Taylor Manufacturers, 117 Front Street East, Toronto, c. 1875*

Toronto Studio

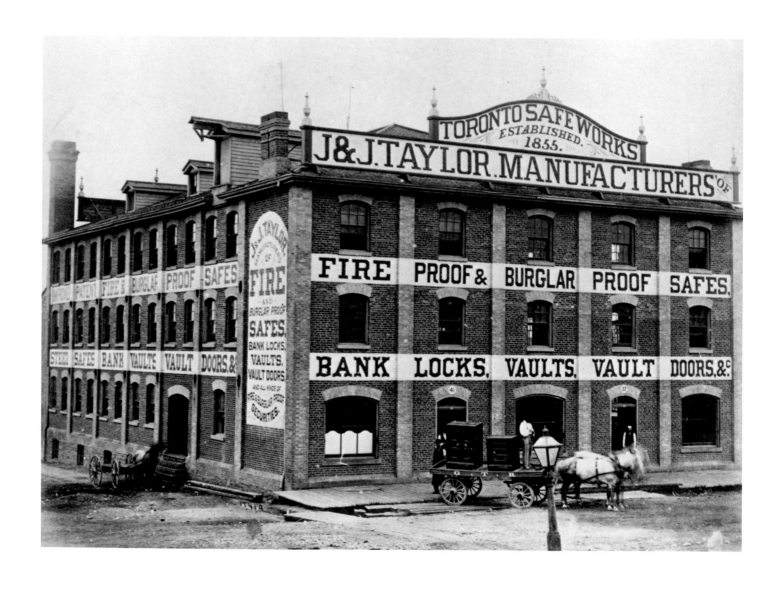

*83 Hollis Street, looking south from the northeast corner of George Street,
Halifax, Nova Scotia, c. 1880*

Halifax Studio

84 *Lady Clanwilliam's tennis group, Admiralty House, Gottingen Street,*
Halifax, Nova Scotia, c. 1886. Richard James Meade, the Earl of
Clanwilliam, Vice-Admiral in the Royal Navy, was Commander-in-Chief on
the North American and West Indies station, 1885 to 1886.

Halifax Studio

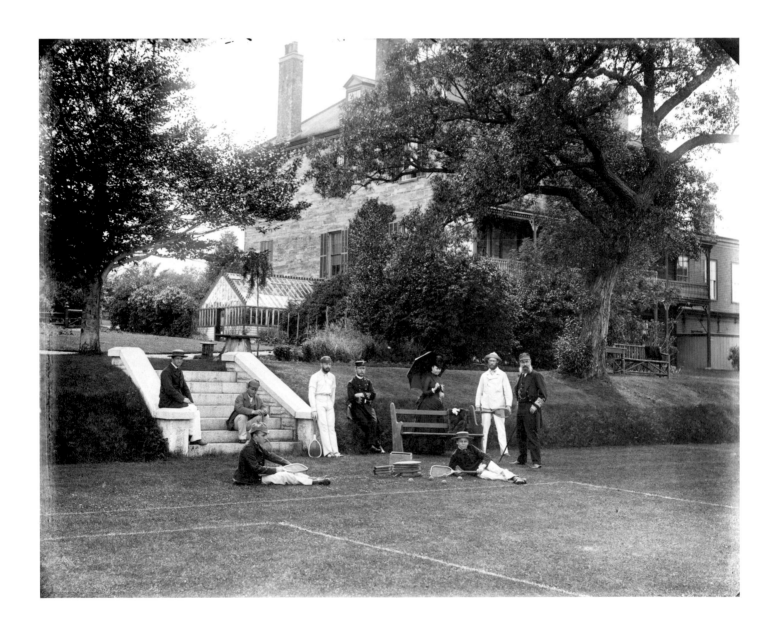

Halifax Studio

87 BELOW: *Miss Beatrice Whidden, Halifax, Nova Scotia, c. 1880*

Halifax Studio

88 OPPOSITE: *HRH Prince George, Halifax, Nova Scotia, 1883. Second son of Queen Victoria, he arrived in Halifax in 1883 as a midshipman on* HMS Canada. *He was later to become King George V.*

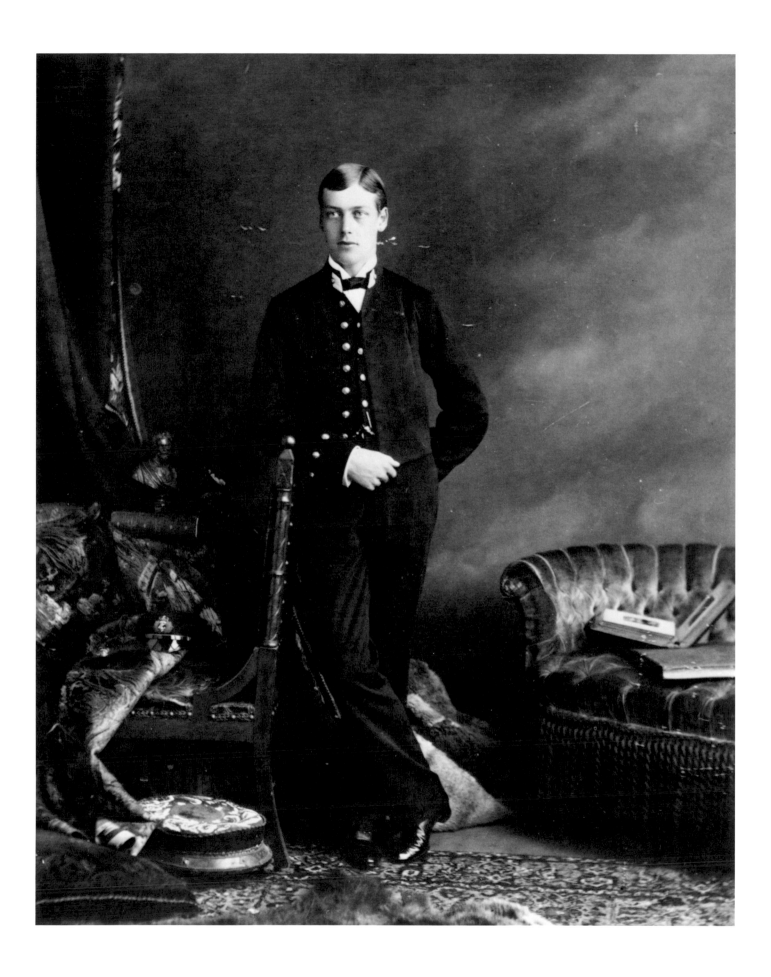

89 *Intercolonial Railway passenger station at North Street, Halifax, Nova Scotia, c. 1876. Erected in 1876, it was destroyed by the great explosion on December 6, 1917.*

Halifax Studio

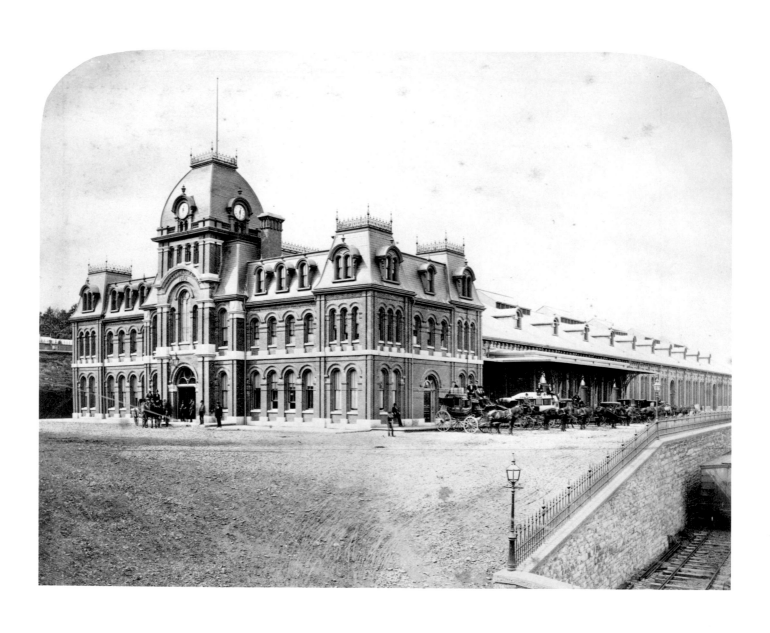

91 *The Bedford Hotel, Bedford, Nova Scotia, 1889. Built on Bedford Basin by Thomas Getz Maurice, it was first named Bellevue House. When sold in 1870, it was named the Bedford Hotel. Under new ownership in 1880, it became the Claremount and, on further sale in 1889, it took back its former name.*

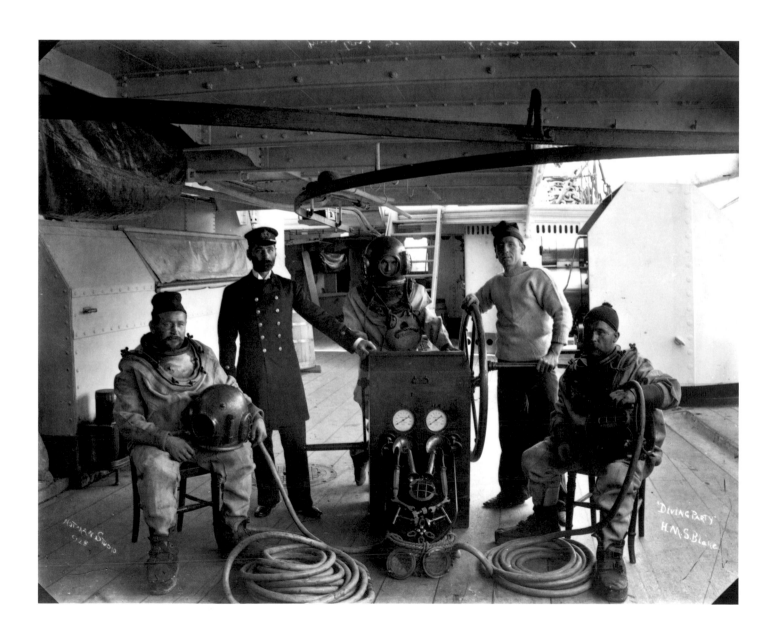

St Mary's Cathedral & Glebe House

NOTMAN 12381

93 OPPOSITE: *St. Mary's Cathedral and Glebe House, mid-1890s. The Roman Catholic church and presbytery stood on the corner of Spring Garden Road and Barrington Street, Halifax, Nova Scotia.*

94 BELOW: *Mr. J. E. Binney's bridal party and guests, Halifax, Nova Scotia, early 1880s*

157 ❦

Halifax Studio

*95 William Cunard's residence, North-West Arm, Halifax, Nova Scotia,
c. 1870. William was the youngest son of Samuel Cunard, founder of Cunard
Steamship Line.*

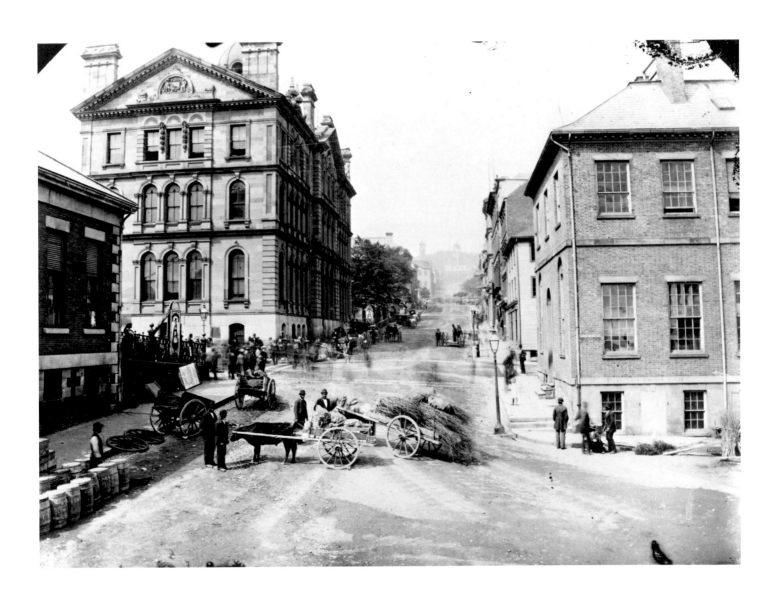

97 TOP: *Fishing boats, foot of King Street, Saint John, New Brunswick, 1872-77*

98 BOTTOM: *Harbour tugs, Saint John, New Brunswick, 1872-77*

99 TOP: *Calvin Church and St. John's Stone Church, Carleton Street, Saint John, New Brunswick, 1872-77*

100 BOTTOM: *Prince William Street, Saint John, New Brunswick, 1872-77*

Saint John Studio

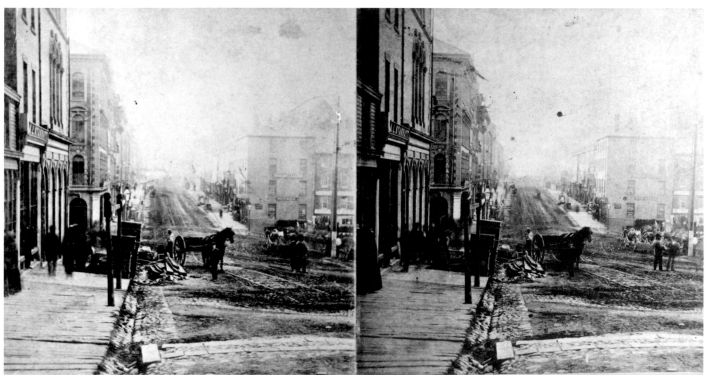

Saint John Studio

101 TOP: *Christ Church Cathedral, Fredericton, New Brunswick, 1872-77*

102 BOTTOM: *Queen Street, Fredericton, New Brunswick, 1872-77*

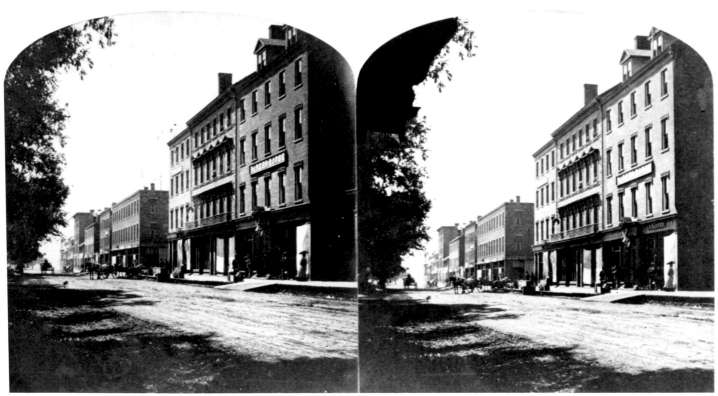

*103 RIGHT: Mrs. W. W. Turnbull, Saint John,
New Brunswick, 1872-77*

*104 BOTTOM LEFT: Edwin Daniel, Saint John,
New Brunswick, 1872-77*

*105 BOTTOM RIGHT: Henry Thorne and W. D. Forster,
Saint John, New Brunswick, c. 1872*

Saint John Studio

106 *Victoria Hotel, corner of Germain and Duke streets, Saint John, New Brunswick, 1872-77*

Saint John Studio

108 Harvard and McGill football match, Montreal, 1874. The games of American and Canadian football developed through matches played between Harvard and McGill colleges. This composite photograph was put together in the Montreal studio.

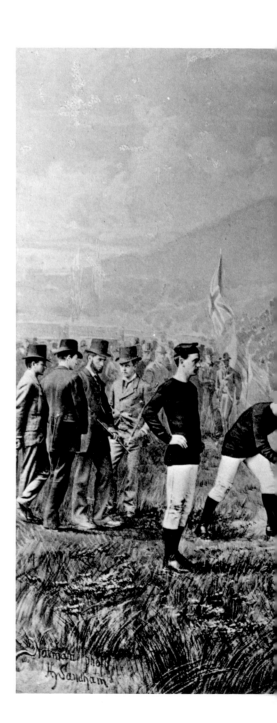

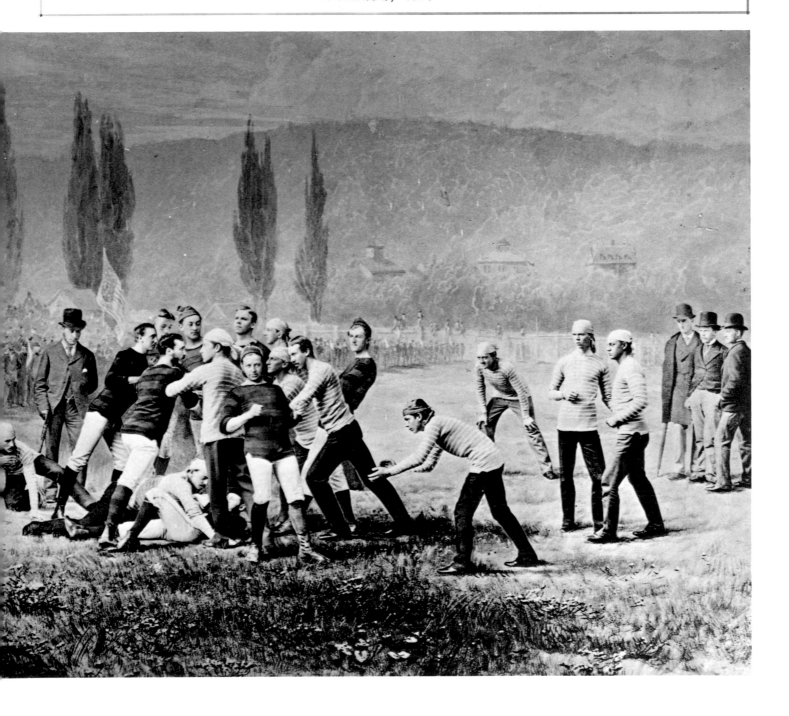

1 R. L. McDonnell
2 A. F. Ritchie
3 J. S. McLennan
4 Walker Hartwell
5 David Rodger (Capt.) M.
6 H. W. Thomas H.
7 Morton Prince H.
8 F. C. Henshaw M.
9 O'Hara Baynes M.
10 R. Huntingdon M.
11 J. M. Nelles M.
12 H. L. Gilbert M.
13 W. C. Sanger H.
14 Gorham Faucon H.

15 Henry Joseph M.
16 R. H. Rogers M.
17 Perkins Goodhue H.
18 Gus. Jasigi H.
19 W. S. Seamans H.
20 H. L. Morse H.
21 J. S. Hall M.
22 - Wetherbee H.
23 Reg. Gray H.
24 Arthur Ellis (Capt.) H.
25 - Whiting H.
26 F. S. Watson
27 G. E. Jenkins
28 J. B. Abbott

HARVARD VERSUS McGILL
~ Montreal, 1874. ~

*109 Boat house, Harvard College, Cambridge,
Massachusetts, 1876*

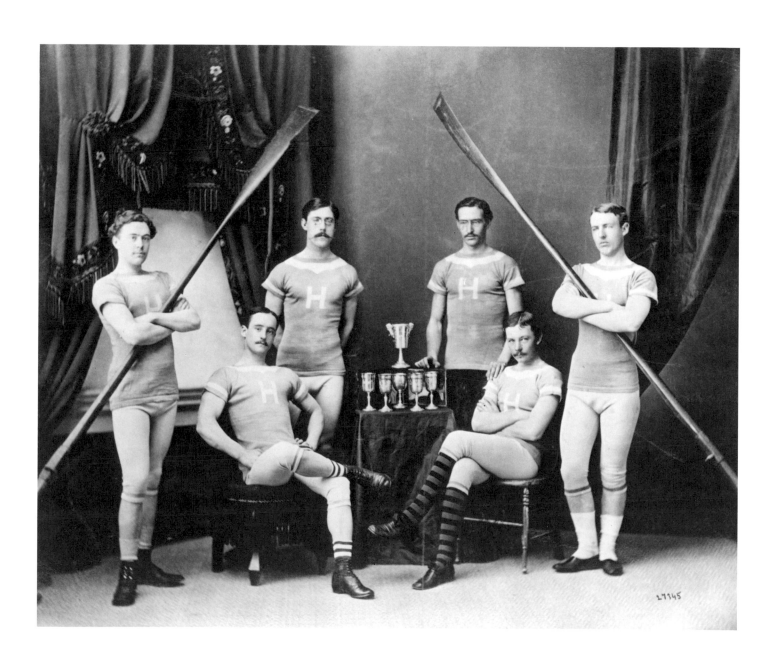

School Photographs

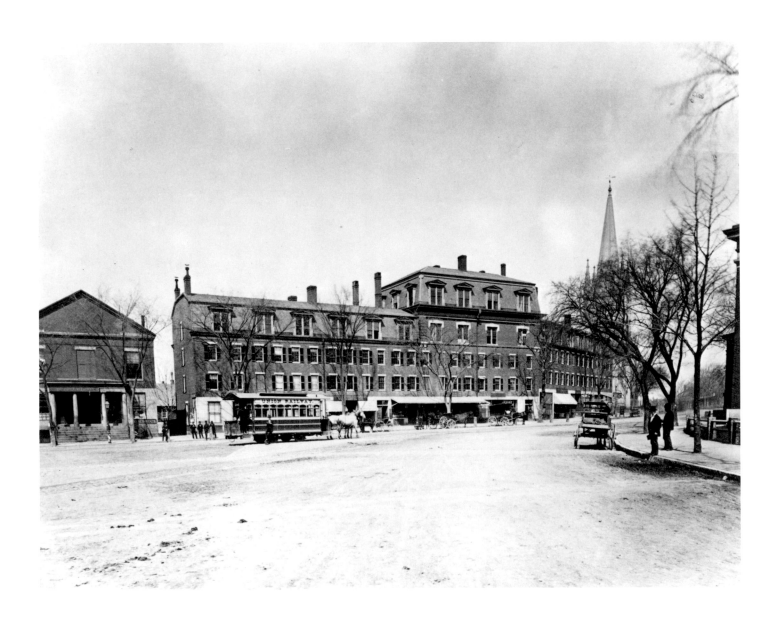

113 Members of Pierian Sodality Orchestra Group, Harvard College, Cambridge, Massachusetts, 1876

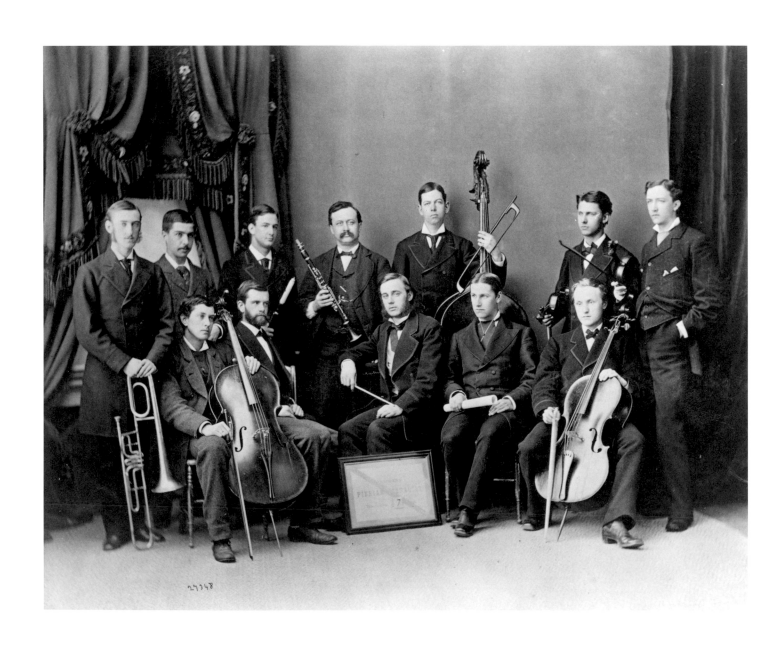

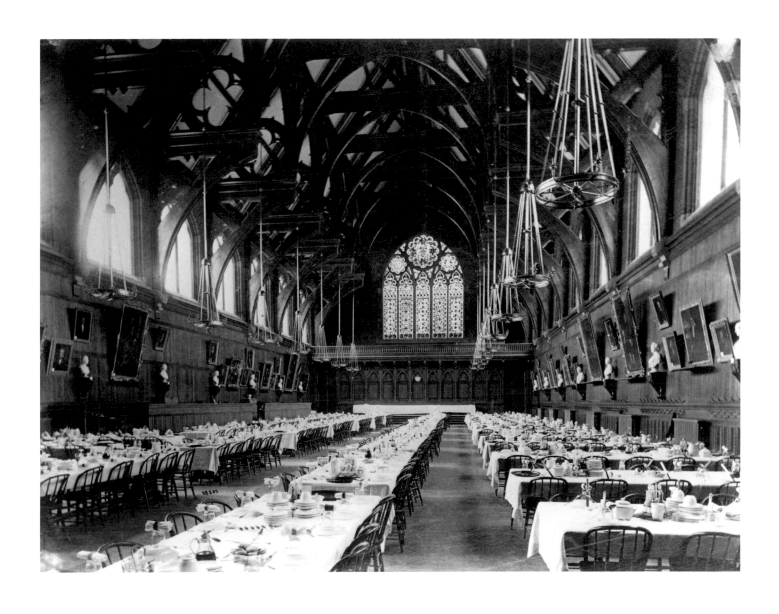

115 *Professor Wyman's natural history room, Harvard College, Cambridge, Massachusetts, 1876*

School Photographs

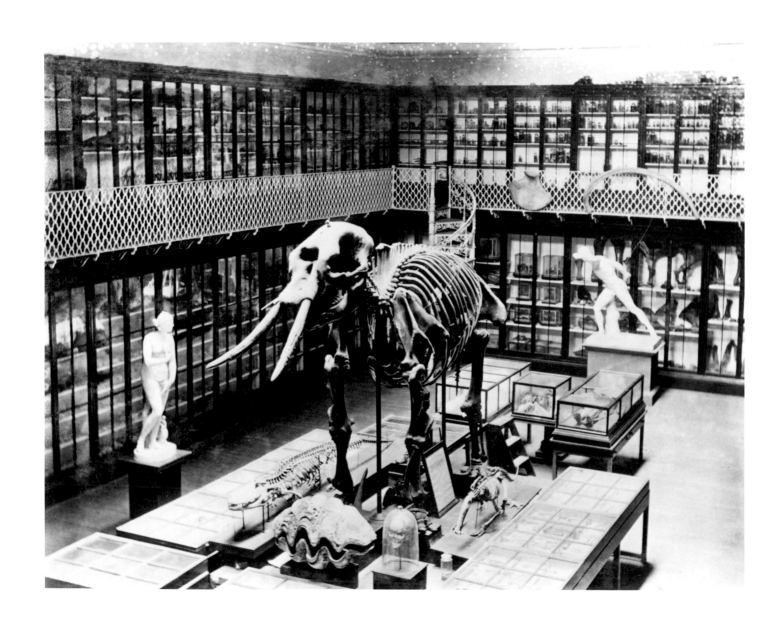

117 BELOW LEFT: *Jane Delia Cushing, 1889. After graduating from Smith College in 1889, Jane Cushing taught English, Latin, and Greek in several girls' schools. She joined the staff of the Masters School at Dobbs Ferry in 1899 and rose to the position of Associate Principal, retiring in 1934.*

118 BELOW RIGHT: *Florence Augusta Merriam, 1886. After graduation from Smith, she pursued a career as an ornithologist and writer. Based in Washington, D.C., she travelled in the western United States with her husband, Vernon Bailey, who, as a respected mammalogist, made up the second half of this effective team of naturalists. Her brother, C. Hart Merriam, was the founder of the U.S. Biological Survey.*

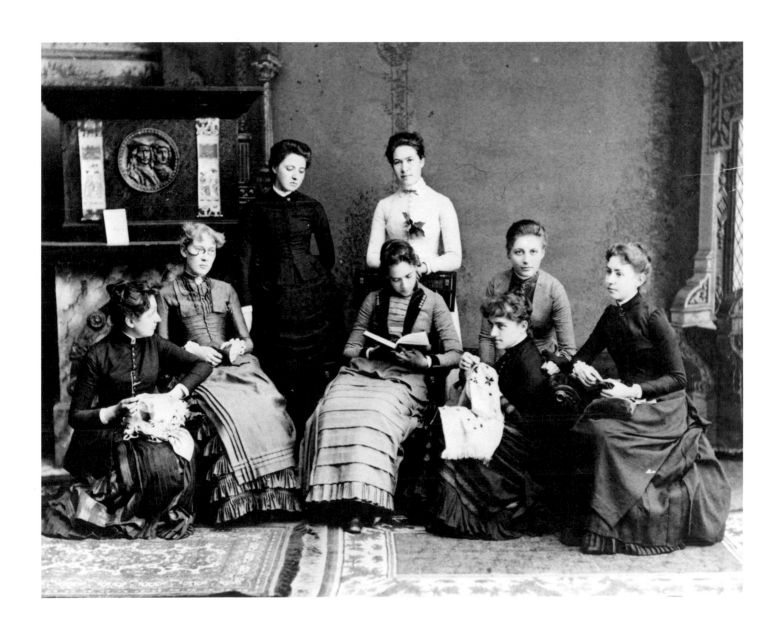

120 Tennis on the lawn at Dewer House, Smith College, Northampton, Massachusetts, c. 1886

122　*Morgan Library, Amherst College, Amherst, Massachusetts, 1880*

School Photographs

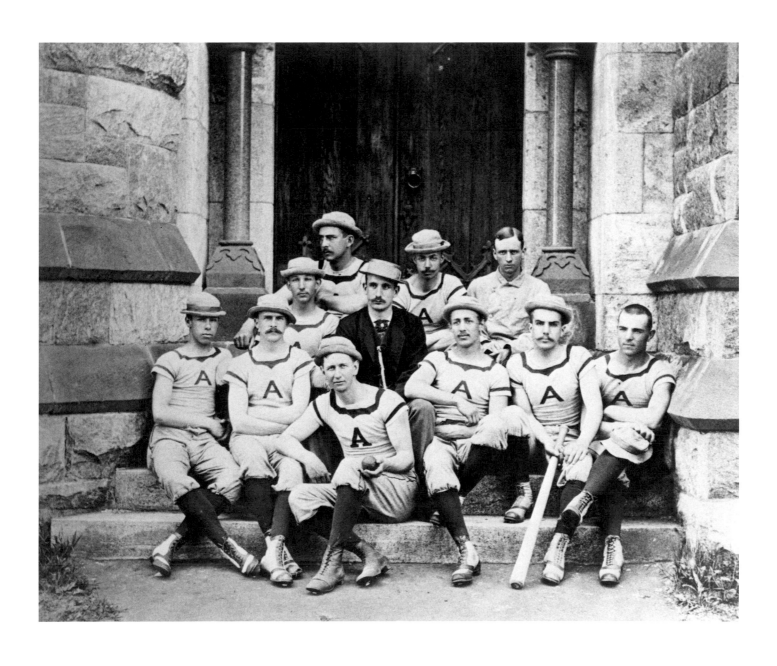

124 Yale College group, New Haven, Connecticut, 1872. A composite photograph put together in William Notman's Montreal studio from individual photographs taken at Yale.

125 John C. Green School of Science, College of New Jersey, Princeton, New Jersey, 1877

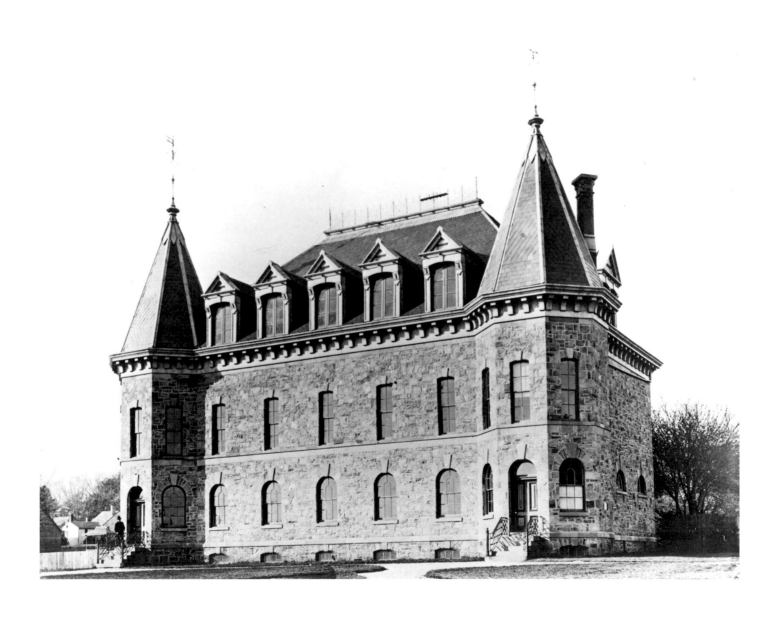

*127 Halsted Observatory, College of New Jersey, Princeton,
New Jersey, 1877. Built in 1872, it was demolished in 1932.*

School Photographs

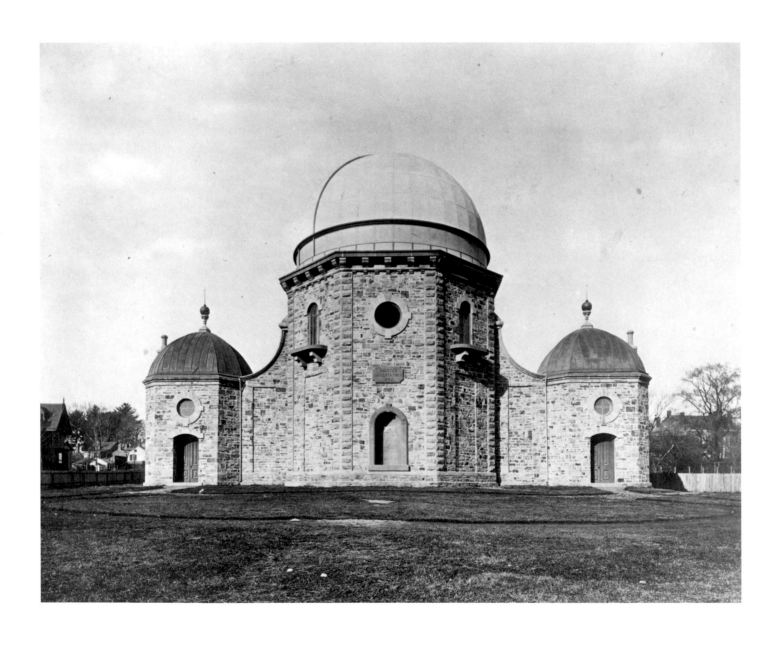

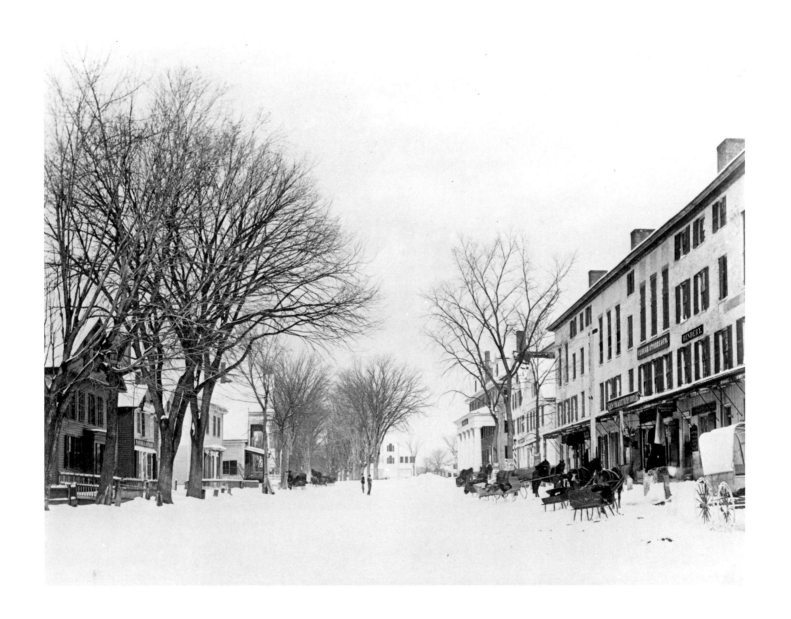

129 *Shattuck Observatory, Dartmouth College, Hanover, New Hampshire, 1874*

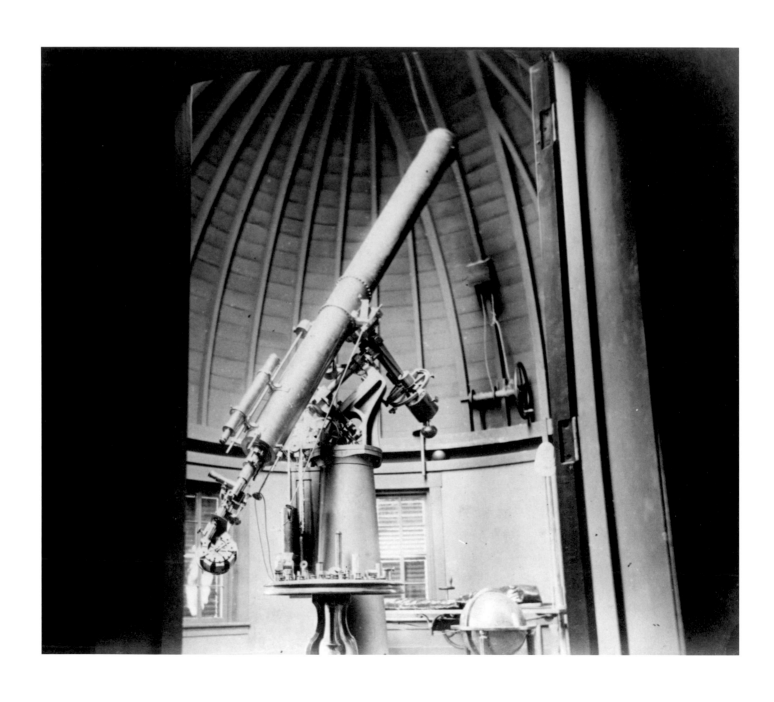

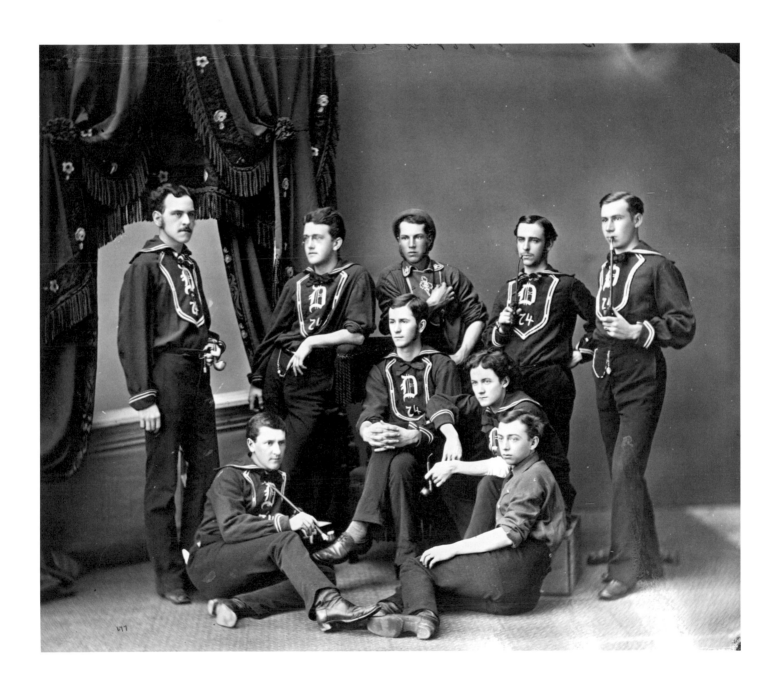

131 *Gymnasium, Bissell Hall, Dartmouth College, Hanover, New Hampshire, 1874*

Centennial Photographic
Company

133 TOP: *Bird's-eye view from main building, Centennial Exhibition grounds, Philadelphia, Pennsylvania, 1876*

134 BOTTOM: *Opening ceremonies in front of Memorial Hall, Centennial Exhibition grounds, Philadelphia, Pennsylvania, 1876*

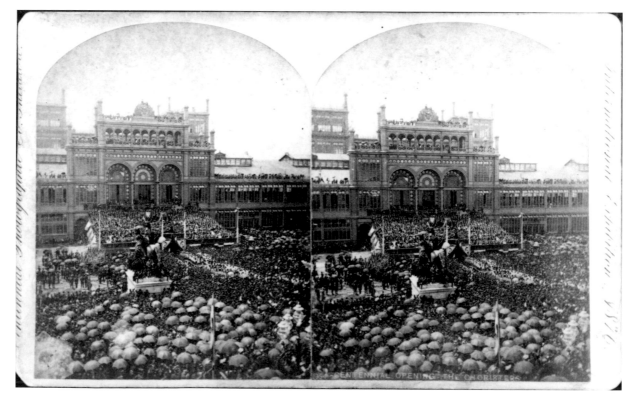

135 TOP: *Centennial Photographic Company headquarters, Centennial Exhibition grounds, Philadelphia, Pennsylvania, 1876*

136 BOTTOM: *Photographic Hall, Centennial Exhibition grounds, Philadelphia, Pennsylvania, 1876*

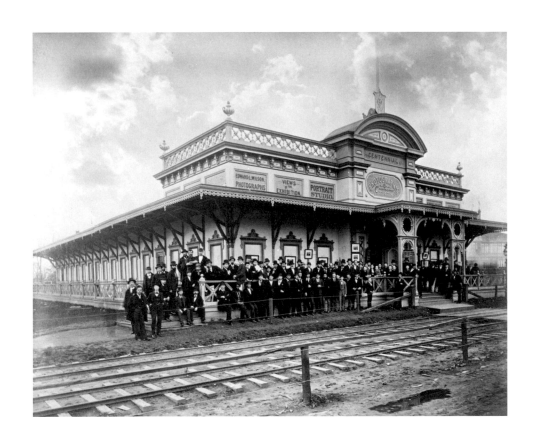

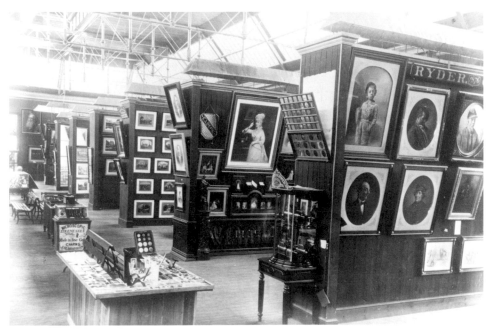

Centennial Photographic
Company

137 TOP: *Floral Hall (West End), Centennial Exhibition grounds, Philadelphia, Pennsylvania, 1876*

138 BOTTOM: *Machine Hall, South Avenue from east end, Centennial Exhibition grounds, Philadelphia, Pennsylvania, 1876*

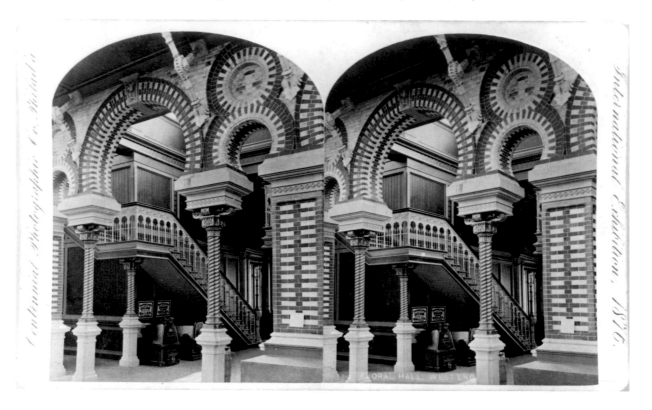

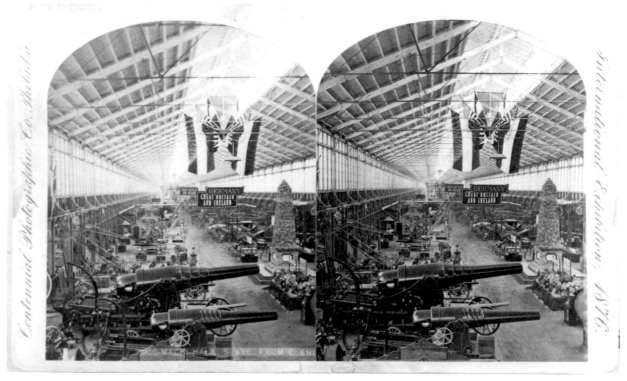

139 TOP: *Agricultural Hall (nave looking north), Centennial Exhibition grounds, Philadelphia, Pennsylvania, 1876*

140 BOTTOM: *Agricultural Hall nave, Centennial Exhibition grounds, Philadelphia, Pennsylvania, 1876*

Centennial Photographic Company

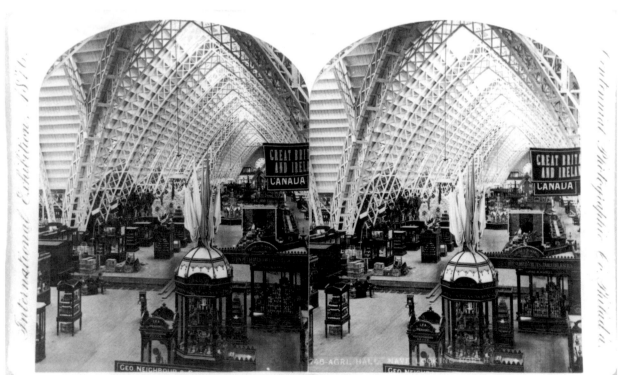

141 BELOW LEFT: *Samuel Kirkland Lothrop, Boston, 1868. A graduate of Harvard Divinity School, he served as pastor of the Brattle Square Church in Boston from 1834 to 1876. His son Thornton became a Justice of the Supreme Court.*

142 BELOW RIGHT: *Rev. Rufus Ellis, Boston, 1868. He officiated at the First Church in Boston from 1853 to 1885.*

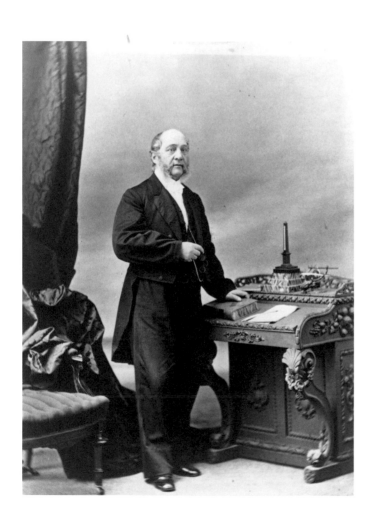

145 BELOW LEFT: *Rev. Charles Cleveland, Boston, 1868. City missionary for the poor in Boston from 1830 until 1869, he was photographed at the age of ninety-six by John Notman.*

146 BELOW RIGHT: *Charlotte Cushing, Boston, 1869. The Cushings were an influential Boston family whose ancestors first arrived in 1638.*

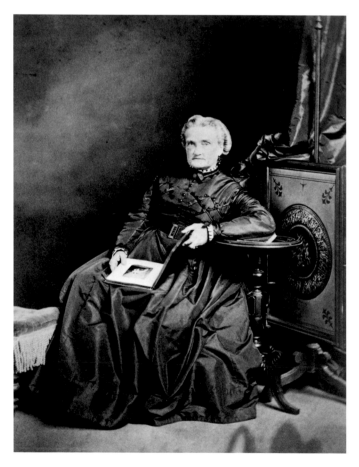

John Notman

148 BELOW: *The Saturday Morning Club, Boston, 1890*

James Notman

149 OPPOSITE: *Lillie Langtry, Boston, 1886 or 1887. Born Emily Charlotte le Breton in 1852 on the English Channel Island of Jersey and known as the "Jersey Lily," she was one of the great stage beauties of the day, and a favourite of the Prince of Wales. Notman's brother James captured her in his Boston studio during one of her several visits to America in the 1880s.*

James Notman

150 Franklin Haven of Boston and Beverly, Massachusetts, c. 1890. A graduate of Harvard Law School in 1857, he served in the Civil War as a lieutenant-colonel and succeeded his father as President of the Merchant's National Bank in 1884.

151 BELOW LEFT: Henry Sandham, Boston, 1880s. Sandham worked in Notman's Montreal studio from about 1880 to 1882, then removed to Boston.

152 BELOW RIGHT: Robert Louis Stevenson, Boston, 1879-80. The famous Scottish author (1850-1894) travelled in the United States in 1879-80.

James Notman

153 *Trinity Church, Copley Square, Boston, c. 1877. The church was under construction from 1872 to 1877. Copley Square, still under construction in the photograph, was finished after 1877, and named in honour of the artist John Singleton Copley.*

James Notman

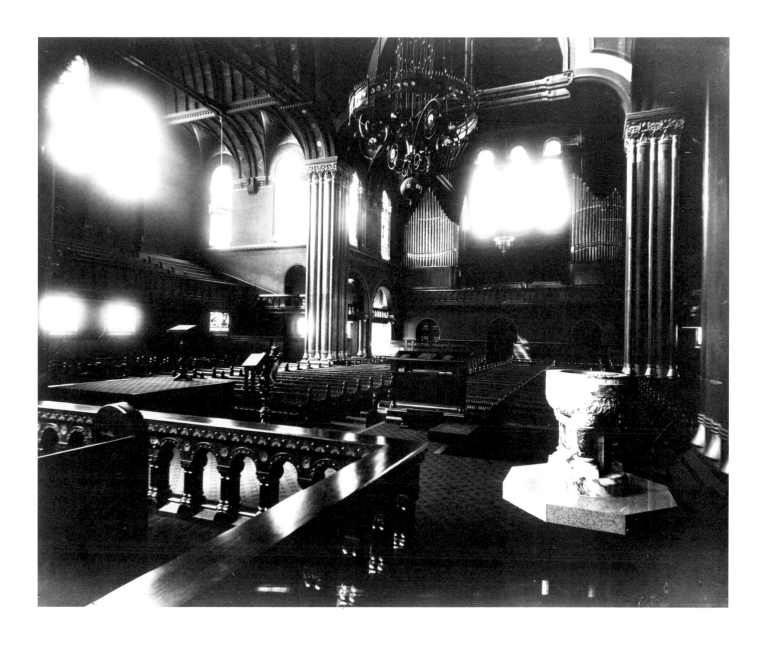

155 BELOW: *Mrs. Elizabeth Maude Barrett, Boston, 1880s*

156 OPPOSITE: *Bed Chamber of State Suite as arranged for President Cleveland, Hotel Vendôme, Boston, 1880s. Grover Cleveland was President of the United States from 1884 to 1888 and again from 1892 to 1897. The President stayed at the Vendôme on November 6, 1886.*

157 BELOW: *Yachting, Boston, 1880s. This is a composite photograph.*

Notman Photographic
Company

158 OPPOSITE: *Eminent Women, 1884. This composite photograph of American authors was compiled in the Montreal studio from portraits taken in the Boston studio, 1884. The background was composed of four interior views of Canadian railway financier George Stephen's house in Montreal.*

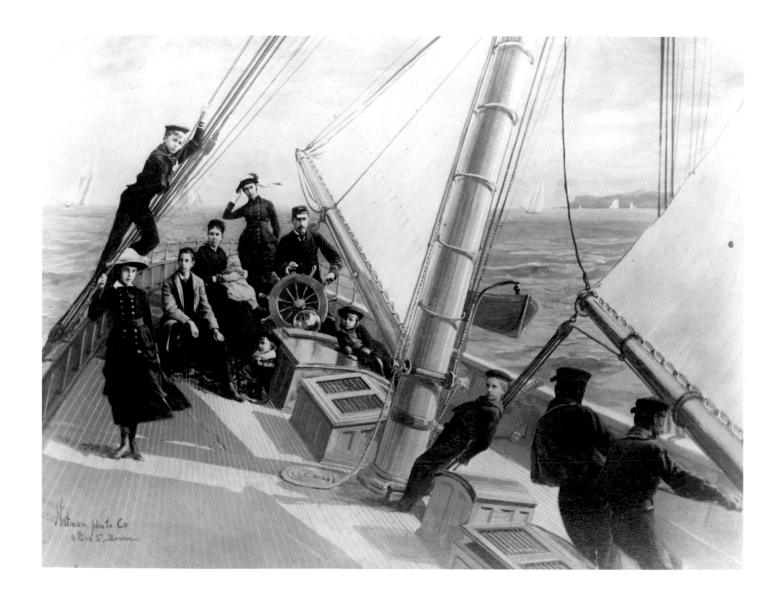

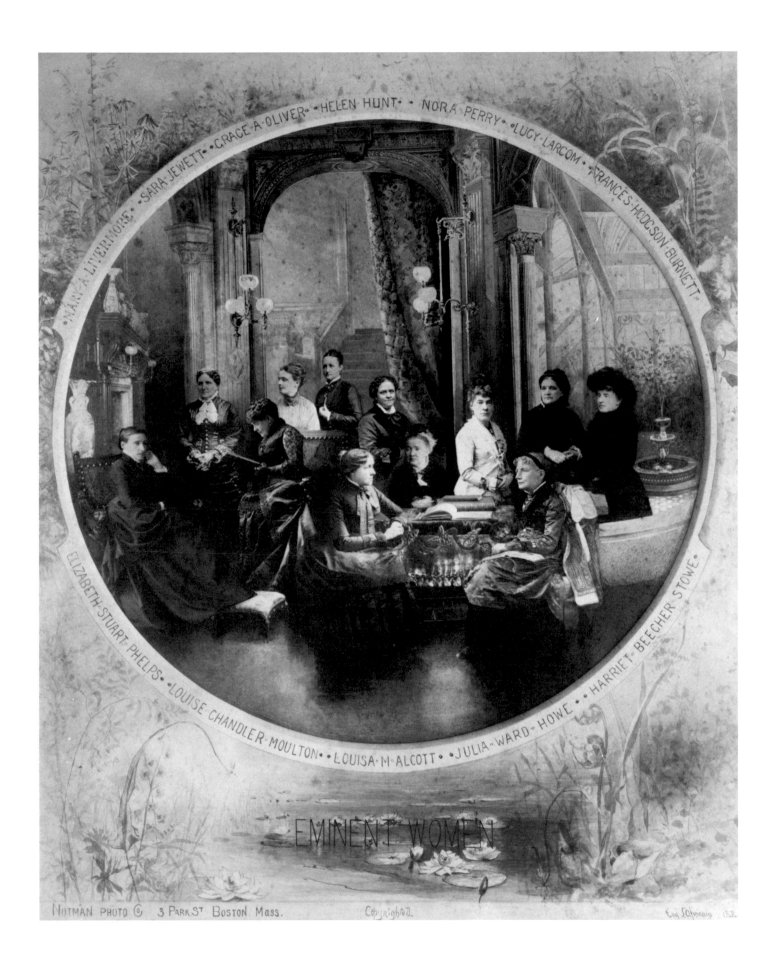

MARY A LIVERMORE · SARA JEWETT · GRACE A OLIVER · HELEN HUNT · NORA PERRY · LUCY LARCOM · FRANCES HODGSON BURNETT

ELIZABETH STUART PHELPS · LOUISE CHANDLER MOULTON · LOUISA M ALCOTT · JULIA WARD HOWE · HARRIET BEECHER STOWE

EMINENT WOMEN

159 BELOW: *The drawing room, Thomas Gold Appleton's residence,
10 Commonwealth Street, Boston, 1885*

160 OPPOSITE: *Thomas Gold Appleton, Boston, 1884. Appleton, inheritor of
his father's textile fortune, was a poet, essayist, and artist, much in demand
at Boston society occasions. He became the most substantial benefactor of the
Boston Museum of Fine Arts.*

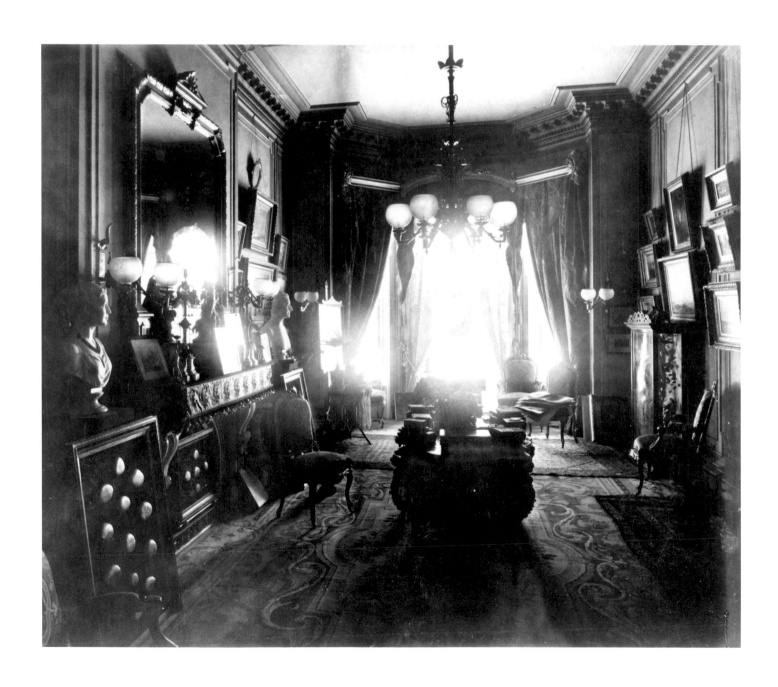

Notman Photographic
Company

*161 Detail of the cover of an album of reproduced photographs of
Hartford, Connecticut, made in Boston by the Notman Photographic
Company, commissioned and distributed in 1885 by The Travelers
Insurance Company as a promotion.*

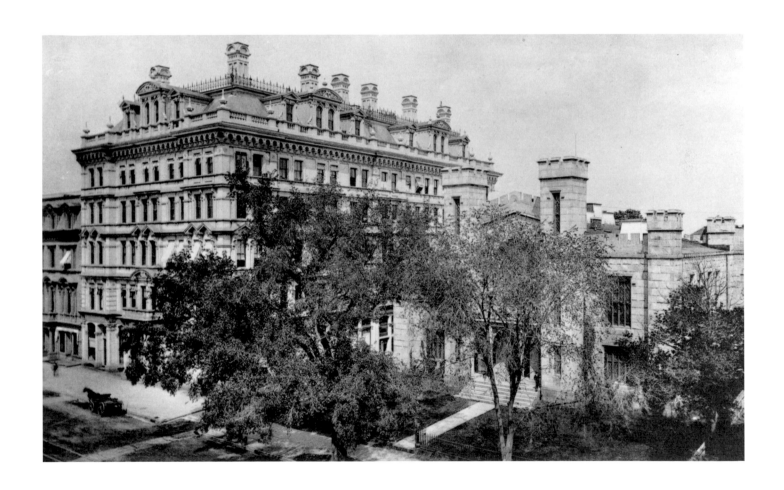

Notman Photographic
Company

163 OPPOSITE TOP: *Samuel L. Clemens, Hartford, Connecticut, 1885. Known by his pen name, Mark Twain, Clemens was America's most famous humourist. He lived in Hartford from 1870 to 1891.*

164 OPPOSITE BOTTOM: *The Clemens residence, Hartford, Connecticut, 1885*

165 BELOW: *Residence of Mrs. Samuel Colt, Hartford, Connecticut, 1885. Her husband was the inventor of the Colt revolving pistol and rifle. His factory was in Hartford.*

Notman Photographic Company

Notman Photographic
Company

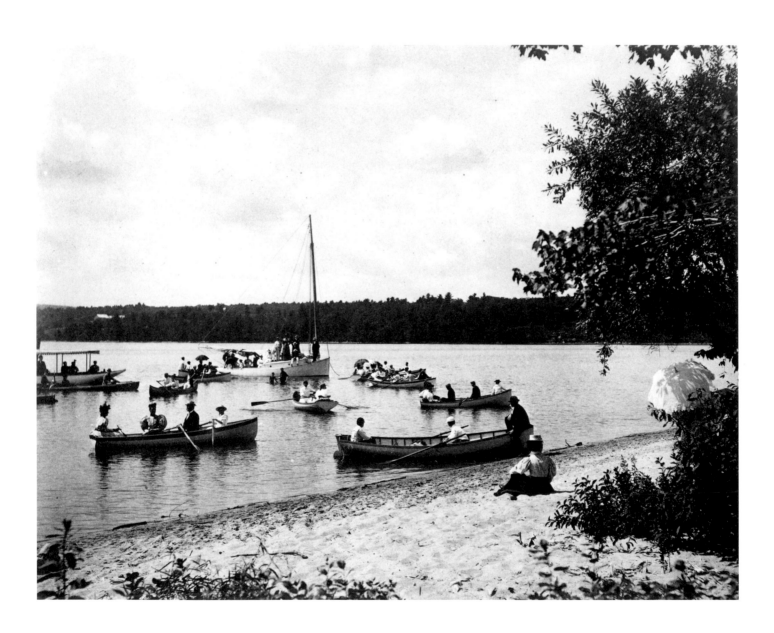

Notman Photographic
Company

Notman Photographic
Company

168 BELOW LEFT: *Looking up the carriageway to the State Capitol, Albany, New York, pre-1883. The building was demolished in 1883.*

169 BELOW RIGHT: *Looking down the carriageway from the State Capitol, Albany, New York, pre-1883.*

170 OPPOSITE: *Second Reformed Dutch Church, Albany, New York, c. 1880*

Notman Photographic
Company

171 BELOW: *The State Assembly, Albany, New York, c. 1878. This composite shows the interior of the old State Capitol. Construction of the new building was begun in 1867, but because of delays it was not completed until 1897. The assembly continued to meet in the old building until January 1879.*

172 OVERLEAF: *Looking east near the corner of Steuben and James streets, Albany, New York, 1878-79. The large square building centre left is the Delovan House, which stood on the present site of Union Station. The building with mansard roof, centre right, is the old Union Station, which opened in 1872.*

Notman Photographic Company

Notman Photographic
Company

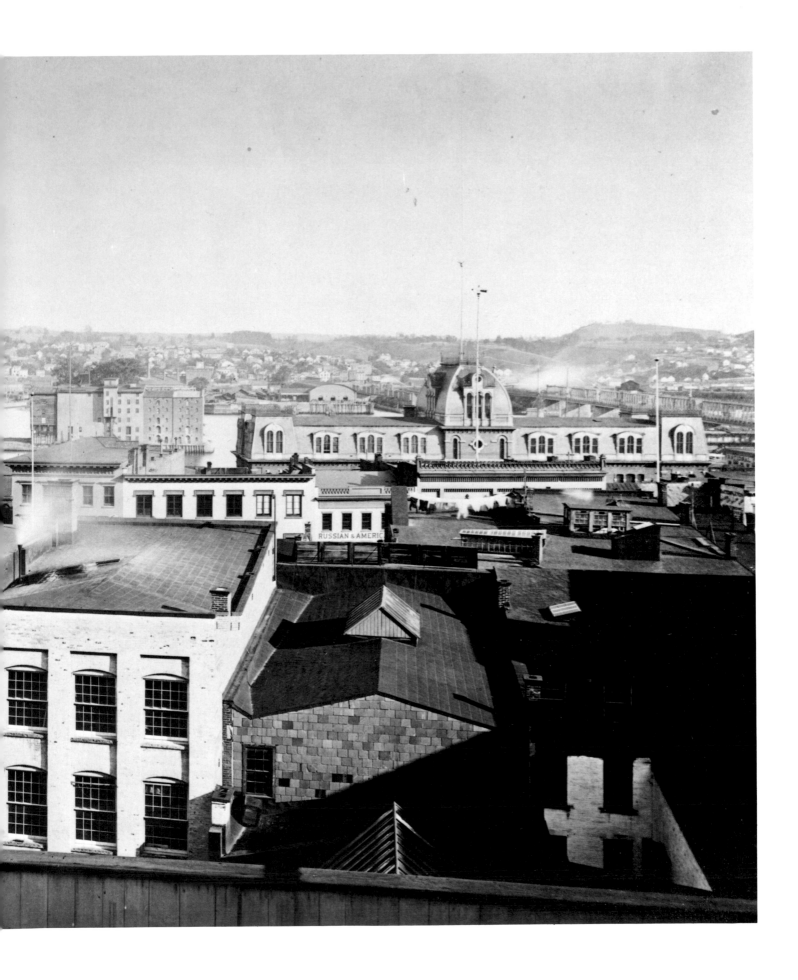

Notman Photographic
Company

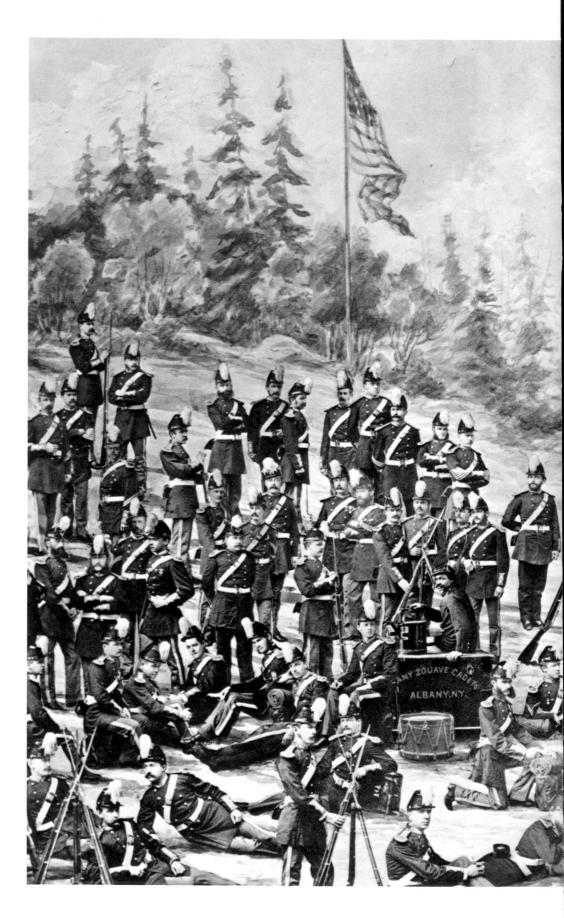

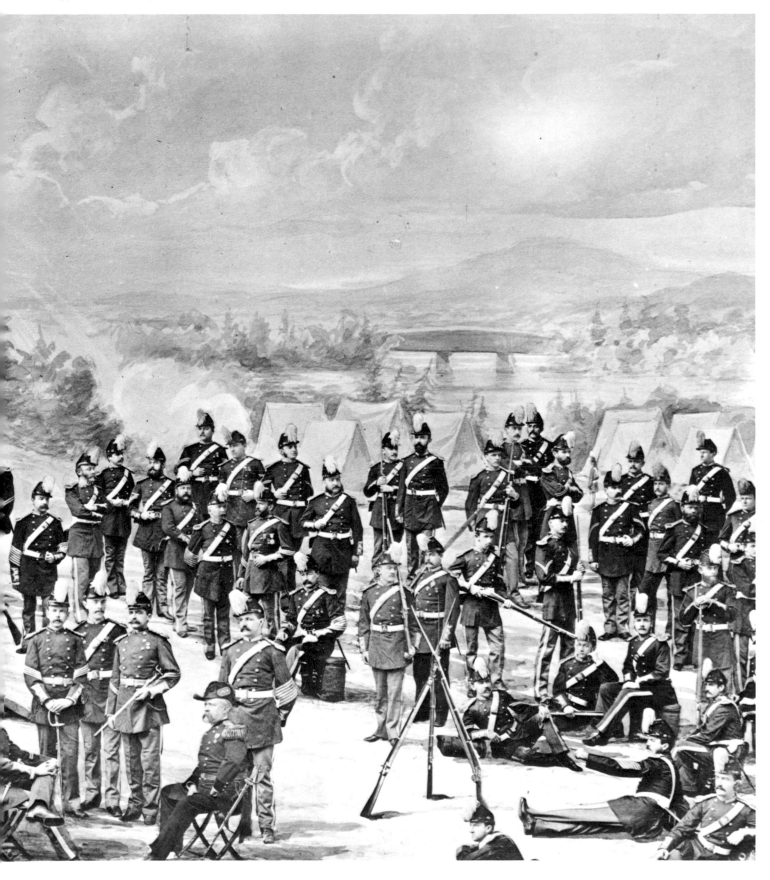

173 *The Albany Zouave Cadets, Albany, New York, 1879. Composite photograph.*

Notman Photographic
Company

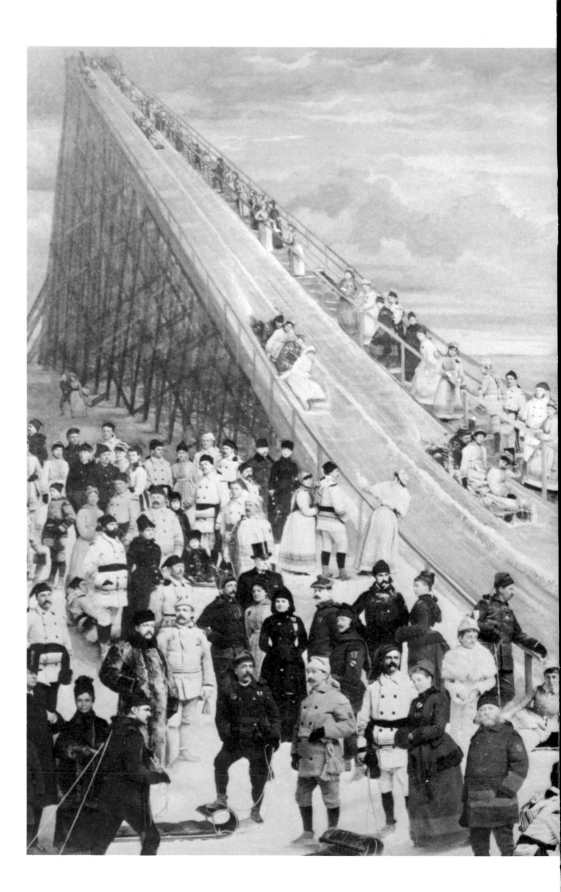

Toboggan Slide, Albany, New York, 1889. Composite photograph.

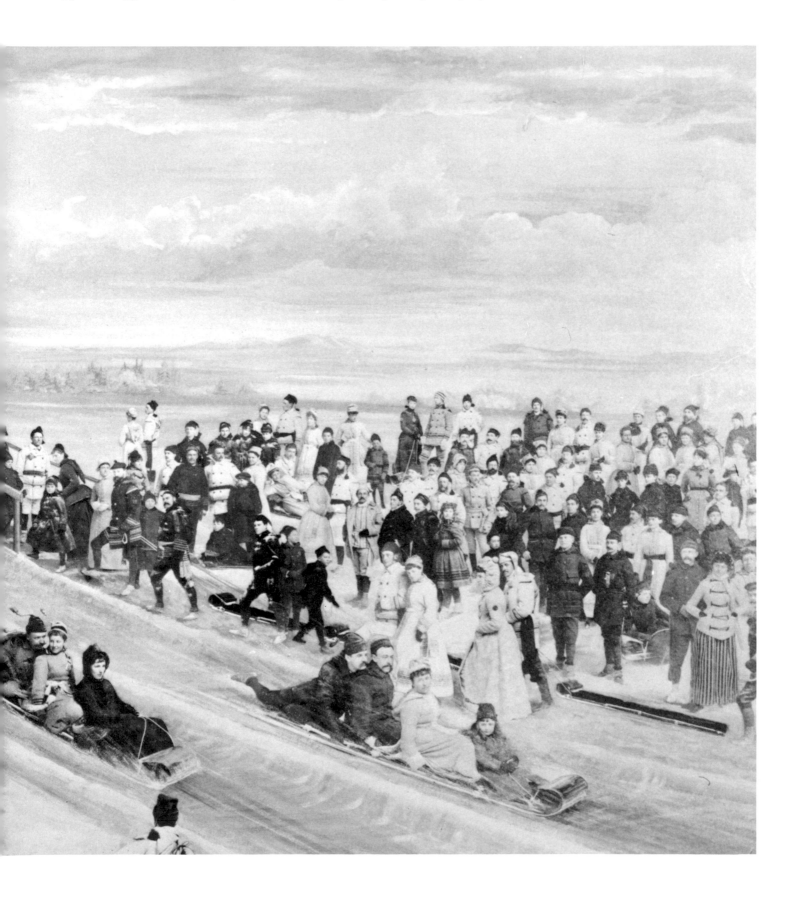

Acknowledgements

The first book-length indication of the wealth of the Notman photographic output was *Portrait of a Period: A Collection of Notman Photographs, 1856-1915* (Montreal: McGill University Press, 1967), Stanley Triggs's collaborative presentation with the late Canadian art historian and critic J. Russell Harper. Long out of print, that volume is now a collector's item. *Portrait of a Period* concentrated on displaying a wide selection of Notman's Montreal studio photographs in large size, and included as well a short history of the Notman business as it was understood to that date. Subsequently, in various works on photography, thematic or historical, or innumerable publications on Canadian historical, architectural, or artistic subjects, the photographs of William Notman's studios have attracted particular mention or have, of their own power, commanded repeated and special recognition.

A second major volume to feature Notman's work emerged in 1985. To accompany an exhibition of Notman photography at the Art Gallery of Ontario, Stanley Triggs expanded his earlier work into a separate publication, *William Notman: The Stamp of a Studio* (Toronto: Art Gallery of Ontario with The Coach House Press, 1985). In that book, for the first time, the history of the Notman family in Scotland and William's move to Montreal were elaborated upon, the workings of the Montreal studio's art department were examined, the contribution of William McFarlane Notman (the successor proprietor) was assessed, and the range and variety of Notman's staff photographers and artists received proper notice.

In this present volume, Triggs has joined Roger Hall and Gordon Dodds to take the Notman epic into a new realm – William Notman and the United States of America. Though the Notman Photographic Archives in Montreal possesses four hundred thousand images and many additional prints from the Notman business over some seventy-eight years of operation, relatively little of this derives from the large number of American studios developed by William Notman. To redress the "imbalance" and to open up the story of his successful reception south of the Canada–U.S. border, *The World of William Notman* takes a broader view of his business methods and activities in the two countries. Also presented is a further selection of more than two hundred prints, reflecting the striking quality and dimension of Notman photographic imagery across Canada and the northeastern United States. Most of these have not previously been published.

Since the contemporary business records of the Notman operations are virtually non-existent, the search for evidence has been time-consuming and at times frustrating. A battered manuscript wages book, commencing October 22, 1864, and running continuously to July 20, 1917, has been a vital historical source for following the ebb and flow of staff appointments and volume of business in Montreal. A similar document has not yet been discovered for any of the other Canadian or American studios. Correspondence between William Notman and fellow photographers, business acquaintances, social dignitaries, government officials, and clients – personal or corporate – is extremely scarce. Frequently, contacts are found among private collections in the form of routine transmittal notes accompanying or heralding a packaged order, and invoices advising or seeking payment from customers. Some individuals, like Manitoba's first premier, John Norquay, were notoriously slow to pay for their sittings and portraits.

A sorry omission is any tangible evidence of William Notman's communications with Edward Wilson, his friend, colleague, and one-time business partner, and the man who gave Notman his first recognition in 1864 in the pages of *The Philadelphia Photographer*. Neither is there much correspondence available between Notman and his partners, such as his two brothers, John and James, John Fraser of Notman & Fraser (Toronto), Henry Sandham of Notman & Sandham (Montreal), and Thomas Campbell of Notman & Campbell (Boston). Nothing has yet come to light from any

of the various Boston and Cambridge studios. Apart from a couple of relatively inconsequential items at Harvard University, there is nothing extant of Notman's connection, other than photographs, amongst the archives of New England universities and colleges – and yet, from both internal photographic evidence and external commentary, it is clear the college trade provided Notman's bread-and-butter work in the United States for more than a decade. Nowhere has it been possible to track down the kind of "picture book" record of portraits, and some views, kept by William Notman in the Bleury Street studio in Montreal.

Neither have we yet been fortunate enough to run across equivalent American sources to the day journal of Benjamin Baltzly, Notman's photographer chosen to travel with the Geological Survey of Canada crew in its British Columbia survey of 1871, or corporate records such as the William C. Van Horne letter books in the archives of the Canadian Pacific Railway, which provide a context for understanding several of the photographic commissions undertaken by the Notman studio. Of the few extant Notman family records in Montreal, there is a scattering of correspondence between William and his wife, Alice, and her parents, principally between 1856 and 1858, a manuscript of an address given by William to a youth group in Montreal, giving insight into his own youth in Scotland, a family tree prepared by William's grandson, Keith Notman, a few letters from the 1930s, and a manuscript memoir written by Charles Notman, Notman's youngest son, a year or so before his death in 1955. This particular document, especially in the absence of business and other family records, is essential for understanding the course of the firm's fortunes after the death of Charles's eldest brother, William McFarlane Notman, in 1913.

Of course, what is available are the products of William Notman's studios – photographs. Those preserved at the Notman Photographic Archives came directly from the firm's morgue, negative and print, or were acquired from various individuals and institutions that possess them as received documents. It is frequently difficult, without contextual or related documentation, to say categorically who took what, where, and when, especially from a firm with a large and energetic photographic staff scattered in so many locations. But by careful scrutiny of style and composition, by checking negative numbers (often scratched into the emulsion of glass negatives) against the studio record books in Montreal, by weighing internal image evidence, and by noting the constantly changing studio crests and logos of Notman advertising on photograph mounts, it is possible to reconstruct the Notman story.

For the balance of evidence, the most common sources have been contemporary city directories, which provide a guide to the firm's movements and the location of its principals and staff, and newspapers, which carry the notices of a photographic event involving the Notmans or a trade advertisement for their services. Certain legal papers (of court proceedings, business partnership, property tenure, company registration, tax assessment, and vital statistics) have been located in record offices and registries in Edinburgh (Scottish Record Office), Montreal (Notarial Archives – though much awaits further exploration – Montreal City Archives, Anglican Diocesan Archives, Mount Royal Cemetery), Boston (Sussex County Court House), and Albany (New York Department of State, Corporate Records Section).

Also providing some insight into the Notman fortunes between 1857 and 1885 are the credit reports of R. G. Dun's agents amongst the Dun & Bradstreet records deposited at the Baker Business Library of Harvard University. The records of the 1876 Centennial Exposition are principally divided among the Philadelphia City Archives, the Free Library of Philadelphia, the Historical Society of Pennsylvania, and the Library of Congress in Washington, D.C. Hundreds of plates, prints, and lantern slides of the exhibits taken by the Centennial Photographic Company can also be found in these repositories.

The authors of *The World of William Notman* wish to thank staff in various departments of archives, libraries, historical societies, museums, and heritage organizations, who answered questions, searched for evidence, and made them welcome during research visits. These institutions are:

In Canada: National Archives of Canada (Joy Williams, Andrew Rodger, Jim Burant, and Lily Koltun), National Gallery of Canada (James Borcoman), New Brunswick Museum (Peter Larocque, Garry Hughes), Nova Scotia Museum (Scott Robson), Provincial Archives of Manitoba (Michèle Fitzgerald and Elizabeth Blight), Public Archives of Nova Scotia (Margaret Campbell).

In the United States: Albany Institute of the History of Art, Amherst College (Deborah Pelletier and Daria D'Annunzio), Annisquam Historical Society (Donald Usher), Baker Library – Harvard Business School, Boston Athenaeum, Boston Public Library, Bostonian Society Library, City of Philadelphia Archives, Connecticut Historical Society (Judith Ellen Johnson), Connecticut State Library (Ann Barry), Dartmouth College Library (Ken Cramer), Easton Public Library (Teresa Price), Free Library of Philadelphia (Robert Looney), George Eastman House – International Museum of Photography (David Wooters), Hartford Public Library (Beverley Loughlin), Harvard University Archives (Robin McElheney), Historical Society of Pennsylvania, Library Company of Philadelphia, Library of Congress, Maine State Library (Sheila McKenna), Massachusetts State Archives, Mount Holyoke College (Elaine Trehub), National Archives and Records Administration, National Museum of American History, Newport Historical Society, New York City Public Library, New York State Archives, New York State Library, New York State Museum, Northampton County Historical Society,

Poland Springs Preservation Society (Marion Bunney), Princeton University Archives and Library (Earle Coleman and Nancy Young), Rhode Island Historical Society, Smith College Library (Maida Goodwin), Society for the Preservation of New England Antiquities (Ellie Reichland), University of Maine at Orono (Eric Flower), University of Michigan – Bentley Library (Kathleen Koehler) and Special Collections (Kathryn Beam), University of Rochester – Visual Studies Workshop (Bob Betz), Vassar College Library (Nancy McKechnie), Yale University Archives (Judith Ann Schiff).

We wish to also thank James Egles of the British Library, Hal Keiner and Cathy Corcoron of The Travelers Insurance Company in Hartford, Conn., Andrew Birrell and Joan Schwartz of the National Archives of Canada, Jean Matthews of the University of Western Ontario, and Richard Perren of Toronto for their advice and assistance. Our appreciation for ever-ready hospitality is extended to William Martin of Montreal and Margret Martin of Quebec City, Al and the late Eleanor May of Toronto, Brian and Mineko Smith of Washington, D.C., Guy Stanley of New York, and Julian Field of Philadelphia. For unfailing support, Nora Hague and Tom Humphrey of the Notman Photographic Archives deserve much praise. Will Rueter brought his talents to the book's design, and Patricia Kennedy and David Godine exercised their editing skills.

Most is owed, as always, to Sandra Martin, Marietta Dodds, and Louise Triggs.

The Ontario Arts Council provided financial assistance to help with living expenses during travel. We are grateful for the Council's aid.

Roger Hall, Gordon Dodds, and Stanley Triggs
Montreal, Quebec, May 1992

PICTURE CREDITS

Index

Adams, W. Irving 43-44
Albany Art Union 59
Albany, New York 51-60, 218-27
Almour, A. B. 29-31
Amherst College, Amherst, Mass. 42, 179-82
Ann Arbor, Mich. 52
Appleton, Thomas Gold 211
Arless, George 15, 54
Art Association of Montreal 62
Arthur, Augustine and John 28
Arthur, HRH Prince 69
Associated Screen News 63, 64
Baltzly, Benjamin 21, 32, 41
Barnjum, Frederick S. 78
Barrington Street, Halifax, N.S. 29
Batterson, James 58
Bedford, Nova Scotia 154
Bellevue Avenue, Newport, R.I. 54
Belmont Avenue, Philadelphia, Penn. 45
Bernard, Aldis 72
Berton, Pierre 64
Bleury Street, Montreal, Quebec 9, 11, 17, 49, 62-63, 83-84
Boston, Massachusetts 11, 27, 32, 38-39, 41, 49-51, 54, 56, 59, 63, 199, 204-5, 207-8, 210
Boston Athenaeum 50
Bourdon, Denys 15, 59-60, 63
Boylston Street, Boston, Mass. 50-51, 59
Brattle Street, Boston, Mass. 51
Brennan, M. L. 44
Brown, George 24
Bruce, Jocia 13, 26
Buffalo Bill (William F. Cody) 62, 80
Calgary, Alberta 63, 117-18, 121
Cambridge, Mass. 43, 50-52, 60
Campbell, Thomas 50, 52
Canada East 4, 12, 20
Canada West 11-12, 20
Canadian Pacific Railway (CPR) 21, 28, 59, 62-63, 121, 125, 128-30, 139

Cap à l'Aigle, Quebec 21
Cariboo Road, British Columbia 125
Cartier, George-Etienne 24
Centennial Exhibition 42-44, 49, 192-95
Centennial Photographic Co. 43-46
Chaudière Falls 20, 25, 138
Child, Francis James 42
Christy, Robert J. 44
Clanwilliam, Lady 147
Clemens, Samuel (Mark Twain) 48, 58, 215
Cleveland, Rev. Charles 198
Cochrane, Alberta 119
Colt, Samuel 58
Copley Square, Boston 204-5
Cornwallis West, Mrs. 50
Cushing, Charlotte 198
Dartmouth, The 59
Dartmouth College, Hanover, N.H. 41-42, 188-91
Davis, Jefferson 58, 76-77
Denison family, Toronto, Ont. 142
Dennis, C.W. 13, 15
Doyle, Charles Hastings 143
Dufferin, Lord 25, 140-41
Dufresne, Ovid 62
Duncan, James 52
Eastman, George 60, 64
Easton, Penn. 50, 52
Edward, HRH Prince 12
Eliot, Charles W. 41
Emerson, Ralph Waldo 197
Fairmount Park, Philadelphia, Penn. 43-44
Fenians 69, 91
Fenton, Roger 13
Fifth Avenue, New York City 59
Fleming, Sandford 139
Franklin, Benjamin 13
Fraser, John A. 13, 26-27, 43-45, 61
Fraser, William 14
Fredericton, N. B. 162
Gatehouse, J. M. 38-39
George, HRH Prince 151

George Street, Halifax, N.S. 29
Gillelan, Grace 74
Glacier Park, B.C. 124
Glasgow, Scotland 3-4, 9, 61
Grand Trunk Railway 6, 10, 20
Granville Street, Halifax, N.S. 29
Haggerty, William 63-64
Halifax, N.S. 20, 26, 28-32, 103, 146-49, 152, 155-59
Halifax Evening Press 29
Hammond, John 14, 21, 32
Hanover, N. H. 41, 50, 52, 60, 187
Harrison, Benjamin 58
Hartford, Conn. 54-58, 212-15
Hartford Daily Times 58
Harvard College, Cambridge, Mass. 40, 42-43, 166-74
Harvard Street, Cambridge, Mass. 51
Haven, Franklin 202
Hill, Oliver Massey 30
Hodges, James 12
Howe, Joseph 134-35
Hudson's Bay Co. 11
Intercolonial Railway 28, 32, 152-53
J. S. Notman & Co. 38-39
Jarvis, Samuel 13
Jodoin, Aimé 15, 59, 60
Jones, Andrew 52
Kicking Horse Valley, B.C. 123
King Street, Toronto, Ont. 26-27
Kingston, Ont. 20, 106-7
L'Africain, Eugene 13-14, 30, 57
Lachine Rapids, Quebec 95
Lake Memphremagog, Quebec 106, 137
Lake Ontario 23
Langtry, Lillie 201
London, England 46
London, Ontario 20
London Photographic Society, England 13
Longfellow, Henry Wadsworth 17
Longueuil, Quebec 5, 62
Lugrin, Clarence T. 32
Lyman, Hannah 40

Lytton, B.C. 126
Macdonald, John A. 22, 24
Maclean's magazine 64
Madison Avenue, New York 59
Magnolia, Mass. 54
Marling, Strachan & Co., U.K. 4
Massachusetts Avenue, Cambridge, Mass. 60
McGill College, Montreal, Quebec 41, 64, 166-67
McMullen, Edgar 52, 56
Medicine Hat, Alberta, 120
Millman & Co. 28
Mississippi River 23
Molson, John 62
Montreal, Quebec 4-5, 9-13, 15-26, 28-32, 38-41, 44-46, 49-51, 54, 57, 59, 62-63, 86-90, 166-67
Montreal Gazette 49
Montreal General Hospital 62
Morse, Samuel B. 39
Mount Holyoke, Mass. 42
Mount Stephen, B.C. 123
Mount Royal, Montreal, Quebec 15
Murray Bay (La Malbaie), Quebec 20, 99
New Haven, Conn. 50, 52, 60
New Westminster, B.C. 63
New York, N.Y. 51-52, 59
Newfoundland 63, 104-5
Newhall, Beaumont 64
Newport, R.I. 54
Niagara Falls 12, 20, 30, 112-13
Niepce, Joseph Nicéphore 2
North Pearl Street, Albany, N.Y. 52, 59
North Thompson River 21, 30
Northampton, Mass. 175
Notman, Alice Woodwark (wife) 3, 10-11
Notman, Annie 51
Notman, Charles Frederick (son) 59, 63-64
Notman, Fanny (daughter) 9, 11
Notman, George R. W. 58-59, 63
Notman, George Sloane (son) 51
Notman, James (brother) 11, 15, 31-32, 50-51, 59
Notman, Janet (mother) 11
Notman, John (brother) 11, 15
Notman, John S. 38-39
Notman, Maggie (sister) 11
Notman, Mrs. William McFarlane (daughter-in-law) 127
Notman, Robert (brother) 11, 61
Notman, William: in Scotland 3-4; in Montreal 9-10, 60; Victoria Bridge contract 10-11; "Photographer to the Queen" 13; studio style 15-19; railroad photography in Western Canada 20-22; Canadian branch studios 23-32; painted photographs 30; Edward Wilson 38, 42; American college enterprise 39-41; Centennial Photographic Co. 43-47; business in Boston 50-51; Notman Photographic Co. 52-60; Travelers Insurance Co. promotion 55-58; resort photography 59-60; death in Montreal 62
Notman, William (father) 11, 61
Notman, William McFarlane (son) 21-22, 52, 59, 60-63
Notman & Campbell 50-52, 59
Notman & Fraser 27-28
Notman Photographic Co. Ltd. 52, 54, 59-60
Ogilvy & Lewis, Montreal 9
Ontario Society of Artists 27
Ottawa River 21
Ottawa, Ont. 23-24, 26, 28, 30, 108-9, 136
Pach Bros. 40
Paisley, Scotland 3
Paris, France 46
Park Street, Boston, Mass. 36, 50-52, 59, 63
Parkman, Francis 43
Philadelphia, Penn. 42, 46, 54, 192-95
Phillips Square, Montreal, Quebec 63
Philadelphia Photographer, The 18, 37, 82
Photographic Times, The 40
Pictou, N.S. 51
Poland Springs, Maine 54-55, 60, 216
Portland, Maine 5, 11, 28
Poughkeepsie, N.Y. 40-43, 66
Preston, Edward 56
Prince William Street, Saint John, N.B. 31
Princeton University, Princeton, N.J. 42, 184-86
Pullman's Island, N.Y. 81
Quebec City, Quebec 17, 96-97
Queen Victoria 1, 12, 23, 59
Ramsay, Alexander 52
Ransom Guards 82
Raphael, William 10
Redpath family 85, 89
Remington, Frederick 74
Rhodes, William 17-18
Rideau Canal, Ont. 23, 25
Rideau Falls 25
Rivière du Loup 20
Rocky Mountains 21, 63
Rodier, Charles 12
Rose, John 12
Russell, G. Horne 13, 15
Saint John, N.B. 20, 30-32, 50, 102, 160-61, 163-65
Saint John Daily News 32
Saint John Evening Telegraph 31
Sandham, Henry 13, 30, 57, 61, 203
Saratoga, N.Y. 54
Sarony, Napoleon 40
Schreiver, Stephen 59
Schwarzman, H. J. 45
Seaforth Highlanders 79
Selwyn, Alfred 21
Sharpe, Edward 13
Shawinigan Falls 20, 101
Sherbrooke Street, Montreal, Quebec 12, 62
Simpson, Herbert E. 28
Sitting Bull 62, 80
Smith College, Northampton, Mass. 42, 175-78
Spuzzum, B.C., 125
St. Albans Raiders 18, 37, 82
St Jérôme, Quebec 100
St. Lawrence & Atlantic Railway 5
St. Helen's Island, Montreal, Quebec 12
St. Lawrence River 10, 62
St. Maurice River 20, 101
Stevens, Albert 52
Stevenson, Robert Louis 203
Stieglitz, Alfred 46
Stowe, Harriet Beecher 16, 58
Summerhayes, Robert 15
Tadoussac, Quebec 98
Thames River 20
Thomas, F. W. 62
Topley, William 14-15, 25-26
Toronto, Ont. 6, 26-28, 30, 45, 110-11, 144
Tranquille, B.C. 122
Travelers Insurance Co. 54-59
Tremont Street, Boston, Mass. 38
Tupper, Charles 24
Van Horne, William 21-22
Vancouver, B.C. 127-30
Vassar College, Poughkeepsie, N.Y. 40-43, 66
Victoria, B.C. 131-32
Victoria Bridge, Montreal, Quebec 10-12, 20, 92-93
Victoria Hockey Club, Montreal, Quebec 67
Vogel, Hermann 46
Walker, James 52
Warner, Charles Dudley 48, 58
Washington and Jefferson University, Washington, Penn. 38
Webb, William 15, 29, 31
Wellington Street, Ottawa, Ont. 25
Weston, James 13-14, 57
William Notman & Son 4
Wilson, Edward L. 38, 42-45
Wilson, Mrs. Walter 19
Windsor Castle, England 13
Winnipeg, Man. 21, 114-16
Winter Street, Boston, Mass. 39
Yale University, New Haven, Conn. 41-42, 183